ART FOR PUBLIC PLACES
Critical essays

by Malcolm Miles

D1407101

Claire Smith — at work on Limehouse Reach, Limehouse Library, 1986

ART FOR PUBLIC PLACES
Critical essays

by Malcolm Miles

with contributions by Hugh Adams, Richard Cork,
Amal Ghosh, Juliet Steyn, David Stone and Louise Vines

with a preface by Richard Burton

Winchester School of Art Press
Park Avenue, Winchester, Hampshire

Many people have contributed to the writing of this book.

Particular thanks are due to Valerie Holman, who read several chapters in draft; to Olivia Gonzales, who assisted me in taking many of the photographs; to Stephen Farthing, who encouraged me to undertake the original research; to Ronald Forbes, who gave me many valuable insights as to how to approach the subject; to Frances Smith and Rory Coonan, who have helped me sustain that research; to Peter Hill, Roland Piché and Juliet Steyn, with whom I have had many interesting discussions; to David Haste, who has helped me reconcile the demands of employment with those of writing a book; to Bob Tegg, who has printed many of the photographs; and to the many artists and administrators who gave time to talk about their work. Without their help it would have been impossible to write this book.

Financial support has been received from South East Arts, in researching British art for public places, from the British Association for American Studies, for a visit to the United States, and from the British Council in relation to a visit to Bulgaria.

My employers, the Kent Institute of Art and Design, have been supportive, and the arguments have been polished in part through discussions with students there and, previously, at West Surrey College of Art and Design.

The publishers gratefully acknowledge the financial assistance of the Southern Arts Association.

Front cover illustration shows *St George and the Dragon* by Michael Sandle.

First edition published in the United Kingdom 1989 by:
Winchester School of Art Press
Park Avenue
Winchester SO23 8DL
Hampshire

Typesetting by Artset Ltd, Southampton
Printed by Thomas Campone, Southampton

British Library Cataloguing in Publication Data:

Miles, Malcolm
Art for public places: critical essays —
(Winchester studies in art and criticism).
1. Visual arts
I. Title II. Series
700

ISBN 0 95067 838 4

CONTENTS

PREFACE

Proposition 2:
Architecture is the material expression of the wants, the faculties and the sentiments of the age in which it is created.

Proposition 36:
The principles discoverable in the works of the past belong to us; not so the results. It is taking the end for the means.

<div align="right">

Owen Jones: The Grammar of Ornament

</div>

The publication of these essays on art in public places is important because it will help those who read them to become aware of the issues and questions with which architects and the public now have to grapple.

It is noticeable that the attention of society swings periodically, at times to the exclusion of perennial subjects of importance. In this category I would place the fusion of art, craft and architecture. We have been through a period, a barren period, when this essential fusion did not very frequently take place.

Yet today we have a great opportunity to redress the balance between art and architecture and at the same time give artists and craftsmen and women the opportunities they require. This balance was sought by the creators of the Modern Movement at the Bauhaus, whose creative activities were broadly based in architecture, furniture, industrial design, weaving and painting. Architects of that period, such as Breuer, Gropius and Mies van der Rohe, all designed outstanding furniture and artefacts, and collaborated with artists. Later, Le Corbusier practised not only as an architect, but also as a painter. In his finest building, at Ronchamp, he brought together his art and architecture in a quite outstanding way.

In this country, art and architecture have become separated, so that artists and architects are themselves for the most part educated in separate establishments. Educationally, architecture is classed as a science, whereas in fact architecture bridges science and art. In the recent past

architects have been thought of by many as professionals serving commercial and institutional clients, clients who have had little understanding of architectural and artistic questions, except sometimes in an historic context.

Now, there are indications of change, both in the cultural aspirations of many clients, and in the degree to which all parties realise the need for closer ties between the artist, the craftsman and the architect. I fully expect this book to further this process of understanding.

Richard Burton

THE ARGUMENTS FOR PUBLIC ART

"... now sing
Recover'd Paradise to all mankind ...
And Eden raised in the waste wilderness."[1]

Awareness precedes change. The social diseases of pollution, planning blight and certain kinds of modern architecture are commonly recognised. Yet attitudes to cities are changing. The place of art, as an imaginative presence, perhaps an agent for wider change, is gaining recognition. It may be seen against the background of a growing concern for the environment.

In constructing a general case for public art, there are two possible starting points: tradition and actuality. Tradition establishes precedents in other cultures, different from our own, but on some elements of which it is claimed our own is built. When we look to Greece or Christendom, we see the Parthenon with its frieze or the Cathedrals with their sculptures: indivisible entities. Significantly, perhaps, the Parthenon frieze is now confined in a museum!

Tradition is fraught with subjectivity. Perhaps it is better to begin from actuality. This is a grey place. In retrospect, even allowing for the way we colour the past from our own sense of loss, it seems unusually so. Have there ever been such wastes as the dim subways or the tower blocks reeking of disinfectant?

Griping is easy. The complaint needs to be precise. It is not a case of claiming an unusual rise in crime (because other centuries were just as violent), nor of overcrowding (because Victorian London was worse), but of an alarming inhumanity, a loss of meaningful scale, a feeling that ordinary people have no claim to the spaces of daily public living. Everything has become internalised, all spaces become private, and what is outside is a margin for vagrancy, like the spaces outside the gates of medieval cities, where the leppers congregated. We are now the leppers in our own

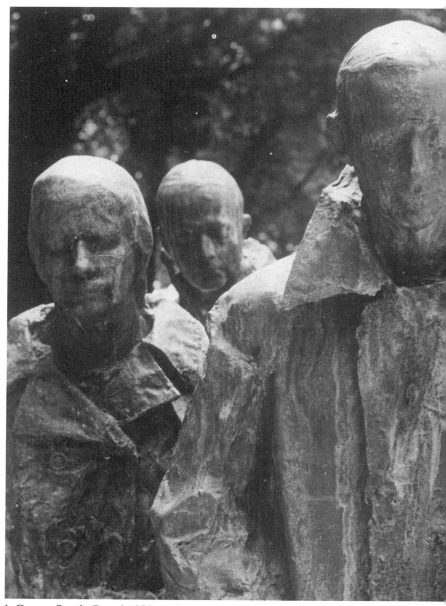

1. George Segal, *Crowd*, 1987, as sited in Broadgate Development, London, but photographed at Venice Biennale, 1988 (B Tegg)

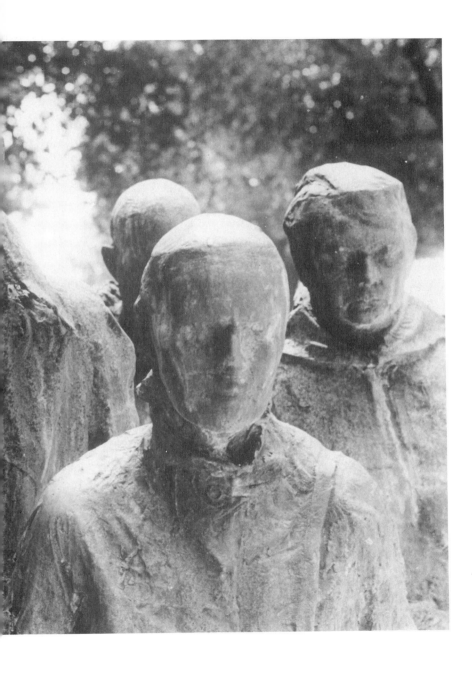

cities, scurrying across deserted plazas. Perhaps George Segal's grey figures in a plaza at London's Broadgate, frozen in their anonymous hastening, stand for all the emptiness (*Fig 1*).

Architects, also affected by internalisation, sometimes see buildings as sculptures, or vehicles for idiosyncrasy. Post-Modernism may bring back colour, but it does little to make architecture responsive to human needs, though there is a growing movement for community architecture.

Our society manifests its world-view by default in the anonymity and lack of feeling of its open spaces and in its abstracted notion of "the public". The role of art is to transform spaces into places, the public into people. This entails a merging of individual with common interests, without contradiction. Art has this: it is personal, and shared.

Art needs to be more than a cosmetic intervention, if it is to be a catalyst for cities conducive to well-being. While, during the 1970s, there was something of a euphoric expansion of art in communities, the mood has changed to one more critical. Phrases such as "cultural pollution" have appeared. It is clear that art needs to be integrated into wider solutions if it is to avoid diverting attention from structural questions underlying urban squalor (*Fig 2*).

Art also needs to be more than the nineteenth-century concept of a monument. The proposal for a brick man at Holbeck Triangle, Leeds, by Antony Gormley, aims to capture the imagination in no uncertain terms. To date it has failed to gain planning permission. The concept itself is challenging. At 120 feet high it would certainly be seen. What feelings will it draw into itself, its dark interior lit by windows high up in the ears, a hollow cavern like an enormous and misshapen chimney? Perhaps it is the hollowness that will stand for the twentieth century: a giant man made of dust, and empty.

Landmarks are more than statues. Most memorials to generals or statesmen fail to arouse public feeling, or even the ability to recall whom they represent. Few of the statues in London are outside this category. Nelson's Column is a landmark only because of its surroundings. The Cenotaph carries a public emotion because of its function and the way its blankness absorbs the rituals performed around it. At certain times, it ceases to be a block of vacant stone and becomes a space for reveries on "vacant dust". The wayside crosses, the ancient burial mounds, have acted as landmarks, maintaining a place in the popular imagination, in folklore and seasonal rite. They can do so because of the loaded content they carry.

How does public art now become a landmark? The question of content cannot be avoided. Perhaps a hollow man of industrial brick is a symbol, standing for a certain area of experience. Perhaps Michael Sandle's *George and Dragon* in London can also re-open a myth which stands for much of western civilisation.

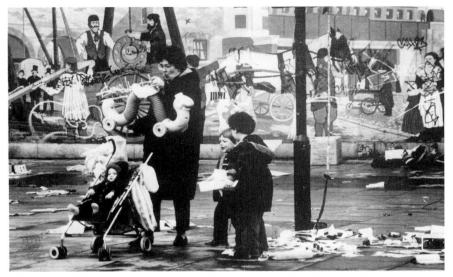

2. Figures and litter in front of a community mural, South East London (P Hone)

To date, public art which has a forceful content has been mainly relegated to marginal sites. Prominent sites, such as Broadgate or numerous plazas in America, exhibit sculptural steel leviathans by artists such as Richard Serra and a generation of Minimalists.

Is it possible to foresee a public art in the centres of towns, integrated with major public buildings and a sense of what the place is about? Is it mere nostalgia to look to the Cathedrals, and ponder a new but equivalent unity of art and architecture, of private reverie and public rite, based in a new, and secular, common wealth of symbolic imagery?

The break between a built environment with art, and one without it, took place this century. Earlier international styles, such as the Gothic or Baroque, show the inclusion of pictorial and sculptural elements in church and state edifices. Even the pastiche styles of the mid-nineteenth century gave art a niche. Art nouveau, and the Vienna Secession, brought art, craft and architecture briefly together in a unified vision. But, soon, a new problem became apparent. Adolf Loos put aside decoration, linking it with crime. A house by Rietveld was a work of art in its own right. Frank Lloyd Wright saw his architecture as so complete that he would have only oriental artefacts to complement it. Where could artists fit within this Purist aesthetic?

Le Corbusier made his position clear in his contribution to Circle.[2]

In the "machine age", man is "inundated with images" — he cites Léger as the source of this idea — and the moment of realist art is over. A "vast animation has seized on the whole world" through construction. "The word is with architects . . ." in the new, optimistic age of a new life of "the sun, nature, the cultivation of the body, the cultivation of the mind . . . another field has become open in world-consciousness." He includes artists in his utopia, and says that "certain" artists are "speaking of it". He extends the concept of architecture to include giving form to the "spirit of a period". Some artists of his generation would have agreed with the role assigned to them. Many today would agree with the idea of an inundation of images through mass culture.

Le Corbusier is often blamed for the artlessness of modern architecture,[3] so it is important to examine what he said:

> "I am an architect, but I am just as much a painter — a painter by trade . . . every day I find myself absorbed in this problem; can the plastic arts be accommodated harmoniously in the architecture of today . . . ?"[4]

"Trade" and "accommodated" do not suggest a primary role for art, but he still seeks a relation of the two. He continues:

> "I believe that we are entering on a period infinitely more serious, when we shall no longer have the right to stick things on something, but when the pure regenerating spirit of modern times will be expressed by organisms with a mathematical interior, . . . art will be given its full value in exact accord with the potential forces in the architecture."

Le Corbusier had in mind a unity of purpose as well as visual quality. The statement poses a fundamental question: is art to be a cosmetic addition or an integral part of a building? From this follows the question of whether artists may be involved in the design stage of a project, or not.

Le Corbusier advocates collaboration. The rift comes less in his work (or in Mies van der Rohe's — his German Pavilion at the Barcelona World Fair in 1929 included a prominent sculpture by Kolbe, well set off by the building and not subservient to it) than in the tide of imitators, the inventors of the "concrete jungle". Some artists have been willing to provide a camouflage or counterpoint to the "jungle". But it is too late when an artist is asked to "do something" with a vandalised subway, or when a piece of sculpture is deposited outside a mirror-glass hulk. Is it enough that art is unique, made by human agency? That could describe more than one kind of "turd in the plaza", so something else is needed to bring such qualities together meaningfully: integrity.

Is it possible that art might permeate a building's design, the whole springing from the same content? That is much closer to what Le

Corbusier said, more "serious", as he put it.

If artists seem on the margins, are architects better integrated into the social fabric? Ron Arad, though not typical, is more individualist than many artists. He has written of being "bored" with conventional architecture, wanting an enterprise which exists "on pleasing itself":

> "Designers and architects cannot make a real contribution to society. ... I ... consider myself lucky that some of the public are interested in my designs and are supportive of my playtime."[5]

With architects and designers like that there is no need for artists to worry about their anti-social tendencies if all they contribute costs 1 percent of the budget.

At the other extreme, *Percent for Art* schemes may simply produce dull interior design bought from a tax-deductable art budget. In the NMB Bank in Amsterdam, a notional percent covered concrete lamp-posts and other items of street furniture posing as craft objects. By contrast, most American schemes exclude utilitarian objects from their definition of art. If one of the general arguments for art in cities is its force of imagination, then uninspired interior design will do nothing to promote its cause.

This is not to exclude the crafts from public art. There has been a resurgence of architectural metalwork since the exhibition *Towards a New Iron Age* (1982, Victoria and Albert Museum). Against mass-produced utility, the crafts can offer things made by hand, with all that is implied in that, and in which form and function are unified. The gates of the Great Hall at Winchester, by Antony Robinson, were successful aesthetically, and cost-effective.

On the other hand, the treatment of the refurbished Princes Gate shopping mall in Glasgow shows how a potent theme, the Tree of Life, can be trivialised into a mess of fake Viennese curlicues. Just as artists were *collaborateurs* in the myth of the "mindless dauber", so metal-workers enjoy the label of "dumb blacksmiths". If artists and craftspeople are to come out of the margins, such caricatures will need to be left behind.

The mood is becoming more discerning, as the scale of funding for works of art in public places is growing fast. In the new Convention Centre and adjacent areas of Birmingham, a *Percent for Art* scheme has generated at least £800,000. Why is it worth it? The question deserves an answer, even if art still represents only 1 percent.

Where to begin? What models of good practice to follow? There are very few precedents and little developed writing on the subject. One of the most urgent needs is for a rigorous critical debate on art in public places, at the same level as writing on "mainstream" art. After all, with the spread of *Percent for Art* schemes over the next decade, public art may become the "mainstream".

There are four major arguments for public art:

It gives a sense of place;
it engages the people who use the place;
it gives a model of imaginative work;
it assists in urban regeneration.

In all cases, success depends on real solutions, integrated into the conceptual fabric of the place. Cosmetic tinkering, putting sticky plaster on environmental wounds, will divert attention from the real questions.

Serious attempts to introduce fine art into public places began in the 1970s. In America, there were earthworks and excavations. In Britain, in 1972, the City Sculpture Project, organised by the Stuyvesant Foundation and the Arnolfini Gallery, Bristol, asked artists to work for specific sites in cities. This was a different notion of "site-specific" from the American, meaning something made for a given place, not the conversion of a place into art. The project was only partially successful. A number of pieces were vandalised, not surprisingly given the anti-social stance of a number of artists at the time, but the idea of relating art to place was introduced into debate. It was realised that it implied more than putting sculpture on the grass or doing very big easel paintings.

To confer identity requires an understanding of the nature of a place. It has three main aspects: the physical location, the people who use the space, and the local history (which may suggest a theme, or give a reason why a space becomes a focal point, as well as being a vehicle for community involvement).

The identification of the users of a place can be problematic. In residential areas, where community arts groups normally work, there is an identifiable community. Similarly, in a school or hospital, a factory or a prison, there will be a group who work or live there. The responsibility to involve them in defining the character of their place through art is clear. In a public square, or railway station, it is more difficult to say who should be consulted. There will be an owner of the space, but it will be a place for an unpredictable group of people who use it, and who are its "emotional owners". Most public art is made for such places (if we separate public art in this sense from community art). We may need to develop better mechanisms for consultation in such places.

To say who is the audience for Tess Jaray's floor at Victoria Station, William Pye's steel-and-water piece at Gatwick Airport, or the rural public art pioneered by Common Ground along footpaths, is as impossible as saying who looks at Nelson's Column. In these cases, the artist will have to work with whoever commissions the work, and the emphasis will probably be on making something which is part of, and brings out, the qualities of the location or the architecture. It is this "bringing out" that needs the users of the place to articulate what it is they value in it, and

8

assist the artist in understanding its complexity.

In giving a sense of place, art can celebrate or remember. War memorials and statues continue to be commissioned, for example the statue of Attlee in the House of Commons by Ivor Roberts-Jones (unveiled 1979).[6] Memorials can find new forms. One of the foremost precedents is Brancusi's work at Tirgu Jiu, his *Endless Column*, and table.

Celebratory examples include John Clinch's Great Blondinis in Swindon, a monument to two acrobats, but also to the skills of the engineering workers who helped him make it (*Fig 3*). Set in the midst of a shopping precinct, it reminds people of the town's former industry as well as being colourful. Anthony Gormley's *Places To Be* in Peterborough celebrates humanity with a figure stretching out his arms to the air. In a "neutral" environment it is easy for such sculpture to determine the identity of its site, whilst, by contrast, the statue of Attlee is something determined almost entirely by its site. But Gormley's work tends to be similar in whichever site it is placed. It is a generalised statement of a figure, anonymous and hollow.

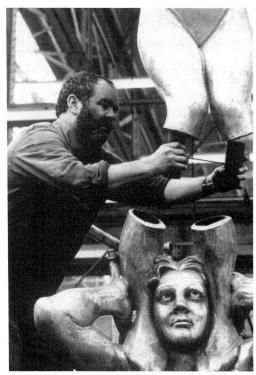

3. John Clinch, *Great Blondinis* under construction, British Rail Engineering Works, Swindon, 1987 (R Parsons)

The relation of art to site follows no absolute formula. It may take over, as Giotto's fresco cycle in the Scrovegni Chapel at Padua: an intense narrative in a plain space. Rivera's murals in the Chapel of the University of Chapingo dominate a similar barrel vault. Alternatively, like Kevin Atherton's lifecast figures at Brixton Station, art may blend into the surroundings, being noticed only by chance.

Tess Jaray's brick floor at the Midlands Arts Centre, Birmingham, is restrained, quietly coloured, yet determines the whole ambience. Perhaps the neatest trick of all was John Latham's attempt to claim the mounds of shale residue in Lothian as an art work. *Niddrie Woman,* as he titled it, is the biggest man-made lump of art on Earth, and the art, if it is, is simultaneously the place. He discovered the mounds whilst undertaking a placement in the Scottish Office organised by the Artists' Placement Group, the first pioneers of this new role for artists integrated into government.

Not many artists have Latham's panache, but there are other spectacles. Lichtenstein's *Mural With Blue Brushstroke* (1984) may be one of the biggest commissions in recent years, at over 20 metres high, in the new headquarters of the Equitable Life Assurance Society, Manhattan. It is the sort of gesture seldom seen in Britain. Patrick Caulfield's mural for London Life in Bristol (1983) is only 6 metres.

Size is less important than scale. The three *Wayside Carvings* made by Peter Randall Page for the Weld Estate in Dorset (1985 – 86), or his carvings for the Forest of Dean (1988) (*Fig 4*) are small, but they have a resonance. They do not compete with the vastness of the landscape, but complement it with a place for intimacy and reverie. The relation to place is one of integration, but at the same time the sculptures give a special meaning to the place at the moment of their discovery.

Public art offers more than objects to be received passively as in a gallery. Quietly or noisily, it may open a dialogue with its audience, drawing them together to consider wider issues than the aesthetic. Gormley has said of his sculptures that they can be a focus for human hopes and fears, even, in Derry, a kind of poultice. Strong feelings may be aroused by the intervention of an artist. Because art is a vehicle for feeling, it opens emotional doors and may activate hitherto untapped resources.

Public imagery opens political as well as introspective questions. It may be confrontational, as in Krzystof Wodiczko's projection of Mrs Thatcher presiding over scenes of degredation, on Calton Hill during the 1988 Edinburgh Festival. In a previous projection piece in Trafalgar Square, the image of a swastika was emblazoned on South Africa House. It was twenty minutes before the authorities noticed. Les Levine designed a series of posters about Northern Ireland with texts such as "Hate God", which did not last much longer!

If art is part of the expression of a value system, then to question the

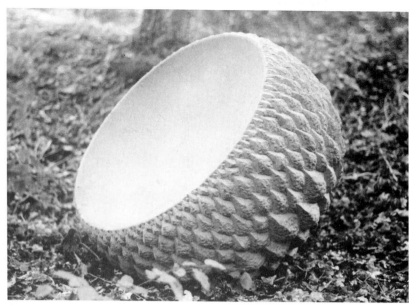

4. Peter Randall Page, *Acorn Cap*, Forest of Dean, 1988 (P R Page)

dominant values of a society or culture is legitimate subject-matter for art. Opening a dialogue is a valuable activity in its own right, a way artists can use the process rather than the products of art to encourage the imagining of possible futures.

Public art can spark off a debate which acts as focus for social cohesion. Our inherited view of art might propose the isolation of artists, but if they are dealing with either a broad visual sensibility, or areas of feeling and content, then these are the very areas most easily shared. Against the grain of competitive greed, art encourages an alternative value system. Sharing authorship is a first step, which needs to begin during education, replacing a competitive ethic with one of mutuality.

Participation may be more than reaction. The practices built up in community arts may be appropriate to some public places for permanent work. At the same time, there is much scope for temporary work, such as has been pioneered by the Artangel Trust. Their projects have included billboards, an alternative peep-show in Soho, and electronic messages in Piccadilly Circus.

The potential of audiences becoming active includes both a political and an imaginative dimension, and the two are not necessarily separate. To think of a socially or environmentally better future is itself an imagina-

tive act. Only a sterile society is limited to the "official" view of tomorrow.

Most public art is concerned to add the quality of the imaginative life to the environment. Imagination grows out of studio practice; to advocate a new "species" of "public artist" would deprive public art of this natural evolution. Creative risk is inseparable from an artist's work. It is because artists take risks in the studio that they can bring some spark of life into a poverty-ridden environment.

Imagination is put on view through residencies. Where artists live and work for a period, say a year, in a community, people can see how images and objects emerge from a process of improvisation and experiment. This creative thinking is in contrast to that required in industrial production. It constitutes a valuable alternative model. Perhaps one reason why hostility is sometimes encountered in the early days of a residency is the contrast of the artist's freedom and the spectator's lack of it. Yet that time for "play" is a vital part of any alternative vision of society. Where work and leisure are divided, there will be no unity or harmony. Acceptance is often won by commitment, and visible skill. Then, the example of the artist can have the positive effect of awakening repressed reserves of creativity in others.

A further argument for public art is its role in urban regeneration. There is clear evidence, for example from the *Blackness Project* in Dundee, in which many local artists took part from 1981 onwards, that art can be one element in a successful programme of renewal. The Blackness District is now significantly more prosperous as well as less derelict. Stanley Bonnar's rehabilitation of an old public lavatory even included the innovation (for the site) of opening it to women (*Fig 5*). Similarly, in Smethwick High Street, where Francis Gomila, as town artist, worked with the local authority's architects, the High Street was rejuvenated with the participation of the community.

Artists may re-habilitate disused buildings as studios and galleries. Art may be introduced with other environmental improvements to upgrade an area, attracting new business. The two strategies may go together. The danger is that improvements will lead to gentrification and the exclusion of the local community. In London's Docklands the artists began by setting up studios. Since then designers have taken over spaces which are increasingly fashionable and expensive. However, a similar experience has not happened at Blackness, nor in Smethwick High Street, and the odd model of London should not be taken as a guide to other regions. Against the cautionary story of Docklands may be set the desire of people in any run-down area to live in a cared-for environment.

So, to restate the four categories of argument for public art: it gives a sense of place; it engages the people who use the place; it gives a model of imaginative work; and it assists in urban regeneration. These apply broadly, as arguments for a better environment.

5. Stanley Bonnar, Rehabilitation of public lavatory, West Port, Dundee,
1986–87 (M Miles)

There are also reasons why a provision of public art would be attractive to various interested parties, such as artists, local authorities and architects.

For artists, it would be a major source of patronage. With development projects worth many millions of pounds taking place in many cities, even 1 percent would belittle other sources of funding. As more local authorities adopt *Percent for Art* schemes public art may become a major route to recognition, as well as the "bread and butter" for a majority of professional fine artists.

For local authorities, the creation of a better environment, more conducive to the happiness of its citizens, would seem an obvious aim, like decreasing pollution and providing leisure facilities. If some projects in the 1970s were cosmetic attempts to camouflage the results of long-term decay, there are now an increasing number of good examples, where the community has been involved, appropriate selection methods employed, and artists given a responsible freedom. Above all, there is evidence, from Blackness, Smethwick, or several inner city areas in the USA, that culture regenerates a city's economy.

For architects, there is a more devious attraction. Most hi-tech buildings are engineering as much as architecture. At the same time, architects are less concerned with building, and seldom manage the whole of a pro-

13

ject. They may be concerned to protect their privilege by falling back on notions of creative genius, though they have largely lost any vision of the symbolic element that made architecture a "fine art". To be fair, some architects have a serious interest in working with artists.

Artists, local authorities and architects may each have their own

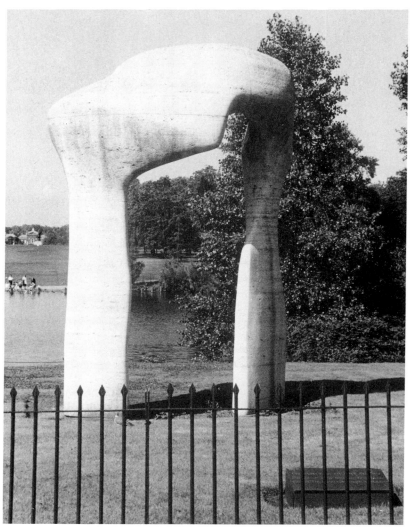

6. Henry Moore, *Arch*, Hyde Park, 1984 (M Miles)

vested interests, and that does not impede collaboration. All have a wider, shared interest in making a more attractive, perhaps more colourful environment. Will this lead to a new, holistic approach to urban design and planning? Only if there is a resurgence of the content which can effectively unify all the arts in giving form to a vision. The vision need not be a utopia. To reinstate the imaginative life is enough.

Enough is plenty, and difficult to achieve. It means a clarity of motivation. It requires not merely policies, but a means of implementation. It will depend, for aesthetic standards, on the growth of a rigorous critical debate, as yet in its infancy.

We are inured to the steel slab in the plaza, and perhaps to the organic Henry Moore outside a crystalline building. Maybe we hardly notice Rodin's *Burghers of Calais* standing on the grass. Such works are the product of a tradition of gallery art, taken for an outing. Does Moore's *Arch* in Hyde Park bring out any quality of the place? Do the railings keep it in a space set aside, a "gallery outdoors" (*Fig 6*)? Does the place need any art?

We are entering a period when such questions of appropriateness become increasingly interesting. Both artists and commissioners will need to think more deeply about the practice of art for public places. The potential, in the context of wider debates on the environment, is for art to be a prime agent in reclaiming urban wastelands for human felicity. It may not bring about a New Jerusalem, but it may help us find a way to well-being.

15

EAST AND WEST

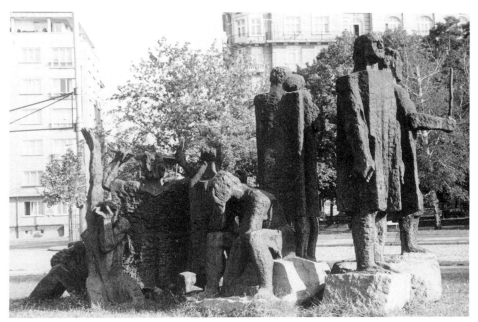

1. Lyubomir Dalchev, *Returning Soldiers*, Sofia, 1981 (M Miles)

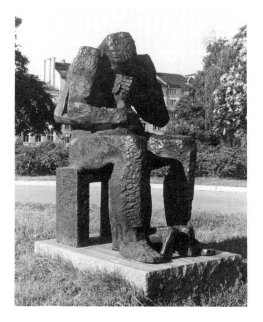

2. Lyubomir Dalchev, *Father and Son*, Sofia, 1974 (M Miles)

18

Chapter Two

MONUMENTAL ART IN BULGARIA

In a garden near the Alexander Nevsky Cathedral in Sofia, are several statues. They stand on low plinths, at the height of the spectator, commemorating those who fell in the long struggle for the Bulgarian state. In some ways, these figures are the epitome of Bulgarian public sculpture.

To describe them as examples of socialist realism would be wrong. Many of the preconceptions about art in socialist countries which were generated through the Cold War — for example that artists have no freedom of expression — simply do not have any relation to the public art on view today. A phrase such as "symbolic realism" would be more appropriate. The figures in the memorial garden are examples of that: they stand for an emotive idea; they combine a narrative with the formal qualities of material, using that sculptural language as a way of heightening the experience.

The largest work in the garden is a group of seven figures by Lyubomir Dalchev (1981) (*Fig 1*), commemorating the 14,000 soldiers of the Bulgarian army who returned blinded by order of the Byzantine Emperor Basil II after their defeat at Belassitsa in 1014. One soldier was allowed to keep one eye in order to guide the others home. How considerate was the Emperor! Dalchev sets each figure in a different pose, giving individual identity, just as Giotto did in his frescoes. The group is cast in bronze. The monumentality is achieved by gesture and juxtaposition rather than by size. The figures are not spectacular.

The soldier carrying a flute, reminiscent of blind shepherds and seers, draws the spectator into a reverie. Another cries to the sky (or the god), another brandishes a stick blindly in the air. Each expresses a human reaction to their savage treatment, from anger to despair. The

leading figure walks, staff in hand, like a prophet, towards home. It seems important that the figures are life-size, mirroring the spectator, and at the same time distanced by their degree of abstraction, standing for history. The parallel with Rodin's *Burghers of Calais* is inescapable: the subject of defeat expressed in a variety of human gesture, the life-size figures at ground level, and the abstraction of figures through the quality of the material. Another bronze in the garden is a father and son group (1974) by the same artist (*Fig 2*). Here, too, the emphasis is on the humanitarian character of the work, rather than any exortation along ideological lines.

These examples are echoed by many others in towns throughout Bulgaria. Much work dates from the 1970s and 1980s, a period of expansion of public commissions as part of an attempt to strengthen the national cultural identity.

A national culture cannot be contrived. It needs roots if it is to be credible. Bulgaria has a history chequered with upheaval. There were high points during the first Kingdom, from 681 (the adoption of Christianity was in 864), and during the second Kingdom at Turnovo, from 1185. Bulgaria fell to the Turks in the 1390s, and national culture was eclipsed until the late eighteenth century. Christianity survived in isolated monasteries and churches (some still rich in fresco decoration) and played a major role in the national revival which culminated in liberation from the Ottoman yoke in 1878.

One thread which maintained a national identity through conflict was the Slav language and alphabet, invented by Saints Cyril and Methodius, developed by Clement of Ohrid, and on which was based a culture neither Byzantine nor European, but sharing elements of both. The Balkans have always seen a ferment of cultural cross-currents.

After the liberation in 1878, Bulgarian artists again painted frescoes, as the monasteries were restored and rebuilt. Zahary Zograf was the founder of the new school. His self-portrait is in the National Gallery in Sofia, a formal but delicate image. He loses none of his personality when working on frescoes, on a very large scale. The style is medieval, but with a nineteenth-century sweetness. The subjects are, as ever, the Saints and Martyrs, the Doom in which the damned look remarkably like Turks, and the salvation of the good. What is instructive is that, when there is a unifying spiritual idea, public work holds its aesthetic power.

A second liberation, from Fascism, occurred in 1944, leading to the establishment of a socialist state. In the 1950s, Bulgaria attempted to re-establish its culture by a massive programme of investment. The guiding light behind this was Lyudmila Zhivkova, the daughter of the President. She initiated policies which gave artists a wide range of opportunities and allowed them to develop studio work parallel to monumental commissions. Most new buildings (in a country where state monopolies mean that factories and housing are also in the public sector) have a mosaic, a

fresco or a sculpture. In addition, there are major monuments in public open spaces, and in the Palace of Culture in Sofia, an arts centre in which each hall contains a major artwork; the murals, wood carvings, mosaics and textiles are not secondary to the architecture but tend to dominate it. The building itself is unremarkable, but acts as home to a large collection of public art.

Perhaps the re-establishment was done too quickly and with too little regard for roots. Many of the decorative panels on buildings (such as factories and apartment blocks) are bland and repetitive. Questions of the specific (often historic) identity of a place were overlooked in the urge to make everything new, just as too many attractive old houses were demolished to make way for prefabricated blocks. Yet, the scale of opportunities was impressive, and established the precedent that art was part of national life at every level. It is natural that in a period of experiment, the results are mixed. What stands out in Bulgaria is the scale of commissioning and the extent of opportunities created for artists.

The programme began in 1956, when the Central Committee adopted a policy of cultural development, its basis in Lenin's writing: "Art belongs to the people, it must be deeply rooted among the masses, it must be understood and loved by the masses. Art must rally the feelings, thoughts and will of the masses, it must mobilise them, it must bring out the artists among them and stimulate their development."

The party's 1971 Plan took the idea further: "The closer a society is coming to communism, the more of an artist there is in man: both as an admirer and a creator of beauty." The implementation of such an ideology raises a number of questions. What is an appropriate language? What are appropriate subjects? What is the position of the artist in relation to the audience?

Taking Lenin's view, the idea of roots among the people could suggest a folk art, based on old decorative traditions found in villages (like those discovered by Kandinsky and Brancusi). Popular crafts such as wood-carving have been revived, and there are examples in the Palace of Culture, Sofia (*Fig 3*).

In the inter-war period some Bulgarian painters (such as Milev) developed a folk style (not unlike Kandinsky's work of c. 1902–06), and they have their followers today, though the style is not highly favoured. It could be argued that a folk art has little meaning outside rural life; alternatively, that its primary means of expression is in carnival and street performances. That tradition exists in Bulgaria. The House of Humour in Gabrovo has a collection of folk costumes, such as the hairy mask and belt of enormous bells worn for the Spring fertility rite, a custom going back millennia. Folk music is also actively conserved, and heard on the state radio daily. It is a rich culture, but one based in agricultural, not urban, society.

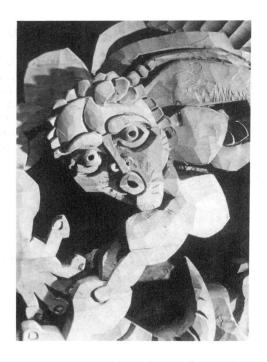

3. Traditional style woodcarving, Palace of Culture, Sofia (M Miles)

Perhaps for modern, urban society, the roots need to be broad and deep. If art is to be accessible and educative, perhaps it needs to be built from the very foundations of national culture.

In Bulgaria, this would imply going back to the Byzantine roots, because, despite frequent political conflict with the Empire, the spiritual unity which informed early Bulgarian art was Byzantine in origin. The earlier Thracian culture is too distant to be related to contemporary life. Byzantine culture was also civic, that is, it grew in cities, was a high culture distinct from village rites, although it spread into, and colonised, village life.

Those roots are strong. Part of the evidence is in the many collections of icons, the largest being in the crypt of the Nevsky Cathedral in Sofia, probably one of the best collections in the world. There are also the surviving frescoes from before Ottoman rule, and those of the national revival after 1878. Amongst the latter the work of Zahary Zograf is outstanding, for example his frescoes at Rila and Bachkovo monasteries.

It is possible to see a spectrum of monumental art, from the Byzantine examples to the post-1956 work under state patronage. Both were dependent on commissioning, but the former had as its centre a spiritual unity, whilst the latter relies on a secular ideology. The expansion

of public art after 1956 was of the ideological kind, though in more recent years the position has shifted very much more towards individual expression.

The Bulgarian artists of the '60s had few precedents which they regarded as legitimate. They had no previous experience of monumental work, and many were trained as illustrators. They turned towards the two extant revolutionary traditions: Mexico and Russia. In the long term, the Mexican influence may be seen as a brief but effective catalyst (just as African masks were for Cubism). It opened up possibilities of large-scale and secular murals, telling stories of national history, affirming the notion of progress. For a few artists it was a decisive turning point. Amongst these the most interesting is Hristo Stefanov.

Stefanov's vast mural in Hall 7 of the Palace of Culture depicts a pageant of national history. The work is both an expression of an idea — the character of national culture — and a narrative — the procession of contributors to that culture, from Saints Cyril and Methodius to artists, writers, architects, musicians and actors of the twentieth century. Hence, it works through a passing of time, but brings that past into a fixed present.

Stefanov worked for a mass audience. It seems logical that his picture is crowded. He uses a central figure to anchor the design: a peasant dancing on hot coals, arms extended in the manner of a crucifixion. Lyudmila Zhivkova stands lower right as a witness to the scene.

The most powerful, emotionally, of the murals in the Palace of Culture is Svetlin Rusev's *Bulgaria* (1981): an epic of grief and aspiration in white and greys. Everything is restrained, yet the limited means are used to considerable effect. In the centre is a bound figure on a stake, which can be interpreted as a crucifixion or a simple atrocity. Under Ottoman and Fascist occupation atrocities were not infrequent. A woman kneels at the foot of the stake, a mother grieving a dead son. The archetypal power of the subject is the greater for the restraint which brings it into an ordinary human realm of experience. To the right are women working in the fields, and figures floating in the sky. To the left are crowds of mourners, one holding red flowers, the high point of colour in the work.

What Rusev has achieved is monumentality without resorting to propaganda. His murals are closely allied to his studio work, such as the large painting of a group of grieving figures on which he was working in 1988 (*Fig 4*). His figures are often fragile yet have a sense of survival; the work maintains its aesthetic dimension despite its size. It also has more than size: a sense of scale. Rusev is in this respect the heir to Denko Ousounov, the "father" of modern Bulgarian art, one of whose works, a pale and soft fresco, can be seen in the new hotel at Kazanluk.

In the park around the Palace of Culture is Valentin Starchev's monument to the 1300th anniversary of Bulgaria (1981). On the side of

23

its unfortunate architecture are three figure groups, the central one being a *pietà*. It stands for the years of oppression, under the Turks or the Fascists. A hollow figure in a veil, echoing the Mother from frescoes and icons, contains a wounded and bound figure, slumped back in the space. The figure is treated freely, the bronze almost like melted wax, though details such as the head are more defined. It is another example of "symbolic" rather than socialist realism (*Fig 5*).

Starchev is clearly aware of the mainstream developments of Modernist sculpture, of the distortions of Expressionism, of "truth to materials", and perhaps even British post-war neo-Romanticism. Henry Moore is a major influence in Bulgaria (and one of his bronzes is in the Lyudmila Zhivkova Foundation's International Gallery in Sofia). Starchev sometimes strives to achieve the wounded quality of works such as Moore's *Fallen Warrior*, and to merge figures with abstracted materials. This also relates to the influence of Rodin, who is probably regarded as the most important sculptor by most Bulgarian public artists.

The method of commissioning established after 1956 still operates, and, despite recent budget reforms, still offers a very large patronage to artists, both recognised and younger. The first approach is made by the institution or enterprise wishing to commission, directly to an artist (who will be a member of the Union of Artists or Studio of Younger Artists). The artist prepares a design, with sketch, model or whatever is appropriate. This is presented for approval to a committee of the Union. The artist argues his case before a jury of about a dozen senior members experienced in monumental art. If the Committee approves the idea, a fee will be fixed for the project (the design) and the execution. There is no fixed percentage of capital costs, and projects are often for buildings already constructed. Any subsequent problems are referred back to the Committee.

The Artists Union are the arbiters of taste, not the commissioners, who have little control over the finished product, though they suggest the theme. The artist receives a fee, or a salary whilst making the work.

Perhaps because the system has been operating for so long and because commissioning is normal, the methods of community involvement have not been developed which public artists in Britain have evolved in response to the difficulties of gaining commissions. There seems little regard for popular opinion, despite the ideology of popular will. When asked about consultation with the users of the space, one Bulgarian artist said (in a private conversation): "No-one has ever asked them, thank goodness!" His own murals are somewhat rhetorical.

Major monuments are not confined to Sofia. The monument to the second Bulgarian Kingdom (founded by the brothers Peter and Assen in 1185) in Veliko Turnovo, by Krym Damianov, Ivan Slavov and Vladimir Ignatiov (1985) is a mixture of two styles and two approaches (*Fig 6*). It

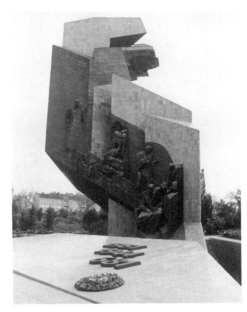

4. Valentin Starchev, Monument to 1300 Years of Bulgarian State, Sofia, 1981 (M Miles)

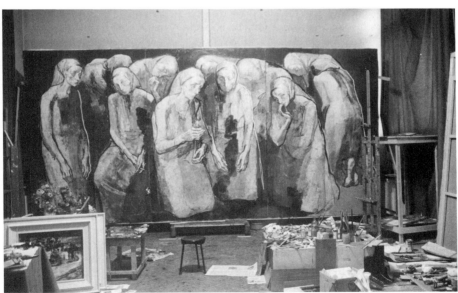

5. Svetlin Rusef, *Group of Mourners* (work in progress), 1988 (M Miles)

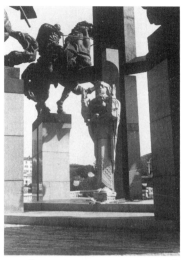

6. K Damianov, I Slavov & V Ignatiof,
*Monument to Second Bulgarian
Kingdom*, Veliko Turnovo, 1985
(M Miles)

stands on a promontory over the Yantra, by the newly reconstructed art
gallery. In the centre is a sword/obelisk, surrounded by four horsemen,
medieval warriors with swords and shields. They are heroic, the alle-
gorical content overtly emphasised by the stretched proportions, the
straining muscles of the horses' necks. Beneath the obelisk, and in a quite
different style, is a Mother and Child in grey granite. The two parts con-
trast strangely. The one is allegory, the other symbolism.

The Mother's arms are raised, the Child leans forward. The strict
verticality of the drapes is offset by the rounded features of the child, set
within a circular niche. The Mother remains statuesque, perhaps remote,
a vessel (is she our mother or the mother of nations?). People place flow-
ers at her feet. Above, there are the active, warlike heroes. The warriors
are like the noise of politics, the pursuit of power; the Mother and Child
are more akin to the silence of the aesthetic, set in a niche (*Fig 7*).

Both modes are characteristic of much Bulgarian public sculpture.
Neither could be called socialist realism as such. That is typified by a large
statue of Lenin in the centre of Sofia, made by a Russian professor,
appearing stranded like a beached whale (*Fig 8*).

History has been the subject of murals as well as of sculptural monu-
ments. Teofan Sokerof attempted to convey the whole epic of Bulgarian
history in the rebuilt church on the Tsaravets hill in Veliko Turnovo. He
used devices such as painted niches, cracks and overlays to simulate the
quality of an old wall, but it all has a distinctly modern look. The figures
writhe and gesticulate, carry the masks of history, but not its feeling. The
most successful part is the Mother and Child in the apse, with a humanity
not found on the walls.

26

7. K Damianov, I Slavov & V Ignatiof, *Monument to Second Bulgarian Kingdom*, Veliko Turnovo, 1985 (M Miles)

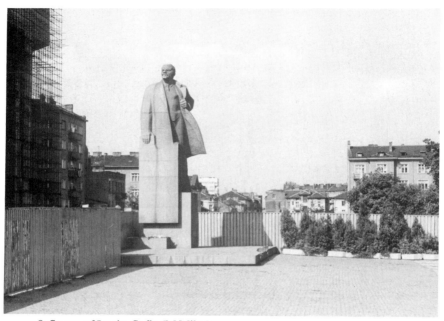

8. Statue of Lenin, Sofia (M Miles)

Grigor Spiridonov also uses history as the subject of his work. He believes in the educative role of art, to inform and inspire by recreating the characters who made Bulgarian history. He was trained as an illustrator, but is one of the few artists to carry the intensity of his smaller works into very large compositions. He works today in Veliko Turnovo and uses a water-based paint, building up thin washes on wood or paper. His work is tightly detailed, hundreds of figures filling some of his large pieces. He uses small areas of rubbed gold leaf to give the patina of age, and looks to medieval models for both visual precedent and the narrative content of his work.

The number of very large monuments is limited. The majority of sculptural commissions since 1956 are medium-sized figures in bronze or limestone. Sometimes, the artist has given an old subject some human warmth, for example: Mitiu Solakov's monument to the partisans in a small village near Gabrovo, a *pietà*, about twice life-size but not remote, and on which flowers are often still placed.

Such memorials act as a focal point in villages and smaller town squares. They are also highly charged with the memories of violent conflict and suffering during the Fascist period.

Not all examples of public art are commemorative. Outside the

House of Humour, a large gallery and theatre complex in Gabrovo, are three works by Georgi Chankunov (1978 – 82) honouring comic characters: Bulgaria's Sly Peter, mounted on a mule, Charlie Chaplin, and Don Quixote. The latter is welded entirely from bits of car and machine. The theme relates to the purpose of the building, which contains fine collections of humorous and satirical art, and hosts a *biennale*. This represents a more relaxed kind of commissioning, placing what are large studio pieces outdoors because of their direct relation to the site (through its function).

A number of problems remain. The aesthetic intensity of studio art is seldom encountered in public art. The attempt to recreate a tradition (or invent a new one) in a few decades is perhaps too ambitious.

And yet Bulgarian artists are reclaiming their tradition. Byzantine art is seen as a central aspect of national culture, and is carefully conserved. It is exactly in the medieval frescoes and icons that a fully integrated public art can be found. Equally, Zahary Zograf, reviving that tradition, lost none of his aesthetic force in his murals.

The question of "presence" in monumental art remains open. The western equivalent of the rhetorical monument is the steel sculpture which stands outside the glass-walled building. Neither free enterprise nor state commission have found the answer. Images may inform an audience, and yet not move it emotionally. The questions of great subjects and appropriate language have not been faced fully, either in the east or west.

Chapter Three

COMMUNITY MURALS IN AMERICA

"... it is in the cities that the real challenges for a new kind of public art lie."[1]

The community mural movement in the USA "began" in 1967, in Chicago, with the *Wall of Respect*, but there had been artists working with communities through the 1960s. There was also the precedent of the Federal Art Project of the 1930s.

The *Wall of Respect* and the *Wall of Pride* were murals for Black Power. Their origin was in the Civil Rights movement. Hence such murals (unlike the New Deal murals of the 1930s) had no state blessing and were spontaneous expressions of a democratic will. Style was of no importance. They were less an attempt to put art in the streets than to put a political message in the streets for a community without access to broadcasting or the press.

More than twenty years on, we may ask whether community broadcasting would be more effective in giving cohesion to a social voice, but the public mural still has an impact and can make a powerful statement. However, the role of temporary works and those utilising recent image-making technologies is growing. *Messages to the Public* is a project using the computerised messages of the light board in Times Square, New York. Recently, artists such as Barbara Kruger, Keith Haring, Jenny Holzer and Edgar Heap-of-Birds created 30 second messages for the daily audience of 1½ million passers-by. In Britain, the Artangel Trust has funded several temporary public works, such as Tim Head's *Contracts International* (1986), Conrad Atkinson's *Posterworks in the Metro* (1987), and work by Jenny Holzer in Piccadilly Circus (1988). These projects require substantial sponsorship and a degree of official sanction.

30

The *Wall of Respect* was perhaps under more direct control.

The *Wall of Respect* was painted by a group of black artists co-ordinated by William Walker. The Chicago Mural Group published a manifesto in 1971:

> "we work with the support of local community groups and are aided by the community residents. They have never asked for our credentials or the prestige of a 'name'. They demand only that the artist bring respect, commitment, and vision to his work".[2]

The intended audience was the local community; it was "their picture" and nothing to do with whatever may have been going on in galleries. Not surprisingly, there was little interest from the art press. Does this reflect the black or female authorship of most of the murals? Do the art magazines depend on the advertising of a gallery system concerned to retain its privilege? Given that the origins of community murals were social and political, they constitute a challenge to establishment ideas on what is admissible as art, the more so in the rarefied atmosphere of late Modernism.

Writing in retrospect, John P Weber (a muralist) said of the early work that it was "historically unique: a non-official public art movement". He maintained it kept that non-official role despite state funding through the 1970s.[3]

Following the first murals in Chicago's South Side, work appeared in many black neighbourhoods. The idea was taken up by other "minority" groups, including Hispanics and women. For example, there was a *Wall of Respect for Women* in New York, and other projects which took place in more specific relation to their site, such as Faith Rinngold's mural for the Women's House of Detention on Rikers Island, begun in 1971, or Beth Shadur's work in the Barlinney Special Unit in Scotland.

Parallel with the growth, almost an explosion, of American community-based murals, was the beginning of a quite other vogue for siting sculptures by established artists in public squares, and for "environmental" pieces in open spaces. Robert Smithson made his first proposal for a "site-specific" work in 1967, following his employment in the development of Fort Worth air terminal. He wrote of a "sense of the Earth as a map undergoing disruption" which emphasised to the artist that "nothing is certain".[4] Major disruptions of the landscape had a particular appeal for some American artists.

The developments of community art and public fine art or land art have little in common beyond placing art outside galleries. But the fact of being outside a gallery is not enough to imply a social responsibility. The siting of a Calder in Grand Rapids in 1969, for example, had no social intention (and cost $127,900). Such purchases were both an expression of (at that time) white civic pride, and a good investment. Since, public

fine art has become a major growth area with its own intentions and ideas of "place", but the origins of street murals were different. The fact that so many have been demolished suggests they were not reckoned to lend civic prestige.

Brian O'Doherty, director of the National Endowment for the Arts' Public Art Programme, supported community murals in a guarded way. His *Progress Report*[5] was officially sanctioned but most of his article was concerned with work of "international" standing. He described the common aims of grant award and selection of artist as "encouraging local communities to think in terms of public art, to debate its merits, and to prepare themselves for reception of a work". This reveals his central concern for art in the gallery tradition, that is something experienced passively (received) by the audience. Most of the Endowment's financial support was aimed at encouraging commissioning rather than community art.

He gives four categories of public art, each supported by a distinct programme of funding:

major (hence expensive) work by artists of the stature of Calder and Noguchi;
work by regionally known artists (he illustrates Benton's *Joplin at the Turn of the Century,* 1973 in Joplin, Missouri);
temporary work to test viability;
"outdoor murals".

In 1970 the Endowment began its mural scheme, based on the work done by artists such as Walker. O'Doherty describes it as being "in response to the spontaneous evolution of wall-painters" and accepts that it "brought a very different social complexion to the programme." He calls them "wall-painters", not artists. After a discussion of social context he says that public art is not a style or movement but a social situation. "Most of us can't begin to cope with it . . ."[6] He does concede the importance of the inner city mural programme, and the public debate on the role of art, saying "walls become community newspapers". Yet the feeling remains that the Endowment looked to an extension of professional art into the streets and that community art was a marginal area of practice.

The "official" attitude is largely unchanged. Most talk is of expanding the audience for art, assuming a division of art community from the "uninitiated" audience. Yet O'Doherty did realise there was a problem of the "tinker-toy minnow" in front of the big building—"as much the public art cliché of our age as the 19th century's general on a horse",[7] and he advocates avoidance of an imposition of taste at the expense of interaction between artist and community.

The stylistic influences on many community artists were outside the

taste of the *cognoscenti*. Muralists looked more to Mexican artists such as Orozco, Rivera and Siqueiros, and graphic traditions such as the poster. Some artists claimed the monumentality of Giotto, others were more concerned with a direct and populist language closer to illustration.

In her mural for the Women's House, Faith Rinngold used several close-up faces. She explained this in terms of her own cultural roots:

> "I never knew why I always used to paint big faces and heads and littler bodies until I became aware of African sculpture and found out that all natural peoples make a big thing of heads because the head is the seat of character . . . It is much more Greek to make a big thing of bodies . . ."[8]

There are eight triangular scenes in her mural, following a traditional device of the Kuba tribe, making up an eight-foot square. Each section has a distinct scene, including a woman doctor teaching drug rehabilitation, a woman bus driver, a wedding and a black woman President. None of the images is allegorical, although in early consultations the inmates requested images of Freedom and Peace. She gave them images of women able to fulfil themselves in society.

Chicago, New York, Los Angeles, San Francisco and Boston are the main areas of American community mural activity. During the 1970s, it spread from black districts into those of all ethnic groups. In Los Angeles, there was a major development of work in housing projects as part of a drive against crime. This represents a shift from concentration on image to concern for process.

The Chicano districts of Estrada Courts and Ramona Gardens, both low-rise, had around a hundred painted walls in the mid-seventies. The styles ranged from European (such as surrealism) to Aztec, to popular illustration ("comix"). These were supported financially by the City Housing Authority and the National Endowment for the Arts.

Art in housing zones has continued, taking an increasingly environmentalist approach. In another area of Los Angeles, MacArthur Park, a project was begun in 1983. The park was deteriorating and had a high incidence of "casual" crime. It was near the downtown area, and had once been a "showpiece"; it was also adjacent to the Parsons School of Design, who commissioned Al Nodal to direct the project. Eleven artists were selected by a panel, to reflect the ethnic mix of the neighbourhood, and the artists were required to spend time resident in the area and meet local representatives. Some of the resulting pieces were functional, such as seating, and others, such as *Border Crossing* by Luis Jimenez, engaged people in a more political way.

MacArthur park paved the way for many projects using community-related art as a means of regeneration. It seemed to be successful in ways beyond the aesthetic. For example, the Los Angeles Police Department

reported a drop in crime in the area: robberies fell from 134 in 1983 to 28 in 1986; aggravated assaults fell from 70 to 32.[9] Such initiatives have encouraged more ambitious programmes, such as the Los Angeles Community Redevelopment Agency's policy of a *Percent for Art* scheme in the Downtown area. Through this (and schemes in some other cities), funding raised as a percent for art can be used in a variety of ways to increase cultural access and enhance the environment, not restricted to the immediate location of the building from which the percent derives.

The place of art in regenerating urban areas came to be accepted by the business community as well as by residents. In older cities or districts, shops and housing are usually integrated. In Boston's South Side, an Irish neighbourhood, a series of twelve murals was commissioned in 1975 for shop-gratings: the grey security shutters that gave streets such an alienating mood at night or on Sundays. These were transformed with colourful scenes.

The organisation of the project was undertaken by the Director of Visual and Environmental Arts of the Mayor's Office, Mark Favermann, after consultations with other city officials. Reporting the project, he stated that the shopkeepers had been "instrumental in instigating the mural project" and had offered money in support.[10] Local pride, which he claimed to be strong in the Irish community, led to local history being the theme. An information sheet was distributed through the local press inviting artists to send proposals, which were put on show in shops. The choice was made by popular vote. This represents an enlightened model of a selection procedure. The involvement of the users of the space decreased the chances of vandalism. When one mural was damaged, a week after completion, the local newspaper defended the murals in an editorial, imparting a territorial claim on them for the locality, and there was no further problem. This is one of many cases where engagement has increased the survival potential of a mural in a "rough" area.

Not only "problem" areas have murals. In California, large walls provide opportunity for skilful megalomaniacs to publish their illusions. Cosmetic alterations such as some Californian murals, often manipulating illusory languages of perception, may simply be intriguing playthings, or they may imply a poverty of the urban environment, the result of a lack of responsible town planning.

Cosmetic solutions can take attention away from the underlying problems. Painting a wilderness over a house does little to bring the American dream of the log cabin (of Thoreau and *Walden Pond*) any nearer, and results merely in a contradiction between the reality of the building and the unreality of the painting. Such escapist murals (the British equivalent of which tends to be jungle scenes like coconut-bar advertising or a mad travel agent's window) may be harmful, in affirming the stereotypes and illusions of media culture. Attention may be directed

away from structural problems. In other streets, more pressing problems need a more practical approach. If underlying disquiet and the effects of bad planning are not addressed, the mural is more likely to be defaced with slogans. The writing on the wall often speaks of the immediate question.

Community murals in the 1960s and '70s were not confined to the United States. In Latin America, where a radical mural movement began in the late 1960s, the slogan on a wall is the principal form of dissident political communication, as it has sometimes been in Europe. Hence, the street was a natural place to put political images, not only in poster form.

During the Allende campaign of 1969-70, the Communist Ramona Parra Brigades began to add imagery to slogans. After Allende's election the murals spread. The style combined a Cubist influence (from Léger) with popular imagery. Eva Cockcroft, who worked in Chile, said later in an interview that walls became transformed into constantly changing sequences of symbolic images: "A fist became a flag became a dove became hair became a face . . ." [11]

The Chilean style was distinctive, and was recreated by a group of artists in New York's SoHo as a memorial in 1974. The murals were totally identified with Allende's brave new state. Their function had been "mass political education".

Like the agit-prop volunteers in Russia, groups of artists went to isolated communities where they gave performances and painted walls. During Allende's presidency, they worked with local communities and factories to create large-scale public monuments, as the Mexican artists had done. Although the function of the mural was reminiscent of Mexican work, the style was not.

Cockcroft cited the Chilean artists as saying: "The style of Siqueiros and the Mexican mural movement is no longer relevant even for Mexico, since it serves as the symbol of a prostituted revolution." [12] The murals were group enterprises, in which no question of authorship arose. Students contributed with the revolutionary brigades, as did the painter Matta. During the first month of the military dictatorship, the murals were destroyed.

The emergence of community murals in the Americas since the late 1960s has set a variety of patterns: the political demand for recognition, the attempt to decrease crime by aesthetic intervention in a neighbourhood, the illusion which contradicts its setting, in Chile the brief celebration of a new regime. For the most part, the question of style has been secondary, though in some cases a language (such as the hybrid images in Chile) has been associated with a specific intention or group of artists.

There have also been murals simply to draw attention to an area, or to draw attention to a business, such as the Flying Pigs on a restaurant in New York's SoHo. This area, colonised by artists seeking lofts and now

the fashionable "bohemia" of New York's gallery world, is festooned with murals. Some of these have been abstract, in the manner of late Modernist gallery art. Some have played tricks with perception or have shown a sense of humour.

Most murals, however, are figurative and have something to say. In the USA, the majority have probably been associated with groups or areas of some deprivation, whilst corporate buildings have commissioned from the upper reaches of contemporary taste.

The rapid expansion of mural activity in the 1960s and '70s did not allow much time for reflection, although the muralists have been as articulate as any other group of artists. That expansion is over. The future may look more towards collaboration between artists and architects. That will be at a professional level, in open public spaces. The emphasis in neighbourhoods may be on environmental art which involves the artist as a catalyst for the creativity of others, or which serves to increase awareness of the identity of a place. Schemes such as MacArthur Park may be the models for developments for the next phase of community-based art. That phase may go beyond pictures on walls to consider environments as a whole.

The question of language remains problematic. There is no coherence of style in mural art, and its dependence on different communities would imply that none is possible. In a pluralist society, with a variety of ethnic groups, a pluralism of culture, and hence visual language, is inevitable and desirable.

Yet the question of using given languages from mass culture needs to be addressed. Do the assumptions of a language carry over into its mix of uses? In propagating "comix" styles, are street artists affirming the rather dubious value system of the publishers of such literature? As graffiti is brought into New York galleries, does it become merely licensed dissent, defusing but not solving the deeper cause? Or are New York subway trains to be considered moving galleries? In the end, does the "writing on the wall" say that society is a mess?

QUESTIONS OF LANGUAGE AND THEORY

QUESTIONS OF LANGUAGE

"To look back on things of former ages, as upon the manifold changes and conversions of several monarchies and commonwealths; we may also foresee things future, for they shall be of the same kind."[1]

The history of art has sometimes been presented as a history of styles. The history of public art will more likely be seen as a history of intentions. These are clearer — community service, enhancement of the environment, creating monuments — and constitute more of a common ground between artists. But intention may also imply appropriate language. This question has been subject to little debate amongst public artists.

Language is a framework for interpretation, whether of appearances or dreams. Hence, the visual language used, for example, by David, or Courbet, or a community muralist, affects our perception of the content of their work. The realism of Courbet fits easily with his democratic sympathy; by contrast, David remains part of a classical tradition revived and reconstituted during the eighteenth century. His work implies an ideal world encapsulated in a past summed up in his idealised forms. And today's artists? Does their work stand apart from the onslaught of consumerism and mass culture?

One of the problems for any art allied with social progress is that in order to propose new types of social structure, it may need a new language. Otherwise its message may be subsumed in an unsympathetic cultural current, or create a contradiction.

The difficulty can be seen in a painting such as Delacroix's *Liberty Leading the People* (1830). In this picture, the people, the new force, look contemporary, but Liberty is like a Greek statue in rags. The picture breaks in two as we try to read its opposing codes simultaneously. The people are seen in the urgency of the struggle for freedom. At the base of the composition are the dead: immediate, devoid of classical idealisation, more like the photographic images, slightly awkward, that were to be

made decades later. But Liberty is alien to the scene, a hangover from neo-Classicism, even if a little *dishabillé*. At the conceptual level, Liberty is the old aristocratic liberalism, rather than a popular notion of freedom. Her eighteenth-century classical dress is appropriate to her, if not to the "crowd".

Delacroix never fulfilled any further ambitions to be a revolutionary artist. His work became increasingly orientalist (as in the *Women of Algiers*) and when Victor Hugo accused him of a contradiction between his ideas and his work he agreed and said his painting was a "turpitude".[2]

Liberty Leading the People is a useful example, if an unsuccessful painting. It shows the split between a way of treating images as symbols for abstract ideas, and, on the other hand, as representations of ordinary life. In each case, the image is mediated by the process of painting, but the symbolic language suggests a detachment, places the image in abstract thought, whilst the representational or Realist painting declares itself more directly, in actuality. Or does it? Perhaps the immediacy of the imagery, the crowd surging in awkward, "unposed" poses, is also a convention of art. But then our whole way of seeing depends on systematic interpretation to make sense of the data received at the retina: all is convention.

A contradiction similar to that of Delacroix's *Liberty* is seen in the work of Diego Rivera. He is caught between wanting to make monumental images which represent the Mexican peasant, and wanting to idealise the figures as symbols of heroism. It may be that the idea of the monument is out of keeping with the progressive thought he espoused. Is it possible to celebrate a social class in terms of the cultural concepts, such as heroic statues and images, of a previous era? Is the image of the archetype compatible with the political desires of the masses?

The concept of monumental art is fraught with the kind of problem over which Rivera and Delacroix stumbled. Rivera attempted to merge the two notions of actuality and abstraction, the real and the ideal. He intended his figures to be symbolic of revolutionary aspiration, and be credible as individual people. But the effect is rhetorical; is it more than Liberty in a poncho?

Goya may be almost alone in having expressed an overtly political message, in the *Disasters of War* or the *Executions of 3rd May*, and maintained an intense aesthetic quality. His figures are timeless and archetypal, and contemporary; they retain the immediacy of the "crowd" and are subsumed in a traditional, religiously charged imagery. The figure in a white shirt, arms raised, in the Executions, is inevitably Christlike, given our and the nineteenth-century spectator's awareness of a tradition of crucifixions. Yet, the figure stands for the ordinary, unnamed victim, being given the particular identity almost of a portrait. By contrast, the soldiers turn their backs, their occupation robbing them of the humanity

of a face. Nothing in these images is generalised, either at the level of how the image is made, or of what it depicts. By contrast, Rivera's figures are non-people inhabiting non-places.

Rivera was unable to achieve an engaging monumentality. It was not that his murals were very different from his studio work (apart from the early, Modernist pictures done in Europe), as was evident in the show at the Hayward Gallery, London in 1988. His girls with baskets of flowers remain impersonal, like the insurgents in *The Trench* (1928), for the Ministry of Education. Both are de-personalised, made into abstractions, conceptual commodities. Oddly, the figures in *The Trench* have their backs to the spectator, with two exceptions: one seen in profile, the only face; the other's covered by a hat (*Fig 1*).

Language still defeats public artists today. In the ambitious mural painted for the TUC Education Centre (in what used to be Hornsey School of Art), Paul Butler and Desmond Rochfort were unable to agree on a common language for their two halves of the wall. Butler's is more sophisticated, Rochfort's more strident. They employ different spatial organisation, different "keys" of colour, and different ways of constructing form within two-dimensionality. Butler uses the Goyaesque device he tried previously in the Cable Street *Mural,* and contrasts the policeman's back view with the suffragette's profile, his dark uniform with her white dress. Rochfort turns his figures away and crowds them together, as if faces were too difficult to paint. A third language separates the antagonistic halves in the form of a flurry of newspaper headlines (*Fig 2*).

The root of the problem faced by Delacroix, Rivera and others, is that so much of the inherited language of art is traditional. This means more than just Classical, but includes that. Tradition implies looking to origins, within a world-view which sees the ideal as a lost Eden. Rousseau expressed this in terms of the Noble Savage; David in terms of the Roman Republican. Both looked to a revolving wheel of change, corruption and purging. Yet the political programme for which some public art is produced is a departure from tradition, in favour of Progress.

For David, change was revolution: the models were always in the past, like Poussin's *Arcadia.* For the Revolution of 1848, Liberty had already become outmoded, tainted with eighteenth-century liberalism; freedom required a new concept of history, its model in the future, its method constant, progressive innovation. This implies a linear, as opposed to cyclic, notion of time and history.

If Progress posits a one-way road to the future, then it cannot appropriately be expressed through traditional languages of art. Perhaps new languages made possible by photography and reprographic processes are more suitable, though they, too, can become entangled in the "aesthetic dimension".

One break from the past is implicit in Realism. The language evolved

1. Diego Rivera, *The Trench*, Ministry of Education, Mexico City, 1928 (Press photo, Hayward Gallery, 1989)

2. Desmond Rochfort and Paul Butler, *Labour in History: the struggle for power*, TUC Education Centre, London, 1986 (Press photo, TUC)

by Courbet monumentalises without making remote or mysterious. It was closer to ordinary perception than were the conventions of Classicism or Romanticism. Its accessibility, like that of photography, was its claim to represent the new, democratic and industrial age. Pictures such as the *Stonebreakers* still tell a story, but a demythologised one. The *Stonebreakers* are not Work or Dignity, but two men who break stones; there is a moral, in the progression from youth to age, but not a myth or fable. Similarly, the peasants in *The Burial at Ornans* are not Civic Virtue or Piety — even if they are wearing their Sunday clothes — but the people of a village, who may yet be virtuous or pious. Many of Courbet's friends and family posed for the portraits which describe, but do not symbolise, others of their kind. The composition was derived from sources in popular as well as high art, and this "popular monument" was exhibited in unfashionable provincial halls, for an audience who could identify with what they saw. As Courbet said, you can paint anything, whatever is in front of you.

The new language of ordinary things, of skin, cloth, leather and earth, was not designed to carry symbolic meanings. Yet it was not without the capacity to arouse emotion. Van Gogh utilised a Realist language in his early work, and his various paintings of boots evoke the personalities of himself and his brother Theo. They almost take on a "loaded" quality, and have been interpreted by Heidegger as doing so.[3] Any work of art is necessarily detached from the realm of commonplace experience. But it is a further step to assume that it can have a symbolic status.

The symbol derives its authority from tradition. Just as in other societies the value of an action or rite was derived from its participation in the origin,[4] so a symbol is "magic" because it is the "form" of some idea which surfaces into consciousness through art, or dream. The difficulty for a public artist is finding a language both accessible and imaginative, which uses images not remote from everyday reality, yet alluding to the universal, without contradiction.

By the end of the nineteenth century, Realism and Symbolism appeared opposite languages for opposite intentions. Modernism grew out of Symbolism, and Realism was identified as an aspect of avant-garde art; its nineteenth-century language was retained (as in Socialist Realism, though that derives from quite other sources and introduces quite other narratives). It seemed that "progressive" art, with a political or social programme, might be marginalised into an outmoded language, split off from mainstream developments and styles.

Léger reclaims the middle ground between politics and art. His work is an affirmation of the life of ordinary people in a technologically advancing world. In 1936 he had his first opportunities to address an audience of the proletariat, at the Renault factory. Some of the car workers came to his studio for classes.

Yet, his work reclaims an iconic quality, making a symbolic universe for ordinary humanity. It does this in the language of Modernism, derived from the discoveries of the late nineteenth century (Symbolist) period: the flat colour affirming the picture surface, the abstraction of the image, the autonomy of pictorial forms.

He paints the ordinary in the service of the idea. Images take on a mythical quality, out of time, though still recognisable as ordinary figures. Perhaps they are a little heightened, but the construction workers and musicians, or the family having a picnic, are figures of daily life, observed, and strangely distanced. That ambiguity gives Léger's work a particular feeling, as of a moment of joy just gone.

Léger's achievement is to have reconciled the contradiction of symbolic art and Realism, archaic stories and everyday life. This partly explains his enthusiasm for David, and perhaps makes as much sense as a political explanation of that enthusiasm in the context of the Popular Front.[6]

Returning after the war to France, Léger found the political climate shifting towards de Gaulle's anti-communism. Attitudes towards revolutionary art were brought into focus by the David bicentenary in 1948. Léger painted *Les Loisirs, Hommage à Louis David*.[7] The picture relates to the leisure activities of Popular Front days, and contains a paradoxical relation to David's *Marat Assassiné*.

The foreground figure, holding a paper inscribed "Hommage à Louis David", is posed like Marat. Yet she, the ordinary working girl, is perhaps a modern Charlotte Corday. The dead man of David is supplanted by the living woman of Léger. This may be significant, more than a return to allegories of France or La Madelaine, a kind of machine-age goddess, and a cyclist, too.

Trees and doves suggest an atmosphere of growth and peace, or post-war reconstruction. A second cyclist is darker and warmer. Is she a figure of memory, from past days, or is she present and the whole outing a memory? Perhaps the contemporary Charlotte was one of those resistance fighters of the left, making a gesture against totalitarianism and terror, still smiling as she gazes out of the picture. Or perhaps she was the humanising influence of a feminine political consciousness less dedicated to power. Women were given the vote by de Gaulle in 1944 in recognition of their resistance work.

Léger reclaims the stability and pastoral feeling of Classicism, in a twentieth-century language derived from Cubism and Purism. The flat colours and bold outlines are part of a language of his time, within mainstream Modernism, but as a vehicle for subjects which have a resonance alluding to the pastoral scenes of Claude or Poussin. Perhaps this, too, explains his hommage to David, whose paintings of scenes from the Roman Republic were a proposed return to a more stable society. If one

archetype of return was characterised by Rousseau as the Noble Savage, another by David as Brutus, then a third was depicted by Léger as the female cyclist.

The French Communist party venerated David in the 1940s, following the "decadence" and "femininity" which had almost lost France two major wars. The Communist artist Fougeron copied the gestures of the *Oath of the Horatii* in his *Defense Nationale* of 1950. He, as David had done in some works, put women in a marginal position, being savaged by dogs! But Fougeron merely illustrates the idea. Léger "returns" to a more complete world-view in which femininity has a place. It was the quality which began to humanise his work after the machine images of the early 1920s.

Léger enjoyed ordinary experience, the commonplace activities and meetings which provided his subjects; he may even have cultivated a "peasant" image, and wrote in 1936 of the need to reject the individualism artists had acquired in the Renaissance in favour of the "collective and contemporary".[8] To be contemporary entailed using a language derived from the "machine age". To be collective implied humanising this language. Neither precluded looking to past traditions.

In 1925 he published an article on "Popular Dancing", celebrating the fact that dance belonged "exclusively to the people".[9] He extolled the alertness of a group of shoplifters, and noted the "harsh and tragic atmosphere" created by the "clean and austere" clothes the dancers wear. He describes the places as "beautiful and tragic, loaded with passionate undercurrents . . ." This is the characteristic atmosphere of *Les Deux Soeurs* of 1935, with its two grey figures, one holding a branch, on a sulphurous yellow ground, and of the *Composition aux Deux Perroquets* of 1935 – 39, with its strangely lost group of figures, or of *Adam and Eve* of 1935 – 39. The *Three Musicians* of 1944 (New York) was based on earlier drawings, and shows the musicians in their best clothes, perhaps about to play for one of those dances he described in his article of 1925 (the year of the drawings). They are sombre against the red floor and yellow wall, serious and melancholy, filled with a sense of loss, despite its bright hues.

Léger undertook a number of murals, such as *Travailler* (1937) for the International Exhibition, and *Les Transport des Forces* (1937), in the Palace of Discovery. Industry and Nature are brought together in the creation of hydro-electricity. As in the *Paysage Animé* series, architectural elements are contrasted with organic shapes, staccato rhythms with arabesques. In the centre is a great waterfall, from which springs a rainbow.

Léger's work situates him in the Avant-Garde tradition, as an optimistic believer in Progress. What distinguishes his work from that tradition is its combination of Realist ideology with a twentieth-century

45

language, which also takes on a symbolic and narrative role. He utilises the discoveries of Modernism, particularly that language is a thing in itself, that no view is seen without the effect of the window. His Realism is of the machine age, but also allows a symbolic dimension. The figures who inhabit his countryside are more than merely incidental. They stand as much for a state of psyche as for the mundane, and this gives his work a strangely compelling quality. He believed such work, using appropriate subjects, could appeal to a wide audience.

Seurat had attempted a similar project. A follower of Kropotkin and anarcho-syndicalism, he saw mass production as the solution to scarcity. Leisure for all would follow, in the new society. This is what he painted in *The Bathers*, a monumental work. His composition and colour are both orchestrated for a sense of harmony, the same Harmony which was a key-word in Fourierist thought. Later, he adopted the theories of Charles Henry in an attempt to systematically use colour and composition to create a universal communication at the abstract level, permeating the imagery of his pictures. The separate images are subsumed within this overall plan, which is a vision of a possible future conveyed with the detached quality of a dream.

Something of this is echoed in Léger's series *Les Constructeurs*. In part, it is post-war reconstruction, and in part a counterpoint to the earlier cyclists. It has the same optimism as Seurat's work, with bright blue skies and playful scaffolding towers. Aspiration is realised through co-operative effort — the figures holding a girder — and there is time for leisure — the group at the base of the tower.

In the study (1950) now in Edinburgh (*Fig 3*), there are two bicycles and a residual tree reminiscent of the picnics and cyclists. The picture stands for the same mutual aid celebrated by Seurat. There is no need for heroic gestures, the monumentality is achieved through the whole group of figures, the "crowd". If there is a paradox, it is that the whole construction looks fanciful, like a house of cards.

Are there contemporary equivalents? The separation of community art from the mainstream of gallery art has marginalised mural painting, and its language has often been unconsidered through a lack of critical discourse. The result is a pastiche of borrowed language, from illustration.

There are exceptions. Claire Smith's mural *Limehouse Reach*, in Limehouse Library (1986) is one. A soft and monumental female figure floats over a view of Limehouse Reach (the view behind the wall on which the image is painted). *Limehouse Reach* is in a long tradition of allegorical and symbolic subjects. It is painted in a language (adapted to a large scale from the artist's studio work) which echoes Blake's flowing curves and Turner's sense of light dissolving forms in primary colours. The effect is sympathetic and peaceful, welcoming all spectators like a secular Mad-

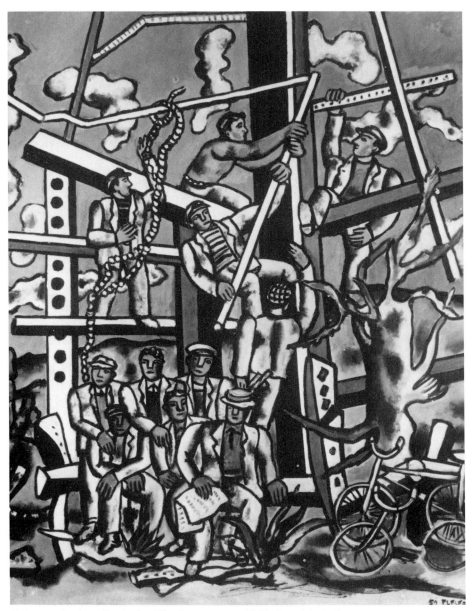

3. Fernand Léger, Study for *The Constructors*, 1950, Scottish National Gallery
of Modern Art (Press photo, Whitechapel Gallery)

onna (*Fig 4*).

By contrast, John Clinch made the *Great Blondinis* for the Brunel Centre in Swindon (1987) in an overtly populist style, representing two acrobats from the 1930s. The figures are colourful, accessible, a focal point to lend identity to a bland environment. The sculpture was the result of a collaboration between the artist and six craftsmen from the British Rail Engineering Works, which may be as valuable as any aesthetic resonance it lacks (*Fig 5*).

There is a place for art which uses a language of simplified representation. It is outside the debates of Modernism, but sets up its own territory of art for everyman. Yet can there be figurative sculpture as accessible as this, but with the added virtues of aesthetic quality and emotive impact?

Elsewhere in Swindon, at the W. H. Smith building, are three *Running Men* by Elisabeth Frink. They are part of the sculptural language of the twentieth century, for example in declaring their own method of making. The bronze shows the touch of modelling, the accumulation and paring away. By being obviously sculpture, objects made by someone's hands, they are also distanced from actuality, placed in a realm where they can stand for more than one figure—perhaps be a kind of every figure (*Fig 6*).

The *Running Men* are in a tradition of figure-sculpture going back to archaic times whilst being of our time. To work in a tradition implies thinking in terms of a cycle, whereby everything partakes of origins. This idea of time can be expressed through the Greek word *Kairos*, the matrix of time. Progress, on the other hand, the neurotic pursuit of things always new, is expressed in linear form by *Kronos*, the time of the chronometer, which is always running out. Using the same model, we see our consumption of raw materials, our expanding economies, our spreading urbanisation, as linear processes. We use materials and discard them; there is no cycle of reclamation, of waste products or of old art-isms.

It is not a question of proclaiming a return to Classicism, in art or architecture. That is only one aspect of past culture. It is more that all past languages of art have offered something of the monumental, the universal.

Yet much community-based art assumes a need to use a language of the lowest common denominator, as if only the blandest signs can communicate—so many figures in the conventions of basic graphic design and yesterday's illustration! The advertisers ceased doing this years ago, and only use such styles as ironic pastiche. What allows this to happen is that the received language does not declare its own fact as a framework of mediation—as if there were no glass in the window. But the prime characteristic of art in this century is its insistence on making the structure of its language evident, from Cubism to Neo-Geo. With Minimalism, there was only the glass in the window. Public art needs a

48

4. Claire Smith, *Limehouse Reach*
(detail), Limehouse Library, 1986
(M Miles)

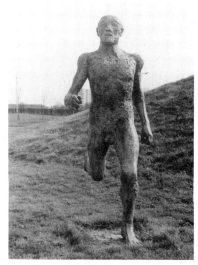

5. John Clinch, *Great Blondinis*, Brunel
Centre, Swindon, 1987 (M Miles)

6. Elizabeth Frink, *Running Man*,
W. H. Smith's Building, Swindon
(M Miles)

view (a subject, a content) but it need not be devoid of a considered language.

When new languages were introduced in the past they stood for something. David's austere Classicism stands for the Roman Republic as much as the narratives of his paintings. Courbet's Realism stands for democracy in art, though it may no longer be appropriate, or may have been outdated by new media such as photography or film, or holography, in its representational aspect. Seurat's ordered colour and composition is his visual manifestation of Harmony. Léger's monumentality is a paradox of modern life and Classicism, a search for the timeless, for pathos in the mundane. But for what does the generalised language of community murals stand?

After an era of expansion, it is now time to consider the results. This is not to mount a criticism of particular examples, but to raise the next question to be faced. Language is this question. If community murals speak for a new world, do they have a new, as well as appropriate, language? In a pluralist society, is appropriateness itself a multiplicity of languages, each re-invented to carry its particular content?

Chapter Five

PUBLIC AND PRIVATE

Juliet Steyn

"Public art" has its roots in radical leftish politics. It also finds itself, in the 1980s, at the heart of Government plans for urban regeneration in the form of Garden Festivals. Each side, left and right, claims its rightful inheritance, but, paradoxically, each side seeks to narrow the claims made of and for a Public Art.

So whatever the underlying politics, the discourses around Public Art seem to coalesce and agree. What this and other definitions imply, accept and reinforce is a dichotomy between *public* and *private*—an opposition which goes deep within our culture and our language.

I think it useful to examine more closely what is meant by the terms *public* and *private*. Commenting upon the entries for *public* and *private* in the Oxford English Dictionary, Ludmilla Jordanova, in a paper given at the Association of Art Historians Conference, in 1987, noted that "the status of the other as its opposite is clearly signalled and then reinforced by the largely negative definition offered for each".[1]

Private means, for example, "withdrawn or separated from the public body", "not holding public office or official position", not within the cognisance of people generally". Moreover, throughout the numerous meanings of *private* certain themes stand out: the sense of exclusion from things general, official and powerful; the association with secrecy, exclusiveness, personal property, individuality and intimacy. In the context of art, *private* has come to signify art for sale, an intimate art of easel painting and objects to be owned. It has come to mean the art of the bourgeoisie.

In contrast, *public* offers what might be construed as fewer negative definitions than *private*. The overall tendency of the dictionary entries is to move towards generality; "the people as a whole", something "done or made by on behalf of the community as a whole"; "authorised by, acting

51

for, or representing the community". Hence for many on the left, Community Arts came to signify radical alternatives to mainstream art as represented in and by museum and gallery culture.

The values implied by these terms cannot be ignored, and with the renewed interest in Public Art an examination of the roles that it plays within the state at both national and local levels is called for.

Culture as displayed in museums has been partially deconstructed in recent theory, so that we now know more about its class and gender basis. Museum culture is now frequently understood to represent the tastes, history, power and interests of a ruling class. In order to counter this, Community Arts developed art outside museums. They attempted — and this work was developed by the GLC and other Metropolitan Authorities — to increase the participation in culture of groups who had hitherto been denied access to it, or who had been marginalised by and from it, notably women and ethnic minorities. In *Campaign for a Popular Culture*, published by the GLC in 1986, the potential dynamism of these communities is recognised: "Participation not only means involving people in the arts but also involving artists in other areas of work, including social areas. The Sub-Committee wanted to fund a number of artists to work with organisations, like union groups, not normally associated with the arts. One of the effects of encouraging cultural participation — in decision making, as well as in activities — is that it opens up the debates about art and culture to include a wide range of people and a wider range of values and interests."[2] What was clearly at stake here was the control of culture which inevitably affected ideas about what constituted art, who is the artist, and the relationship between culture and political struggle.

PROJECTS

Various strategies have been employed to make art more visible and more popular, by bringing them closer to people's daily lives and by making them more popular, by bringing them closer to people's daily lives and by making them more participatory. The Hackney Visual Arts Touring Circuit was established in 1985 to provide local artists with sites in the Borough outside conventional spaces for viewing art. Its aim was to raise peoples' expectations about art and to place *good* art in new and unexpected contexts such as the foyer of a swimming pool and a District Housing Office.

The Docklands Community Poster Project provides an example of an art which invades public places such as advertising hoardings (*Fig 1*) and by so doing changes the meanings of those spaces. The point, made by one of the art workers, Peter Dunn, is that the Poster Project, in what it says and how it's made, arises from a process of consultation with a steering committee made up of representatives from the wider community

1. Docklands Poster Project, *Canary Wharf Poster*, 1987 (P Dunn)

groups.

Dunn explains "People say 'how can you work and design by committee?' But it's not like that. If you live and work with people who are involved with the changes going on and who live with the issues, your discussion isn't around what this or that image should look like but what the issues are. People speak them; and they usually speak them in images. If you go away and construct that image and they say it isn't what they meant, then you go and do it again. You go through a process of visualising the issues and the statements. To work like this is incredibly stimulating. Central to all of this is that people are defining themselves and the issues through the imagery."[3]

Artists' residencies have been established in various places like schools, hospitals, old peoples' homes and factories. Local Authorities, for instance Lewisham, have also funded artists. This example is of particular interest in so far as the artists involved, Conrad Atkinson followed by Glenys Johnson, have been required to participate on Council Committees including Planning. The potential of this sort of political involvement is great. In this instance it led in 1985 to a *Percent for Art* scheme being adopted in principle by the Borough. This initiative was introduced by Atkinson to Edinburgh when Artist in Residence there in 1987. The Labour controlled Council there, too, has adopted a *Percentage for Art* scheme and has subsequently appointed a project officer whose job is

funded partly by the Scottish Arts Council.

Developing alongside these initiatives and in a certain sense inflected by them, are both the Arts Council and the Regional Arts Associations. In 1988 the Arts Council of Great Britain pledged itself to develop the concept of a *Percent for Art* campaign nationally. Public funding has been allocated to put art in public places.

But problems emerge. The American critic Lucy Lippard cautioned in *Studio International* in 1977 "The Parks Department (New York) began with a good idea — to have sculpture scattered around the city in areas where art had rarely penetrated. But what happened was that, for the most part, gallery art was simply placed outside, and some of the sites chosen were absurd." [4] Many examples of lamentable failures of this type have occurred in Britain — an Anthony Caro sculpture for the North East London Polytechnic, a glacial boulder arranged at Singleton in Kent by Antony Gormley, to name but two. This aspect of Public Art has been criticised by both sides for merely *parachuting* art into the environment, for failing to consider the site or its users.

In spite of the very different histories and traditions of Public Art, a consensus seems to be emerging in which different values are being ellided. Public Art means openness, inclusion, availability, participation, accessibility and visibility. Its contrast, according to this discourse, is art which is private, exclusive, unavailable, non-participatory, inaccessible and invisible. Where does that leave art in a museum, whether publicly or privately owned, which in either case can be accessible, available, participatory or inaccessible, exclusive and non-participatory? Where does that leave Picasso's *Guernica* or Glenys Johnson's *Women Returning from Work (Fig 2)*? These images, the one in a museum, the other in a studio, may be less visible and accessible in an obvious sense than a street mural. But are they necessarily less public and accessible in their meanings? The discourses around Public Art refuse to tackle the problems inherent in these questions.

EDUCATION OF THE PUBLIC ARTIST

Following the directives of the government's National Advisory Body to the effect that Fine Art students should be trained to acquire professional skills, a few Fine Art departments have responded by including a Public Art dimension in their courses. Inevitably the emphasis within these courses differs in detail from college to college. What is of interest here is which aspects are regarded as the determining features of Public art and to what are they opposed?

At the Kent Institute of Art and Design, for example, Public art is differentiated from the *other* in Fine Art by defining it as "related to place". This, according to the characteristics mentioned earlier, is inevi-

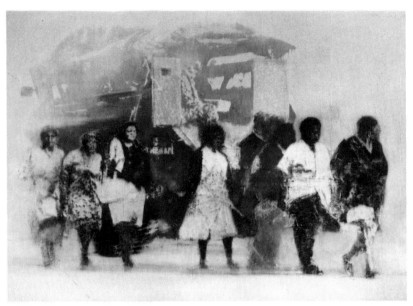

2. Glenys Johnson, *Women Returning from Work*, 1986–87 (G Johnson)

tably an inadequate definition. But it could be argued that the very presence of Public Art in the art school setting does heighten students' appreciation of what Fine Art can be about, where its boundaries lie and how it can be used to promote and develop different ideas and concepts for different social and aesthetic purposes. It demands that students be more aware of the contexts and meanings of their work in general. After all, if they're not *doing* Public Art, what are they doing? If it's the *other* and therefore *private*, what is it? Who is it for?

Students soon learn that art is part of social history and communication. They realise too, that the presumptions and intentions of artists, the conventions they deploy, the traditions within which they work and the settings within which their work is displayed inevitably define the audiences for art and affect the meanings made for their work. An analysis of any historical situation, any work of art, reveals that there are no neat distinctions between public and private. The boundaries now being established should be seen as contingent on an understanding and the outcome of these dialogues.

PRIVATISATION AND PUBLIC CULTURE

Privatisation of the arts may, given current government policy, lead to tax

concessions which could give individuals and multi-national companies too much power. Such funding is already affecting the type of culture with which we are being presented and the values that go with it. The Whitechapel Art Gallery has been enormously successful in attracting large-scale sponsorship, but only particular kinds of exhibitions attract the necessary sums of money. In the long term it may be that the potential of the Whitechapel and other museums to serve their local communities will be diminished. If many of us were once critical of museums for their remoteness, paternalism and élitism, we yet have to be prepared to save them from becoming even more inpenetrable.

When Owen Kelly in *Community, Art and the State*[5] lamented the passing over of Community Arts from communities into the hands of institutions and professionals, he was worried that first they would become too bureaucratic and that they would then accept established doctrines. Yet we have to use those institutions and ensure that they are more democratic and accountable. They need to be seen not merely as inhibiting or constraining agents, but as enabling ones. Indeed some museums like Rochdale have been rethinking their practices and as a consequence have produced some challenging exhibitions. For example, by re-presenting aspects of their permanent collection of nineteenth century paintings they have been able to raise specific questions about art made by women and to create alternative interpretations to the dominant history of nineteenth century art.

The participation of the political left in the formation of civic cultures including museums, libraries and art galleries has been formidable, but now in many cases is decaying and must be revived. We have a government which is taking advantage of that decay and is attacking that tradition. If we're not vigilent *public* will collapse into *private*. It is clear that the public domain now under attack needs protection in order to provide real alternatives to privatisation. We need to unpick the discourse in which the cultural politic of Public Art has been reduced to decorative schema to patch up our decaying town and city scapes or to adorn the human face of corporate enterprises. The core idea which I seek to present here is a notion of a transforming visual culture which enriches and is enriched by the concepts of public culture. The re-energising of these concepts is one of the most important tasks facing the political opposition today. This can only be done if we integrate cultural policy into economic and social policy. In *Saturday Night or Sunday Morning?* G. Mulgan and K. Worpole call upon their experiences with the Greater London Enterprise Board and the GLC to demonstrate the links between cultural and social, economic and employment policies.[6] For his part, Franco Bianchini has argued that concrete examples can be found ". . . in the strategies of *cultural urbanism* used by sections of the European left (especially in France, Italy and Spain) since the late 1970s, who tried to

address the problem of the quality of life in the city through a complex of cultural policies for the urban public space."[7]

Thus in 1976 N. Nicolini invented the *Estate Romana* (a summer festival) which attempted to revitalise the city immobilised by the heat of the summer and its evacuation by those with enough money to flee from it. Public art in this context was conceived a celebration, a series of cultural activities in which people participated in self-conscious ways. Bianchini suggests that in the variety of cultures represented—high and low; local, national and international: Augustan mausoleums and Japanese software, "the spectator felt part of a collectivity, but was always totally free to interpret what was happening all around. The invisible hand of the council took great care not to force any preconstituted meaning on the Estate's events and to put the audience into action. . . . It obviously meant different things to different people, but the net effect was to help retain a sense of self-identity and re-aggregate the community in a situation which could have evolved towards violence, apathy and further divisions."[8]

The purpose of the *Estate* was to break down the deadlock and seclusion of urban living. It would not have worked without a heavily subsidised bus service and a reliable public transport system running through the night. Equally important were other initiatives which involved lighting public spaces to make them both more attractive and safer.

The 1981–86 socialist government in France provided a marvellous example of the state funding of art. It pledged itself to doubling the budget for culture and by 1986 had reached 0.92 percent of national expenditure—some 10 billion francs. Jack Lang, the Minister of Culture explained, "The basis of our thinking is that all the arts matter, even minor ones, and that culture must be truly popular. . . . What we have done is give a whole mass of local people, in all the arts, the feeling that society appreciates them—and the State is really no more than the voice and agent of society." Moreover, the Ministry of Culture had the courage to sponsor works which in themselves presented a challenge to their authority. The responses reported in *Le Monde* (14.3.1986) to a sculptural installation by Daniel Buren in the courtyard of the Palais Royale, a site of almost "religious" significance to sectors of the French population, represents such a case. In addition to supporting and nurturing the talents of individual artists, by commissioning designs from contemporary sculptors and painters, state patronage was extended to many spheres previously neglected by it. A strip-cartoon museum at Angoulême, a costume museum in the Louvre, a photography school at Lyons, help for the traditional porcelain and tapestry-weaving industries, are just some examples which have brought together museums, industry and the retail trade. *Le sponsoring* by local firms was also encouraged.

Thus it is possible both for local communities (however defined) and

for entire countries to use the idea of Public Art as central to the lives of the people concerned. However it has to be thought of in more ambitious, conscious and structured ways than in Britain today. Public art as it is emerging here risks being trapped and limited by its own definitions. It is almost too dangerous to name. The interpretations, meanings and critiques of Public Art must be constantly made to play off each other to ensure that it is kept alive and responsive to change.[9]

THE BRITISH EXPERIENCE

Chapter Six

COMMUNITY MURALS IN BRITAIN

The beginning of the community mural movement was in Chicago and other cities in America. In Britain it began, again outside mainstream art practice, in the early 1970s. As in America, there was a rapid expansion of practice, and less of a critical debate. The number of artists emerging from education rose significantly through the 1960s, yet the opportunities for a career as a professional artist were minimal. Many turned away from the rather tarnished glitter of Cork Street and the clinically dead style of Minimalism towards the streets. They began to organise in groups, to find studios and workshops in decommissioned industrial buildings, to put on exhibitions outside mainstream spaces, and to find a new audience in communities.

In some cases, artists became Community Artists, acting as catalysts to the creativity of others, or Town Artists, developing a programme of art for the locality. In other cases, they reacted to current events and campaigns, or the needs of communities to have a say in the environment. Their skills were utilised in new ways as well as their knowledge of art history (a catalogue of images and compositional devices).

Much of the work produced was not intended to last forever, and is now faded or peeling, perhaps defaced, or demolished. Not enough careful documentation was made for a full history to be reconstructed. Some examples were purely escapist, others involved research into the aspirations of the community, and acted as a focus of attention on various issues. In a few cases, groups were formed which have continued to specialise in mural art, with strong community links. Most of these are still functioning, often with local authority support.

As in America, questions of language and more probing solutions to environmental decay tended to be overlooked. Yet there is one long-term British mural tradition in which language is an evident concern: that of Northern Ireland, where the two communities of Nationalist and Loyalist have evolved distinctly recognisable visual syntax over many years. This, being the oldest, is perhaps the place to begin an exploration of British

61

murals. Given the conflicts of Northern Ireland, it is a sensitive area. Yet it may offer the beginning of a critique for a language of murals as a whole.

COMMUNITY MURALS IN NORTHERN IRELAND

The longest extant British tradition of political wall painting is that of Northern Ireland. Each community has its own language. It is possible to tell to which community an image belongs without "reading" its text.

Not all the images are sectarian, and even those that are may be mainly concerned with local pride. Murals in Northern Ireland are found in working class areas. In communities which have little comfort, there has to be a celebration of something, history or religion. There is little "public art"; one of the more exciting pieces is the group of buoys outside Belfast Cathedral, not art as such at all.

The production of community-based art in a divided society entails particular sensibilities. Given the two distinct visual codes, any mural attempting reconciliation will need one of its own. The question of language is unavoidable.

The *Outdoor Relief Workers Strike* mural of 1985 is an example of a work seeking a non-sectarian quality. It was intended for a prominent site near the centre of Belfast, and painted by Neighbourhood Open Workshops on marine ply. It was never installed, being overtaken by the events of the Anglo-Irish Agreement. A banner was displayed over the City Hall saying "Belfast Says No", but the owners of the wall were afraid of the consequences of a non-sectarian mural.

The event commemorated was itself non-sectarian, as an accompanying leaflet states:

> "an episode where the prevailing rhetoric of sectarianism was briefly overcome by a city-wide demand for improvements in the basic provision for adequate work and unemployment relief." [1]

Photographs and memories were used in the design, co-ordinated by Ivor Davies and Gordon Wilkinson. The style was that of trades union banners, with the slogan "Work and wages not charity" prominently displayed. This adjunct of social realism seemed appropriate as a language distinct in its own right, but not like the two sectarian languages. Behind strikers emerging from both sides of the city was Stormont, the seat of power. The strikers had found a temporary unity. The leaflet says:

> "their unity is . . . fragile and easily torn apart. The route of the marches is lined by police who maintain the division between the two groups of protesters."

There had been other non-sectarian murals through the 1970s, a significant proportion the work of art students. Most were concerned to

lend colour to a depressing environment. Two murals in Derry were supported by the Department of the Environment: a circus, and a trompe l'oeil hand taking a letter from an envelope.[2]

In Belfast, the College of Art became involved in government sponsored schemes for community art. A city-wide project was organised in 1977. The students worked with a given community centre in each case, and consulted on theme and style. They had little previous experience, and art education has not provided either insight into collaborative work or suitable role models. It is not surprising that not all the murals were a success.

Some of the products were stereotypes from popular culture or advertising phantasy—unconsidered borrowings of perhaps inappropriate languages. There was a quota of jungle scenes, described by one artist as "international plastic Walt Disney type culture" which did not relate to the community.[3] This criticism might well be applied to jungle scenes in Newcastle, Wigan, Manchester and many other places. It is echoed by another member of the community:

> "In Springhill . . . there is an enormous mural [now destroyed] . . . With brilliant flair and astounding absence of sensitivity the artists painted a series of wild animals, set in a jungle. They then went away leaving the residents to contemplate their handiwork and to wonder if it really represented the artists' view of them . . ."[4]

A mural is no answer to poor housing or social deprivation, not in itself at least. A community worker wrote that there were dozens of murals but few skills passed on to local youths.[5]

Other murals, the majority, represented the deeply ingrained sectarian interests of a community. They were, and are, sufficiently effective for the troops to disfigure them. They may also be a more interesting as well as lasting phenomenon than the student murals, relating directly to the communities which have produced them, free in many cases from interference by professional artists.

The Loyalist murals have a restricted vocabulary, centred on King Billy, often riding his horse. The imagery is almost always phallic. Billy sits like a fist on a white charger. In other scenes he lands at Carrickfergus. The derivation of the imagery is in prints originating in the Protestant propaganda of the eighteenth century. Billy on horseback is borrowed from Benjamin West's picture of the Battle of the Boyne, an engraving of which was published in 1781 and circulated in Ireland. It can be seen today in several popular forms, such as tea towels and postcards.[6]

Bobby Jackson, a coach painter by trade, in a family business, is the best known of the Loyalist muralists. He painted a number of murals in Derry, using postcards and similar sources for the compositions. He was interviewed by Radio Ulster in 1982 and spoke of making his own

colours.[7] During the 1970s the city council wanted to demolish most of the area, but protest saved the wall on which his mural was painted, and it was reconstructed in the midst of a new housing development. It is clear that such murals are an emblem of the community's feeling of origins, whatever they may seem to outsiders.

The "troubles" have re-emphasised the importance of the murals, but they flourished during the inter-war period. Bobby Jackson was active then, making his own paints whilst others acquired them from the shipyards. In recent times, the painters have often been untrained, and the tradition has degenerated into badges and slogans. Art is not a vital part of education in Protestant schools. The skill of the King Billies is lacking in such wall paintings as the Loyalist Prisoners mural in Howard Street, Belfast, a shield, two flags, a slogan: easier things to draw.

Nationalist murals use a variety of sources, and have a shorter but more colourful and broad tradition. There were few of them before the 1980s. Political events such as the hunger strikes, and the "martyrdom" of Republican activists such as Bobby Sands, have provided subject matter. Styles are borrowed from traditional Catholic imagery, as well as from Central American revolutionary posters. The general characteristic is, in direct contract with Loyalist murals, a sense of the feminine in the images. Figures are contained, carried, or otherwise given a sense of matriarchal context.

In 1981, the Catholic populations of Derry and Belfast were encouraged to support a campaign of peaceful disruption during the second hunger strike (for political status for the Republican prisoners in the Maze prison). At first, advertising hoardings were painted over in black, and used to display the letter H in white (for H Block in the prison). Some walls were similarly blacked out to emphasise slogans amidst accumulated graffiti. Then murals began to appear on gable ends. It has been claimed that 150 were painted in Derry and Belfast in one year.[8]

The murals are essentially local, and those who produced them, sometimes youths, in other cases people in their twenties (and one with an art qualification), "seldom strayed far from their own streets".[9] Some muralists were harassed by the authorities, and one slogan painter was shot. The imagery is drawn from traditional sources which are immediately accessible and familiar to the Catholic communities. Even from some distance, the content is communicated before the text is noticed. Often the words are in Irish. It does not matter if local people speak it, the visual language tells them the content, and they know the stories as well as the songs.

Some symbols have as long a history as the Loyalist postcards, such as the *Phoenix of the Fenians*, or the starry plough. Others are more recent, such as the lark rising from barbed wire, relating to a statement by Bobby Sands likening the lark to freedom, and to a traditional song, *The*

Lark in the Clear Air. Christ and the Virgin Mary also appear, as does, looking like the Mother of God, Mother Ireland gathering the dead heroes into her skirts. These symbolic images are a living, popular visual tradition. If ever there has been a "shared symbolic order" it is here.

The initial energy of the Nationalist murals seems to have declined. Many are in poor condition, and covered by graffiti as well as the marks of paint bombs. Far fewer have appeared in the last few years, though many survive as symbols of the minority community's aspirations. They have become part of the character of the neighbourhood. It is even possible to buy postcards of them.

Like the Loyalist murals, the place of the Nationalist wall paintings is in their own neighbourhoods, rather than being a provocation to outsiders. For both communities, the murals are a force for social cohesion, a reminder of long-standing cultural identities. Despite the sectarian implications, they are probably more successful in their own terms than cosmetic attempts to "brighten up" the areas.

What emerges from even a brief study is the degree to which each has its own language: the Loyalist being masculine, with the phallic Billy, his horse, his aggressive stance and the record of his conquests; the Nationalist being feminine, with the enveloping and curving figure of the Mother gathering up her persecuted and bleeding sons, the lark, the green.

The hidden codes, the general and underlying character of these murals may communicate more directly than any slogan, or more overt narrative. They each have a symbolic quality, expressed in the formal elements of the language. Very few community artists on the mainland have considered visual language to the degree it has been (almost unconsciously) evolved in Northern Ireland.

COMMUNITY MURALS IN GLASGOW

Glasgow was probably the first British city to establish a major public or community art programme (followed by Swindon a year later). In 1974 the Scottish Arts Council set up a pilot scheme for four gable end murals by local artists, which were the first of many through the following decade.

The first four murals were *Boy on Dog Back* by John Byrne, *Celtic Knot* by James Torrance, *Hex* by Stan Bell, and *Klah P II* by John McColl. All were large scale adaptations of the style the artists had previously exhibited at the Glasgow League of Artists. Stan Bell maintains that abstract work was less controversial, and attracted less graffiti. His own *Hex* was "signed" by Rocky Maldo on the black lower area, an intervention by part of the local community which became regarded as legitimate. By contrast, John Byrne's more elaborate and figurative work was

quickly "claimed" and received most graffiti:

"The artist's work is all in vain,
The Tiny Partick strike again!"[10]

Two of the gables involved community groups to a significant degree. James Torrance worked with ASSIST, and John McColl with the Mile End Project. A local sign-writer, Ian Bateman, assisted in all four works, and children who had helped paint *Klah P II* signed their names at its base, which discouraged graffiti by giving a sense of local ownership.

The pilot project related to walls due in most cases for clearance. The brief existence of the murals may have led to suspicions that a gable end painting was a signal for demolition, though the underlying reason was more to conserve the tenement blocks and retain the social fabric.

Today Glasgow is no longer the city where "windows are broken from both sides" but the city where "walls are sandblasted from both sides", and the remaining tenements are secure and becoming gentrified as their architectural interest is recognised. In the 1970s, the activities of the city planners were a major threat, as road schemes caused the widespread break-up of communities. The gable ends were a way to draw attention to community spirit as well as being visual improvements.

In 1977, Tim Armstrong painted architectonic murals on a pair of gable ends in Ancroft Street. He used the details of the Victorian buildings, and colours relating to the red sandstone. The project was part-funded by the Scottish Development Agency, as well as the Scottish Arts Council. Paint (an exterior textured emulsion) was donated by the manufacturer. These murals were intended as part of a rehabilitation of the area, and set a precedent of art being used in urban regeneration, as well as being related directly to architecture.

Some questions were left unanswered, such as the upkeep of surrounding green areas. Today the paint is worn and faded, having lasted its normal span, but there is a lot of graffiti, and the grass is covered with junk. In the distance, three tower blocks are each re-clad in a pattern of blue and red.

The following year, a more ambitious project was begun: the Garnet Hill Project, within sight of the Glasgow School of Art. Ten artists were employed. Two gable murals were painted, one geometric and one a design incorporating a poem based on the idea of garnet as a mineral in a chain of being. Learning from previous shortcomings, the project involved the community more fully. As well as taking part in the painting, local children gained a play area. Behind the football pitch is a mosaic, still in good condition.

By 1980 the gable ends were part of Glasgow's culture, and began to reflect a more diverse spectrum of communities. Roger Hoare organised Public Image, a project for seven murals. He contributed one overlooking

66

Wilowbank Primary School using Indian legends. Other artists employed included George Massey, who later worked on the Easterhouse mosaic. The success of such projects helped establish the appointment of town artists to work with local communities. Some of them, such as Hugh Graham, have seen their role as a catalyst to other people's creativity. By contrast, David Harding and his successors in Glenrothes, Fyfe, created large concrete reliefs and sculptures in a hybrid style of industrial motif and "Scottish Aztec".

Perhaps the most successful, and ambitious, project was not a gable end, but the mosaic on the east and west walls at Easterhouse. The area is a social disaster disaffecting nearly 50,000 people. Unemployment at the time of the project (1984) was about 40 percent amongst men. The project brochure optimistically described it as "a young town . . . in the process of building its networks and its sense of identity." The local public house, the Casbah, had no windows for fear of vandalism, and this typified the architects' preconceptions of the community. To live in Easterhouse was to be written off.

The artists, co-ordinated by Allan Kane, arranged a meeting to consult the community. Seven people arrived, and when a request for roof repair was declined, a woman and her sister left. Only by an amazing effort, with informal talks and finding local people with a concern for the environment, was a network of contacts formed. Many people doubted the mosaic would survive, but some noticed the skill with which it was being produced and respected that. It has survived, and bus tours are organised during Mayfest for visitors to see it.

The east wall is a landscape, and was made with help from local children. Allegorical presences in the foliage include Time and a tower.

The west wall is a more complex work, designed by George Massey. It is a polemic, in the form of three tableaux. Writing of his work, Massey says:

> "In seeking this 'broadened context' it was not enough for me to play a part in improving the built environment . . . it was such an opportunity for a critique. . . ."[11]

He tried to create a "shared meaning" through symbols, such as Liberty. A treadmill stands for repetitive labour, and a roulette wheel seems to determine the rise in unemployment. It is a difficult work to interpret, but all the images have a documentable provenance, and there are several accessible symbols, such as the brick structures reflecting the alienation of "what passes for architecture" and separation of individual from commonality in the imposed regime of such grim estates. A by-product of the mural was that the brewery spent £60,000 in refurbishing the Casbah.

George Massey is by no means the only Scottish mural artist with a political consciousness. Ken Currie in his murals in the People's Palace

(1986–87) uses a style closer to Mexican murals and more directly propagandist than Massey. Currie is part of the new wave of Glasgow artists, uses bold lines and shadows, and an almost violent colour sense. The subjects range from the Calton Weavers to the Miners' Strike, and there is a general sense of a procession, a kind of Progress. He has defined history as "class struggle" [12] and mixes nationalism with socialism, influenced by Courbet, Léger and Grosz. In the end the rhetoric wins.

Community-related art in Scotland is not confined to Glasgow. Several local authorities have appointed town artists or set up community arts workshops. In Edinburgh, there has been a major project in Leith, including a celebration of local history in the *Leith Mural* by Street Artworks. The mural conference in Edinburgh in 1986 demonstrated the strength of the movement in Scotland.

Artists for Justice and Peace use a prominent site on the walls of St John's church in Princes Street for topical murals which they repaint every two or three months. These have included themes relating to Central American conflicts, World hunger, and refugees. In 1986 they produced a *Nativity*, using de la Tour's *Madonna and Child,* with the "good" visitors of McLeod of McLeod, Mother Teresa and Winnie Mandela. The "bad" were Reagan, Thatcher and Botha; the latter was at an early stage thought to resemble Archbishop Runcie, and was suitably modified to avoid confusion! The occasion of the INF Treaty was celebrated with a double portrait of Reagan and Gorbachev (*Fig 1*).

Murals are still being painted in Scotland, in open public sites and in schools and hospitals. Kate Downie incorporated children's work in her mural in an Edinburgh hospital in 1988 (*Fig 2*). The Doctors, Nurses, Cleaners and Porters were all depicted on different levels of a stairway, by both herself and children who were patients on each floor. This is a compromise between artist as producer and artist as catalyst, involving both. The hospital provided a studio, and the act of including so many staff was a cohesive force.

Perhaps artists are taken more seriously in Scotland, and there is a continuing tradition of their involvement with communities at many levels. This is enhanced by the prospects offered by *Percent for Art* policies.

COMMUNITY MURALS IN LONDON: A FEW EXAMPLES

Whilst murals in Glasgow, Swindon[13] and many other cities where they flourished during the 1970s were expressions of local feeling or history, those in London tended to be more concerned with a political message. The funding for many projects came from Labour controlled local authorities, the GLC before its abolition, and Greater London Arts. Without this funding many murals would not have been possible.

68

1. Artists for Justice and Peace, *INF Treaty*, St John's Church, Edinburgh, 1988 (M Miles)

2. Kate Downie, *Mural*, Royal Infirmary for Sick Children, Edinburgh, 1987–88 (M Miles)

By 1986, there were about 300 murals in London, 53 of them in Islington, 48 in Lambeth, and 55 in Tower Hamlets. Several groups had been established in the 1970s, such as Free Form and the Greenwich Mural Workshop. Some artists were beginning to specialise in public work as a conscious rejection of the galleries. Carol Kenna of Greenwich Mural Workshop wrote that it was a "liberating experience" which gave artists a place in society and people a chance to reclaim their environment.[14]

An example of community involvement is the Rathmore Youth Centre project, begun in 1976. During the previous year, Greenwich Mural Workshop had contacted the residents association of Lower Charlton. When a redundant church was acquired for a youth centre, collaboration began in designing murals. In successful projects of this kind the users of the space have been involved from the beginning. The fact that public art is often contentious is no disincentive. In this case, an initial meeting rejected the idea, but a second, public, meeting affirmed a majority desire for the project. For the artists, it was an opportunity in the mould of the avant-garde to work through art for social progress. As Steve Lobb (who co-ordinated designs with Carol Kenna) said, "working with people *with art* would contribute towards the transformation of society" by encouraging people to think about their environment and their creativity.[15]

The theme is local history: Charlton old and new. Local history has been used extensively, for example by Ken White in Swindon, and is the history that everywhere has. The danger is nostalgia. In this case, the modern centre of congested traffic is less attractive than the nineteenth-century images of boating, craftwork and a market.

The project was extended in 1980 (with an urban aid grant) by making a series of mosaic benches (*Figs 3 and 4*). Gaudi's ceramic seats in the Parc Guel in Barcelona were an inspiration, and the benches echo his curvilinear, colourful style. Waste ground was cleared by local volunteers. The images in the mosaics relate to the murals above, and were discussed with residents before execution. The work was completed in 1982, five years after the first approval of mural designs.

At the same time that Greenwich Mural Workshop were working on Rathmore Road (and other murals), a project for ideological murals was undertaken near Royal Oak underground station. Desmond Rochfort's *The Construction Workers* and David Binnington's *Office Work* were (in 1977) the first murals to use the newly imported paint system Keim silicate. The advantage of this system is that it lasts for eighty years or more. Although the artists were careful to undertake local consultation, the murals have been vandalised in recent years. *Office Work* has suffered more, and there may be lessons to learn from this, whilst accepting that no useful conclusions can be drawn from one case alone.

3. Greenwich Mural Workshop,
Rathmore Road Mosaics, 1979 – 80
(S Lobb)

4. Greenwich Mural Workshop under
construction (S Lobb)

Office Work has two negative factors. It occupies the wall facing the only large, traffic-free paved area in the immediate vicinity; and its language is lacking in any humanity.

Its theme is the way office work dehumanises employees, but it illustrates this by placing a large wheel in the centre, supporting an American eagle and British lion. People are reduced to rather marginal and "cardboard" roles. It may be that work under capitalism is alienating, but this mural uses a language mirroring that alienation, which cannot therefore engage the spectator with human sympathy. It can only lecture the passer-by, being more rhetoric than narrative.

The major reason for its vandalism, on the other hand, may be the environment. The area is depressingly covered by urban sprawl, and many of the population live in restrictive housing, a mixture of high and low rise. During 1987, local youths used the space for a daring form of BMX racing. A ramp was placed against the mural (already well covered with signatures). They cycled at high speed up the ramp, turned in mid-air and came down. The skill was fascinating to watch. Perhaps they made the best use of the space. By 1988 the local authority had placed green railings in front of the mural to prevent such enjoyment. The railings are useful to stand on for spraying graffiti high up the wall.

Rochfort's images of construction workers owe something to Giotto; they fall into several groups, with the distinct gestures and character which Giotto lends his figures, like a tableau vivant, against the background of cranes and girders. Graffiti was confined to a very few signatures in marginal areas, until 1988. It is now a little worse, but it would be an attractive proposition, if unverifiable, that the human scale and interest of the work had helped its preservation, in an area where all walls are heavily graffiti-covered. One case tells us little, but the question of humanity in mural art is an interesting one and may not be unrelated to response.

Rochfort later worked with Paul Butler and Ray Walker on the *Cable Street Mural* (*Figs 5 and 6*), a commemoration of the "battle" of Cable Street when an attempt was made to stop the Blackshirts marching through the East End. It was of local interest, being painted adjacent to the same street in which the battle had raged. Its genesis was in the feeling that Fascism should be seen as a constant danger. This proved a real threat when the mural was paint-bombed (it is assumed by extreme rightist elements) on New Year's Day 1987.

The style is Socialist Realist, and Rochfort in particular was influenced by Mexican art, on which he has written extensively. It has been asked where the Mexican peasants of Cable Street came from! Another device is reminiscent of Goya's *Executions of the 3rd of May*: the heroic protesters are painted full-face — they have identity; the police (cast as villains) have their features partially covered by helmets (*Fig 7*).

72

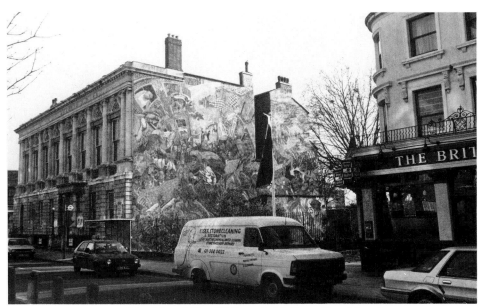

5. Paul Butler, Desmond Rochfort & Ray Walker, *Cable Street Mural*, London, 1986 (M Miles)

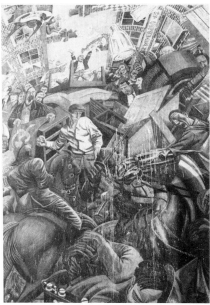

6. Paul Butler, Desmond Rochfort &
Ray Walker, *Cable Street Mural*,
London, 1986 (M Miles)

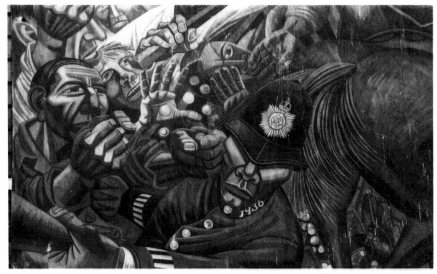

7. Paul Butler, Desmond Rochfort & Ray Walker, *Cable Street Mural*, London, 1986 (M Miles)

In 1983, the GLC funded a series of six peace murals. A precedent had been set by Brian Barnes with his *Nuclear Dawn* in Brixton. This uses a death figure based on Millet's *Sower*, scattering bombs over London. It has been claimed that children are frightened of the mural and ask not to walk past it, though this is difficult to believe.

Most of the "peace" murals could more accurately be described as "anti-war". Paul Butler created a gloomy procession of soldiers at Shepherds Bush (as a result of which a local resident mounted a campaign of protest on the grounds that the mural deepened his depressive state), and Brian Barnes painted politicians sitting on rockets. Greenwich Mural Workshop painted *Wind of Peace* in which people of all races reject nuclear weapons; Pauline Harding painted *War*, balanced by Dale McCrea's *Peace*, a more soothing image, in Brixton.

Most of the commissions were concerned to present a case *against* war rather than *for* peace. This reflects the predominance of a masculine kind of politics, centred in power. Power means conflict, and is always divisive.

But at Greenham Common a new kind of politics was being born. Excluding men, women maintained a non-violent vigil for peace and human values. They were included by London Wall, an all-female mural group, in their peace mural, the *Sankofa Bird* near Kings Cross (*Fig 8*).

In the centre are three women, monumental and graceful, of three

8. London Wall, *Sankofa Bird*
(Women's Peace Mural), Kings Cross,
1983 – 84 (M Miles)

races. They are dressed in the green, white and purple of the suffragette movement. A Japanese child wears a yellow dress with red cherries. The central figure holds the blue Sankofa bird, a mythical creature which reminds people it is not too late to put right past errors. Her other hand joins that of the Asian woman in holding a bowl of the flowing water of life. Light swells from the centre; the colours are fresh and beautiful. It is a true celebration. It is also a symbolic image, in an ancient tradition.

In the small scenes are the Greenham Women, and the dragon and serpent of eastern myth, life-giving forces. At the top, a hawk and a dove wrestle. The mural has been described as a

> "positive image . . . a welcome change from the aggressive weaponry of so many other 'peace' murals." [16]

In a search for a shared public imagery this is a precedent.

There are many other positive examples in London: Free Form's *Garden Mural* in Kingsland Road, London, various projects by Islington Schools Environment Project, Graham Crowley's *Pitt & Scott Mural* and his work at Brompton Hospital, Jane Gifford's work at Covent Garden, and others.

Not all work has been produced by artists. *Family Patchwork* is a tile mural organised by Wandsworth Arts and painted by several groups of residents and children in Roehampton. The design evolved through an interactive process and was completed in 1987. Following Victorian and Portuguese precedents, enamel was fired onto glazed tiles. The finish is durable and colourful, from a distance looking like a patchwork. Closer,

75

the detail of each of the 1,000 tiles emerges.

Some murals have been in open spaces traversed by many but emotionally owned by none. Others have been in places where the community's involvement is vital.

Perhaps open spaces, which seem to "belong" to no-one, can be used to open questions of culture as well as politics. The Artangel Trust, who "fund the unfundable", sponsored two billboard projects in London: Les Levine's comments on Northern Ireland, *Blame God* (1985) and Barbara Kruger's *We Don't Want Another Hero* (1987). Levine's direct slogans, such as "Hate God", even "Kill God", aroused controversy, whilst adjacent posters of Rambo were assumed to be neutral! The owners of the boards became too worried to honour their contract. It is difficult to say how much the theme of hypocrisy in a civil war which claims religious authority was communicated. But the billboard opens new possibilities for public artists.

Billboards bring us back to the question of language: the advertisers have evolved subtle and complex codes to sell us things for which we have no use. Can artists develop other codes appropriate to their aims of subverting the dominant culture, or increasing environmental or social awareness?

CONCLUSIONS

Many community artists sought to "change the world through art", by helping ordinary people rediscover their own creativity, and through it an ability to shape their future. Artists, too, were discovering that it was possible to organise in groups, either for public projects or to convert industrial buildings into studios.

Many of the murals produced in the 1970s in ordinary paint are now showing signs of wear. Others have been vandalised. The political world has, if anything, shifted further to the right. Before asking what may be learnt, it is worth emphasising the quality of hope which most of the murals symbolised. It may be that it was a forlorn hope sometimes, but without a vision of a possible future, life would be desolate. Few muralists would be prepared to accept such desolation, and have kept alive their aspirations, and perhaps those of some communities.

There have been positive results. Art has been associated with the regeneration of areas and reduction of street crime. Where vandalism defaces a mural it is often because the work is inappropriate or has been "parachuted" into the space. At the same time, murals may have seemed, to local authorities, a cheap way to camouflage an environment without looking into more complex problems which would have brought into question planning procedures and the accountability of architects. This is one reason why murals have become associated with run-down areas. In

76

prosperous parts of Britain there has been a resistance to public art because of such factors.

There is also the beginning of a realisation that artists have a role of some sort to play in the environment, not always by painting murals.

The work of various muralists and groups has shown a capacity for teamwork and organisation not traditionally associated with art. From these beginnings a new consciousness may grow, whereby artists are involved in the planning, landscaping and building of our cities. It would be nice to think so.

Three questions need consideration if a critique is to be developed of mural art:

What is the intention (the motivation and strategy)?
What is an appropriate language?
What are the subjects?

Most bad environments result from bad planning, an architecture approaching criminality, the remoteness of government, and neglect. Where people feel marginalised or brutalised they will react accordingly. On the other hand art can reclaim their humanity through imaginative works, and initiate wider improvements, as at Easterhouse. One intention is, clearly, to improve the quality of life.

Community art goes further in this respect when it involves ordinary people in creative work. If everyone has an innate creativity, and sensibility, then to reclaim it is an act of momentous self-realisation. Also, community art may bring people together, to co-operate in a group, realising their capacity for mutual aid. In this respect, a mural project (or street theatre, or any other aspect of community arts, or an inner city farm) may be the foundation of a renewed social fabric. But perhaps to make something "beautiful" is itself a subversion of an ugly world.

If the intention is to improve the environment, and through it the sense of well-being, and to regain the ground of imagination which has been built over by reason, power and commerce, what are the appropriate languages?

Many murals use the style of illustration and its flat areas of colour. This is easy, and emulsion paint does it well, but may not always be suitable. It is no substitute for a genuine popular visual language, and that will be created only by increased opportunities for everyone to take part, combined with ways of freeing themselves from stereotypes and conventions relating to an imposed culture. To realise this, it seems important to find ways in which everyone can "draw" with confidence. Equally, artists will contribute more if they reject the given languages of the mass media. The ability of the spectator to interpret and understand is often undervalued.

The bland language of illustration does not have authenticity; it is

like the mass-produced consumer goods and junk food which contribute to the poverty of life. At the same time, Socialist Realism has a peculiarly dated and remote feeling.

Because their genesis was often in a political campaign, many murals have been ideological. Yet where is the compassion in the abstract world of power? Others, such as Ken White's in Swindon, have used local history as an effective way of involving people in a project. His *Golden Lion Bridge* (1976) was repainted in 1983 to overcome its having faded. It uses local archive material to reconstruct a vanished environment from the days when Swindon had canals as well as railways. Such images can be a source of local pride (*Fig 9*).

Local history is one starting point. The search for a shared vocabulary of symbols is another. But a symbol works only if it is "magic". Parrots and bathers do not make a paradise! The *Sankofa Bird* uses archetypal images of femininity.

Community murals have, at least, tried to contribute to an alternative society, as the dominant social and cultural structures grind towards destruction.

9. Ken White, *Golden Lion Bridge*, Swindon (repainted), 1983 (K White)

78

Chapter Seven

GALLERIES IN THE STREETS

"I want, I want"[1]

Art contributes to the quality of life. This implies that art itself is beneficial. Is culture good for us? If it reminds us of dimensions we too easily repress, or is part of an enjoyable environment, if it makes spaces into places, then it is. But much will depend on why and how it is introduced. In the controlled ambiance of the art gallery, it is expected that we partake of beauty, or update our knowledge of contemporary debates on art and its categories, or both. The gallery is made as a context apart, with a seeming (if illusory) neutrality. The street is never a non-place in that way, even when it is a residual space.

To put art in the street, or the park, or on a Scottish hill, is not in itself to make public art. It may be part of a quite separate desire to widen the audience for the gallery context of art. But the experience in the gallery is uneasily transposed to the street, using architecture or landscape as the "wall" on which to "hang" the art. If the space is treated only as a backdrop, what happens is that the "hermetic" world of the gallery colonises the street.

Where patronage is unstinting, all manner of insane desires may be realised, through art, architecture and kitsch.

One of the more extreme cases is the *Gold Pyramid House* at Wadsworth, Illinois (*Fig 1*). The tourist brochure speaks for itself:

> "This unique structure exists because of Jim Onan . . . and his love affair with the mysteries of ancient Egypt. . . . The Gold Pyramid is aptly named. Its 12,000 square feet of exterior walls are completely covered with 24 carat gold plate . . . It is the only known authentic pyramid to be built in over 4,500 years."[2]

"Like a silent sentinel", a sculpture of Ramses II stands in front of the house. At least, the original would be called a sculpture. The

79

1. *Golden Pyramid House*, Illinois, USA (O Gonzales)

reproduction, in its specific context, raises problems of definition. Inside the house is "a remarkable mixture of Egyptian and American furnishings". A reproduction of Tutankhamun's throne (from the Egyptian Museum, Cairo) sits next to a grand piano. Admission is $7 (children under 12, $4).

The *Gold Pyramid House* tends to support the idea that monumental art is kitsch. Perhaps when the only "symbolic order" available is a super-value mixture of bought ones, the kitsch is inevitable. Fortunately the cost of megalomania inhibits all but the very rich from perpetrating such nonsense.

The municipal equivalent might be the garden festival. The origin of these was to assist urban renewal. Liverpool was targeted as a depressed area, and given a festival to brighten it and bring in business. It was a sound intention, but a temporary, cosmetic measure, to distract attention from the need for more radical solutions. Not far away are the theme parks of Wigan Pier, and Frontierland at Morecambe. Ordinary pleasures like taking the Mersey Ferry appear inadequate. In a climate of structural unemployment, having an escapist day out seems to be ordained a popular diversion.

The theme park is a form of tourism, a pernicious industry which consolidates everything as kitsch, just as advertising colonises the countryside as sentimentality. In 1988 the Glasgow garden festival was the scene of a "noddy-land" of architecture and the work of fifty artists amidst the shrubs.

Garden festivals pose a difficult problem. Are they a venue for widening the audience for art? Are they more than that, a way of increasing prosperity (if so at what and whose expense)? Is art an integral part of them? Or is it an add-on, a bit of local colour but less exciting than the roller-coaster?

The Stoke garden festival in 1986 supported the "union of art and industry". The list of artists included: Henry Moore (on loan from the Tate), Kevin Atherton, Hilary Cartmell, Shelagh Cluett, Rose Garrard, Antony Gormley, Tess Jaray, Bruce McLean, Dhruva Mistry, Ana Maria Pacheco and Richard Wilson. For them it was an important opportunity. It was also a chance for a lot of sculpture to be seen together, which seldom happens outside museums such as the Yorkshire Sculpture Park.

However interesting an exhibition, was it public art? This is a question of intention. The sculptures gave the site a sense of place, but it was not an inhabited place. Gormley's lone lead man on a hill looked across to more desolate scenes beyond the site. Yet Sculpture at Stoke was a way to bring the work of 100 artists to public notice, with most of the work made specifically for the site. It induced many companies to give money for art, bringing the funding for sculpture to something around one percent. There were links with local schools and organisations, and

the selection was adventurous. Christopher Bailey praised the concern with "narrative, humour, symbolism and wit" in place of "poker-faced minimalism". [3] Its most lasting impact may be as a model of *Percent for Art* funding, showing that it can produce a stimulating show.

Garden festivals remain problematic. It would be futile to object to the opportunities they give artists, but still unwise to see them as art in public places in the full sense.

The experience of Glasgow's Garden Festival in 1988 may be a less happy marriage of art and tourism. The basic problem is that art was not integral to the Festival. Druva Mistry's *Reclining Woman* seemed the more bizarre for the background of pavilions and stalls. The nine gates comprising *Folie de Grandeur* by Raf Fulcher and George Carter set out to be banal, and succeeded in epitomising the toyland architecture (*Fig 2*) of much of the site. The white roller-coaster was the image used on posters, something between engineering and play-sculpture.

Ian Hamilton Finlay's *A Country Lane With Stiles* created its own context, sunk in a hollow. A post proclaims "THESIS fence, ANTITHESIS gate"; the stone path winds round behind a stone wall, like the countryside but not as good. There is an irony in that Finlay made several public appeals for artists to withdraw, once his own work was installed.

The opportunities to show sculpture are not so great that artists can easily refuse an invitation like this. Of the fifty-plus included, a number were well known, including Kevin Artherton, Daniel Buren, Richard Deacon, Eduardo Paolozzi and William Pye. Henry Moore and Sir Alfred Gilbert made posthumous contributions. Perhaps the greatest value was to young artists. Alisdair Gourlay's *Three Acrobats* pranced through the trees; Arran Ross made a *Meeting Place* in wood inhabited by cult-like images; Sophie Ryder's *Fighting Stags* in wire and paint played tricks with Scottish stereotypes of the wild. But the banal context neither complemented the art nor offered any real scope for integration. The sculptures colonised the space, and were in turn colonised by the razzamatazz.

Isobel Vasseur, co-ordinator of art in the Festival, claims:

> "Since Liverpool in 1984 and Stoke in 1986, the Visual Arts have played an important part in garden festivals. It has been the aim of the Glasgow Garden Festival to similarly bring an exciting collection of works by contemporary artists to integrate with the 100 acres of gardens . . ." [4]

Fine. But George Mulvagh, who was involved in the original feasibility study, before directing operations, gives a very different impression in an interview by Richard Cork. Asked why sculpture was not fully integrated, he replied:

2. Glasgow Garden Festival, under construction, 1988 (M Miles)

". . . it wasn't thought to be important enough. Probably the link wasn't made between sculpture as an object and the artist as someone who could assist in the planning of the site."[5]

Whilst the debates on art and architecture and *Percent for Art* programmes centre around integration, practice in garden festivals tends to fall back into old patterns of cosmetic additions. Hence, the art is essentially gallery art, put in a strange place, which is only there whilst it remains profitable.

Garden Festivals have been opportunities and problems. They are temporary, but do not capitalise on that particularly, as some other forms of public art have. *TSWA 3D* in 1987 used nine "real sites". It tried to be free from what Richard Cork described as "the tyranny of the predictable". He wrote:

"Although an increasing amount of energy and patronage is now being devoted to art beyond the gallery, the results often take disappointingly limited and timorous forms. Sculpture is freed from a conventional exhibition space only to be herded into a park designated for the purpose."[6]

By using sites which were part of an extant social fabric, not the contrived spaces of festivals, nor outdoor galleries, *TSWA 3D* hoped to create

83

a stronger interaction of art and audience. The organisers chose sites which they described as:

> "already meaningful, already alive with the associations of history... but also places whose stature or symbolic status, whose very lack of neutrality, may have discouraged the idea that they were available for art."[7]

Backed by Television South West, the project gained considerable publicity, partly through lavish receptions which may have had budgets as high as those of some small art projects in the welfare state.

Because all the works were temporary, they evaded planning consents. The selection process also evaded consultations with the users of the site. How else could Edward Allington have imposed a banal ornament on St Martins in the Fields, causing minor damage to the stonework by its fixing?

On the other hand, there were some notable works. George Wyllie's *Straw Locomotive* on Finnieston Crane was a landmark, a celebration of past local greatness. Kate Whiteford's excavated drawings on Calton Hill capitalised on a distant pictish heritage (*Figs 3 and 4*). *Feeling to See* at the Arnolfini was a show of art for the blind, with an evident social purpose.

Some of the work was experimental, such as Judith Goddard's video

3. Kate Whiteford, Drawings for *Calton Hill Project* (TSWA 3D), 1987 (K Whiteford)

84

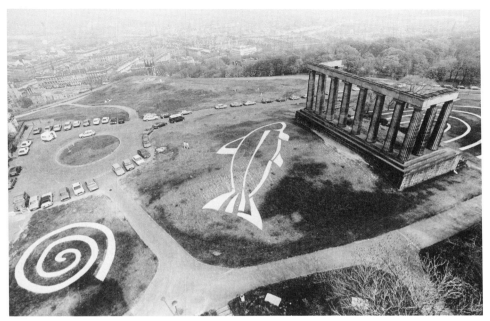

4. Kate Whiteford, Project for TSWA 3D at Calton Hill, Edinburgh, 1987 (S Hudson)

installation on Dartmoor. Holly Warburton, using St James Oratory in Liverpool, created a metamorphosis of Athena. Computer-monitored projections fused death and deathlessness, or it could as easily be life and lifelessness, in keeping with the building's ritual function. These flickering images brought out the psychological essence of the myth. It is unusual for public art to deal with such "loaded" subjects, and this was a contribution to a more profound level of content.

The most controversial piece was Gormley's cruciform iron figures for Derry (*Fig 5*). The site itself guaranteed confrontation. The guarantee was honoured.

The statue was burned, and Gormley regarded this as part of the work.[8] On another occasion he spoke of using his body and mind to focus the feelings of an audience. The figures are cast from his own body. He sees them as a kind of healing process:

> "it shoud act as a poultice and draw to itself feelings and thoughts about the situation in Northern Ireland".[9]

He sees the central image of Christianity (the religion claimed by both communities) as "freedom through suffering" and a "belief in sacri-

85

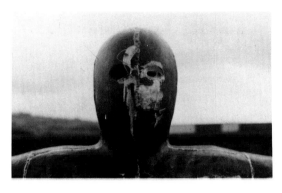

5. Antony Gormley, *Iron Figure* for
Walls of Derry (TSWA 3D), 1987,
showing effects of vandalism (P Hill)

fice". Brian McAvera articulated an Irish objection to an English sculptor
being commissioned for the piece.[10] He also called the work "site-
general" in that it could be put in any place of conflict, and related more to
Gormley's previous work than to Derry. This touches on a key issue: how
does sculpture become "specific" to a site? How does it bring out the
inherent feeling of the place, or gather a latent feeling into something
recognisable but not imposed?

TSWA 3D did not make a better environment, or contribute to urban
regeneration. It caused some controversies. However, it was never clear
whether the audience intended was the narrow art world, the people liv-
ing in the vincinity (regarded as passive spectators in the gallery mode), or
the television viewers, or all of these. The project had all the charac-
teristics of a group show: variety of established names, with a few risks; a
loose but unresolved theme; a semi-secret selection process; a glossy
presentation to the press.

At a conference[11] shortly afterwards, a group of European gallery
directors gave further evidence of this move out of their normal milieu.
The Chambres des Amis in Gheat had similarities with *TSWA 3D*, but
restricted to one city. Richard Serra was hailed as the top public artist. His
arrogance reflects theirs, in a process of colonisation of other people's
places, as in London's Broadgate Development (*Figs 6 and 7*).

Serra represents the current trend in mega-public sculpture, the fan-
tasy of a gallery on the streets. Some precedents in America have encou-
raged this kind of commissioning, seeing a big and expensive statement as
prestigious. It echoes the dehumanised rhetoric of late Modernist archi-
tecture. At least Robert Graham's *Monument to Joe Louis* in Detroit is a
recognisable rather than implied fist!

Out of all this comes a sense of directions not yet perceived. As long
as gallery directors take the initiative, their public projects will tend to be
like their group shows. At the same time, opportunities for artists in Bri-
tain are so scarce that those offered by such events cannot be overlooked.

86

What does survive is the realisation that temporary works have a value as great as permanent ones, if different. They do allow more risk, more confrontation, and may be a way through to a deeper layer of subject-matter.

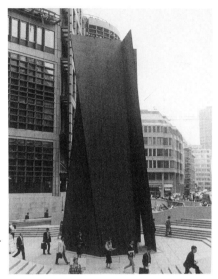

6. Richard Serra, Steel sculpture for Broadgate Development, London, 1987 (M Miles)

7. Richard Serra, Steel sculpture for Broadgate Development, London, 1987 (M Miles)

Chapter Eight

LONDON WALL'S SOHO MURAL

Louise Vines

London Wall is a public art group which has produced nine major murals since 1983. The group works closely with the communities which it serves. It seeks to increase awareness of the visual arts and to promote the status of art in public places. Sonia Martin and myself are artists for the organisation.

This article focuses on one London Wall project—the Soho Mural. It is in three parts: a diary of the project's development; issues arising from the diary; and some thoughts about public art in Britain today.

THE DIARY

The first two years

Summer 1985
The abolition of the GLC, our major funding agency, was imminent. There was an urgent need to promote London Wall's achievements and to find alternative income.

15th August 1985
I went to the Edinburgh Festival, taking photographs of London Wall's murals with me. I met the organisers of the forthcoming 1986 Soho Jazz Festival and showed them the portfolio. They were enthusiastic about the work and suggested that we might paint a mural for the Jazz Festival.

28th August 1985
Returned to London Wall and discussed the idea with Sonia. We agreed that it offered an exciting opportunity to link with a different art form, to widen our audience, to create a public art work in Central London, and to provide income.

10th September 1985
We had a meeting with the Jazz Festival organisers. They asked us to look for three possible sites for the Soho Mural. They undertook to negotiate with site-owners, and to fund-raise for the mural.

We were pleased that someone else was to take on the administrative side of the project, yet felt uneasy because it took away from us the power to "make it happen".

11th September 1985
a.m. Walked down every street in Soho three times until I was sure that I had identified the three best potential "walls".

p.m. Sonia joined me in Soho. We agreed that the best of the three walls was at 15 Poland Street.

18th September 1985
Met again with the Jazz Festival organisers, who approved the three possible locations. They said we would be contacted when there were any developments.

10th October 1985
We telephoned for news. No contact had been made with the owners so we offered to do it.

October – November 1985
The possibility of painting the Soho Mural on a wall in Lisle Street was dispensed with in a thirty-second phone call to the owners. Because we felt that the smallest wall on our list was not prominent enough, we concentrated our efforts on 15 Poland Street (a building in which the poet Shelley had lived).

I ascertained that the café-owner at 15 Poland Street was the lease-holder. Despite several visits and letters, I was unable to meet him, to get a reply to our request to paint the wall, or to identify the freeholder.

December 1985 – May 1986
It looked as if the Jazz Festival had effectively withdrawn from the mural project. We continued working on other murals.

28th May 1986
We made our first contact with the Soho Society.

2nd June 1986
The Jazz Festival organisers confirmed their withdrawal from the project.

17th June 1986
We received a letter from the Soho Society. They had discussed the Soho Mural at their executive meeting and were very much in favour of both the mural and the site. They were unable to contribute to the cost because of a prior commitment to another charity.

23rd September 1986
I rang Westminster City Council to enquire about grant-aid for the project. They said that if we obtained permission and sponsorship, they would back this sponsorship "pound for pound".

25th September 1986
Last-ditch attempts to identify the freeholder of 15 Poland Street led us nowhere. Our plans for the Soho Mural were shelved.

October 1986 – June 1987
During this period, London Wall completed murals at Hitherfield Infants School, Effra Road Ecological Garden, Fenwick Hall and Bellefields Road. We sent out press-releases which led to features in national and local newspapers, addressed the Sixth Annual Mural Conference, made a London Wall video for potential sponsors and educational establishments, published two colour leaflets and registered London Wall as a charity.

29th June 1987
On a visit to the West-End, I noticed that the café at 15 Poland Street had closed and that the premises was being re-decorated.

CONSENT

1st July 1987
Sonia and I returned to 15 Poland Street, armed with photographs and publicity leaflets. We met Vasco and Piero, the new leaseholders, who were shortly to open their restaurant. As always, the prospect of approaching strangers with a mural proposal was daunting. There is no way of knowing how people will react.

They were delighted. They liked the idea and the photographs of our work. They gave their permission and agreed to contact the freeholder. We were to raise the funds.

As Sonia was starting another project, we decided that I would take on the Soho Mural.

2nd July 1987
I waited almost 24 hours and then telephoned Piero to see if he had heard

from the freeholder. He had not, but suggested that I go ahead with ideas for the design.

6th July 1987
I telephoned Brian Burrough, the Chairman of the Soho Society, to let him know that the Soho Mural was back in our programme. He reiterated the Society's support and asked if the mural design would refer to "15 Poland Street's most celebrated occupant" (Shelley). It was an appealing idea.

My first ideas for the design came as a response to the emotional power of Shelley's poetry. I made several abstract charcoal drawings. Then I realised that I needed to make a three-dimensional model so that my design could incorporate the central buttress (which extends three feet onto the pavement). I did this using measurements taken with the eye, and then painted the provisional design onto the model.

22nd July 1987
I took the design to Poland Street and left it with Vasco and Piero to show the freeholder's agent. Piero said: "It's very nice but could you add something recognisable?"

11th September 1987
Piero conveyed to me the freeholder's consent. It had taken us two years to obtain it. Piero said that Westminster City Council had some responsibility for the building, and we should also ask their consent as a "formality".

16th September 1987
The Council informed us that 15 Poland Street had just been made a Grade 2 Listed Building. An application for Listed Building Consent would require a public announcement of our plans and the submission of a detailed design. Westminster would then process the application, send it to English Heritage "for direction", and ratify the decision at their own Committee of Planning and Transportation.

At this time, there was no certainty that English Heritage would give consent, so I began work on a design for a tiled mural, commissioned by Ferndale Community Development Project.

THE FINAL DESIGN

26th October 1987
I took precise measurements of the wall at Poland Street (48ft×32ft) and returned to the studio to make a scaled model for the design. I decided to work with one particular Shelley poem and eventually chose "Ode to the

West Wind". It is a powerful and visual poem. For me it also evoked images of the recent hurricane (*Fig 1*).

1. Design for *Soho Mural*, 1988
(L Vines)

15th November 1987
While walking in Epping Forest, I saw a huge oak tree that had been split in two by the hurricane. The exposed raw wood was beautiful. With the strong red of the autumn leaves the forest echoed Shelley's "Yellow, and black, and pale, and hectic red".

17th November 1987
I began a completely new design for the mural, with the broken oak as a central focus in a landscape hit by autumn's "Wild Spirit".

25th February 1988
I finished the design! and telephoned the Soho Society to let them know. They offered to help with publicity. The new design was also received warmly by Vasco and Piero.

29th February 1988
I delivered copies of London Wall's application for Listed Building Consent, by hand, to Westminster City Council and English Heritage. Although I used photographs of the design for the application, I took the

4ft high model with me, so that my arrival would not go unnoticed.

The Chief Planning Officer indicated that the Council would look favourably on the application. The statutory period for processing such applications is eight weeks, but we were warned that this time would be exceeded due to the burden of other work.

SEEKING SPONSORSHIP

29th April 1988
Having sought advice, I sent out the first sponsorship requests.

"Searching for the financial under-coat", an article about the mural project, appeared in *The Soho Clarion*— the newspaper published by the Soho Society.

May 1988
I developed a sizeable sponsorship package. Thirty of these packages were sent out to businesses, individuals, public funding bodies and charities.

3rd June 1988
Westminster Arts Sub-Committee voted to give £3,000 to the Soho Mural, if this grant-aid could be matched by sponsorship.

July – August 1988
The official decision on Listed Building Consent kept being delayed by bureaucracy. However, we were assured that there was no problem and that the Council was anxious the wall should be improved.

Sonia and I were determined that the Soho Mural would go ahead, with or without sponsorship. London Wall's Directors agreed, but were dismayed at the probable drop in our fees that would result.

We continued to seek sponsorship. Nearly every day a new letter of rejection arrived—sometimes two. It was a dispiriting experience.

18th August 1988
The U.K. representative for Keim paint was persuaded to give a discount on the paint. Arthur Goosen, at Keim, said: "he must have gone soft in the head".

25th August 1988
Listed Building Consent was finally ratified, on condition that London Wall sign an agreement to keep the Soho Mural free of graffiti and that we paint a "rusticated framework" around the lower part of the wall.

31st August 1988
"The Soho Mural Appeal" was announced in a press-release and photographers were invited to 15 Poland Street. Sonia and I stood on the scaffolding, sheltering from torrential rain for an hour and a half. No photographers appeared. We consoled ourselves with a ploughman's lunch in the "Coach and Horses".

5th September 1988
The Soho Mural began.

CONSIDERATIONS

I shall now look at aspects of the Soho Mural which are common to other works of public art.

Planning
There were three chance elements which made the planning of the Soho Mural possible: (i) the demolition of 17 Poland Street during the 1930s (ii) a visit to the Edinburgh Festival, and (iii) a change of leaseholder at 15 Poland Street. But the most important feature of planning was our conviction that the Soho Mural was a good idea and that it was possible. Our belief and our persistence created opportunities.

Every aspect of a mural (permission, publicity, consultation, design and execution) involves planning. What you can't predetermine, and must leave room for, is the creative process which takes place on the wall. Equally important are the things you can't control, like the speed of bureaucracy, and the weather.

The planning of the Soho project had to be integrated with London Wall's other work, over a period of three years. This included planning for the possibility that it might not happen.

Consultation
The first step was to consult the leaseholders of the building and, through them, the freeholder. Without their permission, nothing could proceed. Vasco and Piero gave more than permission. They were continuously positive and supportive. Their views also led to a radical change of design.

It was important to contact the Soho Society as soon as the idea for the project began to take shape. The consultation with the community was to ensure that the mural would be part of the place, rather than "bolted-on". Though I knew that Shelley had lived at 15 Poland Street, the idea that the mural might be linked with him came from consulting with the Soho Society. When working on murals, consultation is more than an obligation. Other people's views about the art, and their support, are both part of the process.

Consultation with the Planning Department at Westminster added to the positive feedback we had received from those living and working in the area. We were obliged to meet certain conditions, however, which put a strain on our finances and involved additional work.

Consultation is linked to accountability. The more permanent the work, the more accountable we are. At the same time, we must remain accountable to ourselves—to our artistic expression as well as to our intellectual and political beliefs. There can be a contradiction between the need to consult the community about public art, and the value art can have in being contentious. I think that public art should raise questions, but being contentious is not an end in itself.

Administration

In terms of time and effort, the Soho Mural has been dominated by "administration". There were many weeks when it occupied ninety percent of my time (including evenings).

The administration involved: arranging and attending meetings; making literally hundreds of phone-calls; writing letters; chasing people again and again; making applications for grants and official consent; seeking advice; approaching famous people to find a patron for the project (we didn't); learning to use a word-processor; developing and sending individualised sponsorship packages; poring over *Who's Who* and *The Times 1000 Most Successful Businesses*; getting quotations for scaffolding and arranging its erection; hiring contractors to pressure-wash the wall and obtaining the Water Board's permission to do it; going to trade fairs; phoning the police about the man who exposed himself to me whilst I was drawing in Epping Forest; producing press-releases; writing articles; and pursuing the press.

This administration was time-consuming and often frustrating, but it was essential that, as the artist, I was directly involved in decisions affecting the mural.

Finance

The raising of finance for the Soho Mural was different, in some respects, from that of our earlier projects. The mural is in Westminster, a London borough with a policy of giving grant-aid to the arts on a "pound for pound" sponsorship basis only. Funding is therefore dependent on sponsorship. This policy encouraged us in the belief that business sponsorship would be forthcoming. The fact that the mural was to be in one of the busiest parts of the West-End seemed likely to make it attractive to business sponsors. Because "business sponsorship of the arts" was being universally discussed at that time, we felt confident in our plans.

We sought professional advice on raising sponsorship. The search

for sponsorship then took over my time so completely that I no longer seemed to be a practising artist. We failed to find a single major sponsor. London Wall invested time and money and got very little back.

We were able to start the Soho Mural only because we had revenue funding from Greater London Arts in our financial reserves. We launched a publicity drive and an appeal fund when the scaffolding went up. Our aim this time was to attract several sponsors from businesses in the area. With the mural more than half-completed, only a few donations have been received.

Several things do seem clear as a result of our experience. Substantial business sponsorship is directed towards mainstream and prestigious establishments, rather than small, new or experimental organisations. Though the public response to murals is positive, and new murals are being commissioned throughout the country, there is no evidence that public mural art can be sustained by sponsorship.

Art

Choosing 15 Poland Street as the right place for the mural, involved several factors. The wall was large. It was at a junction and could be seen from several different directions. It was situated in a busy thoroughfare, off Oxford Street. More than three thousand people per hour pass by it at peak periods. The wall was in good condition and had no detracting features such as advertising hoardings. The building had historical connections which invited an exploration of the link between painting and poetry.

My first abstract drawings were a response to the tone and feel of Shelley's poetry. If I had not consulted the community, the design might have remained abstract. The subsequent decision to use one poem concentrated my ideas. I saw associations between the poem and the October '87 hurricane. This association was deepened by the powerful images that I found in Epping Forest.

I also wanted the design to reflect some of Shelley's symbolism in the "Ode". The death of his son was fresh in his mind when he wrote the lines:

". . . Thou dirge
Of the dying year, to which this closing night
Will be the dome of a vast sepulchre,
Vaulted with all thy congregated might".

I used the vaulted ceiling in the Temple Church as a model for a vaulted shape at the top of the picture. This vaulted shape embraces and divides the sky, which alternates between night and day.

Because there was only one figure in the design, I decided that the figure should be a woman. And the woman is black.

The design involved back-up work: portraits; landscapes; and

96

drawings of architecture. The design was specific to the building, and to its built environment. It involved a scale drawing, model-making, and climbing on the roof to take measurements.

Though this mural was "my" project, Sonia's ideas and practical help were invaluable. The support that members of a group can give each other reduces the extent to which individual artists feel isolated.

Working on a 48ft high mural meant that some aspects of the painting could be resolved on the scaffolding, whilst others (such as the bark of the tree) had to be observed from a distance. I had to return repeatedly to street level to get it right.

The decision to use Keim paint for the mural was a commitment to permanence. The manufacturers have evidence that it lasts for upwards of eighty years. Though expensive, the mural will cost less than £4 a day — a bargain for anyone alive in the year 2068.

Emotions

Producing creative work of any kind is an emotional event. In the studio one struggles without an audience. When painting a mural in public, both the art and the artist are exposed to instant evaluation. One can feel strangely isolated and separate. Fear of failure is both personal and public. However, these fears alternate with very positive feelings.

The day I began priming the wall (*Fig 2*) at 15 Poland Street was exhilarating. I enjoyed being in the busy atmosphere of the West-End. After three years of believing in the project, against the odds, it felt like a victory simply to begin. For the first fortnight the sun shone every day. It was like a reward.

2. At work on *Soho Mural* (London Wall)

Then I realised that I was alone with the wall. Having begun, I had to complete it. The scale of what I had taken on was frightening. Did I have the right to put this painting on the wall, knowing that it could stay there for almost a century? Would it be good enough?

My doubts subsided as the community responded positively to the mural. I began to feel less anonymous. When I came down from the scaffolding, people would comment and ask how things were going. Panic returned when I climbed back up and struggled with the drawing.

The emotions of painting the mural were to be expected. What I hadn't anticipated were the feelings associated with seeking sponsorship. It wasn't only the frustration and the experience of rejection. There was something humiliating about repeatedly asking for money for my work. It was like begging.

THE BROADER CONTEXT

I have described one particular mural project in some detail, but the Soho Mural exists in a broader context. The problem with discussing public art is that there is little consensus about what the phrase means. There are those amongst both artists and critics who hold the view that "community art" and "public art" are separate entities. Though there are distinctions between different types of public art, it is unhelpful and inaccurate to make absolute divisions. Public art may be seen as a continuum. At one end is the type of "community art" in which process is said to be more important than product. At the other end is an idealised notion of "fine art" in public places, where the place is incidental to the product.

It seems to me that artists who work in response to the community, those who work *with* the community, and those who put their art into the community, are all basically public artists. The central purpose of public art is to *enhance* the lives of people and their environment. (*Enhance:* "to raise in value; to heighten; to intensify; to add to; to make more important; to improve" (Chambers English Dictionary, 1988.) Nobody can take public art home, put it up for auction or charge an entrance fee to see it. It is not *kept* in a place—it is part of a place.

What are the characteristics of good public art?

It belongs to the place in which it stands, and for which it was designed.

It is accountable to those who see it because it takes the art to the audience, rather than waiting for the audience to come to it.

It challenges the notion that the only valuable judgement of art is that of an educated minority.

It is a cultural asset, not a financial asset or a commodity.

Status

Ours is more a literary than a visual culture, and visual art has little status. Correspondingly, the status of public art is low. The status of public art is bound up with the status of artists. Making art is not considered to be a job, because art is not valued sufficiently and the product is not necessarily tradeable. Artists don't choose to be poor — they choose to be artists. Our society chooses not to pay them adequately.

Of the public art forms, mural art currently has the lowest status. Painted murals have the reputation of being "political" — and many of them are. Yet murals which are not overtly political are not "noticed", because they do not attract controversy or media attention. While it is acceptable for writing to be political, the same does not go for public art. Is this because anyone can see public art, but only educated people buy books — so politics in books is "safe"? Whatever the reason, it seems that potential sponsors and some commissioning agencies see mural art as "unsafe". As a consequence, mural art is undervalued.

To improve the status of public art in general, and mural art in particular, a change in policy is needed.

Policy

Arts policy is, by definition, political. Present government policy appears to be a belief that good art will survive magically, through a combination of natural selection and market forces. Public art has been squeezed by reductions in public funding, and is meant to rely increasingly on business sponsorship.

But sponsorship is not a real policy. Though it might supplement public funding, it cannot replace it. Business sponsorship cannot be co-ordinated nationally in the way that public funding can. Reliance on it would lead to serious regional imbalances in public art provision.

The Regional Arts Associations have no direct power over government policy, which filters through them, down to the artists. As public funding contracts, the Association's resources diminish, but their power over artists actually increases. Cuts in the annual funding of public art groups inhibit their long-term planning and threaten their very existence.

A more positive policy is needed to ensure continuity of planning and the preservation of skills. This policy should include a national *Percent for Art* scheme or a proper payment scheme for artists. Of these, a *Percent for Art* policy is more responsible, outward-looking and creative. Money is invested in the place, artists will be paid for their work, and the community will benefit.

A generation of artists is waiting for the opportunities which this policy would provide.

THE LAND OF THE BLAND — A VIEW FROM A REGIONAL ARTS ASSOCIATION

Hugh Adams

Public art offers artists and the communities they serve infinite possibilities. With their unique combination of imaginative, daring, craft skills and capacity for problem-solving (often — such is their conditioning — at remarkably low cost) artists operating in the sphere of public art constitute remarkable value in a large number of respects. But frequently they and their works are hostage to the public posturing of politicians, and worse, hostage to the terror of such politicians and the (almost invariably) destructive philistinism of the media in general and that of the press, especially the local press, in particular. We have few examples of a local press avoiding clichéd stories about public art and far fewer still of any recognising and proselytizing for initiatives in public art as a community investment. Given the general embarrassment which exists in this country at any notion of public figures coming out for art in any uncompromised way (we have an Arts Minister who may be privately totally in favour of a *Percentage for Art* in building programmes, but publicly he avoids saying as much), the recoil is natural, given the destructive attitude of the media; but also because he effectively is a "Minister for Culture" in a country which is almost unique in Europe not so much because the intrinsic value of culture is in question (which it is) but because, despite the plethora of "cultural" institutions and "industries", it is never even seriously debated. It is, as a result, difficult not to be despondent about the reality of the "art in public places" movement achieving the maturity and place in

our society that one would suppose its vintage and past success ought by now to have commanded. If it is such a good thing, just why is it taking so much time because, substantially, the basic arguments are won?

But amazingly the arguments are — after some twenty years of public art in this country — still the early arguments: the achievement of *Percent for Art* commitments and high-sounding public art policies in some places notwithstanding, the fight is not to refine the quality of public art but to secure its very existence. We have to beg and justify almost every project as if the last twenty years had not existed! It is by now traditional to compare the state of Art in Public Places in Britain with that in the USA and The Netherlands, the wealth of both countries being held in some mysterious way responsible for the prolific and informed commitment to art in public, while Britain's comparative poverty somehow explains the lack of widespread acceptance or engagement on the part of politicians, press and potential sponsors. That though, is no argument: we may be comparatively culturally impoverished, but not materially. It is how we choose to dispose of the wherewithal which we undoubtedly have that is at issue. Meanwhile the list of countries with solid achievements in this area grows quietly longer, while here, although actual projects may proliferate, their quality and the attitude towards them (with a few notable exceptions) does not advance.

In passing, one notes that it is not without irony that I was asked originally to write about my experience of public art gained as a result of a recent visit to Colombia in South America and known here principally, if at all, in connection with coffee and cocaine. The country enshrines a combination of all those elements which should contribute to cultural stasis — immense political instability, with a handsome diversity of guerilla activity; gross economic distortion caused by the drugs mafia; abundant political murders and kinappings. Yet, in a vast land seemingly having absolutely nothing going for it except the climate and topography of Eden, against all the odds, artists are treated well and the press and media — at both ends of the market — treat culture seriously, well and at length. In the two principal cities (with populations of nine and five million respectively) and I'm told in other towns too, despite a level of street violence which frequently makes New York's seem like playgroup squabbling, there is a commitment to public art in both private and public sectors which is both mature and impressive. In Medellin, Mafia HQ and second city of Colombia, there has been a *Percentage of Art* for many years, and the focal point of this huge city set in a vast bowl in the northern Andes is a much visited and extremely well sited sculpture park. All this has occurred without the self-conscious hi-jacking of art to act a social emollient which is so peculiarly the case in Britain.

Before proceeding to a more detailed discussion of particular projects in this country from the point of view of someone working in a

Regional Arts Association, it is perhaps as well to say something of some shifts of emphasis in public funding, for such changes often profoundly affect the outcome of projects in the sphere of the public art movement. When this was in its infancy, largely as a lever to prise money from local authorities, private developers or whatever, schemes were in existence both regionally and nationally which involved matching "pound for pound" money available from potential commissioners. These might be public authorities, private organisations, foundations, or a mixture. Largely this has ceased to be the case. The funds available in bodies such as ours for this area of work have not increased, either nationally or regionally, while the amount of activity has—to a very large extent. Various ingenious strategies have been employed in order to increase funding and almost every scheme the Southern Arts Association is involved in has an inter-dependent knot of funding partners. This often needs as much servicing as any other aspect of the project, which can fail or be retarded should a partner fall out or prove over-exigent in their demands. It usually works like this: I am approached by someone from an organisation, generally an enthusiast, someone who has had experience of public art or attended one of our conferences or seminars. If I'm convinced that the project has potential in terms of its being exemplary and there is a likelihood of our input securing sufficient other funding, I present an outline brief to my Advisory Group. More often than not we now put in sufficient funds to pay a short list of selected artists to develop finished proposals for a selection committee. Although this in itself may constitute a small proportion of the final budget we are able to contribute it at a crucial stage, often before money has been finalised as forthcoming from other partners. Of course, this is "risk money" and is sometimes lost if projects subsequently go wrong. But when they proceed successfully to completion we have the credit of not only attracting large amounts of matching funds but having been pivotal in enabling the project. This funding approach is in my opinion the best and we are at our best when asked for advice at the planning stage. We like to be involved when projects are at the discussion stage, when budgets for new building projects are formed. Then art doesn't get cut out if estimates come in over budget. Fred Emery Wallis, leader of Hampshire County Council, recently put an interesting point of view when I was proselytizing, probably crudely, for the adoption by the County of a *Percentage for Art* scheme. In his opinion it was not the best approach as it compounded the idea that the incorporation of art was an "extra": to be successful he thought that art and crafts should be budgeted as part of the total infrastructure of the project, for example, if a building, alongside lighting and drains and therefore an inextricable budget item. Fine Crafts is in a slightly better position to achieve this status than Fine Art. My colleague David Kay feels that the notion of presenting and promoting artists and craftspeople in the role of

102

contractors alongside conventional ones, where an integrated approach is possible to a whole new building, might be the most productive line to take.

At present, however, the ability to build up projects in partnership and to attract on an annual budget of approximately £30,000 a sum of between £$\frac{1}{4}$m and £$\frac{1}{2}$m within an eighteen month period has been a notable success for Southern Arts, but what is a considerable source of concern is the overall quality of such public artworks as have ensued. Obviously there is an in-built tendency towards aesthetic compromise and one cannot say that this is invariably bad, representing at least some form of democracy. However, one has to strongly question whether commissioning by committee, which is the norm for public art projects, will ever result in works of such excitement and aesthetic durability as those born of the relationship between the artist and an individual patron. The one incontrovertible statement that one can make about public art is that it is, above everything else, the province of compromise, and in the British case in particular, the realm of fudge, mudge and compromise. The potential is great for a truly inventive art: abroad, but rarely here, artists are given their head and generally function as problem-solvers, which is when they are usually at their best. The result is work not only of great imaginative daring but also of technical ingenuity. Here there is often the confusion between these factors and scale. Rarely do British artworks in the public domain satisfactorily come to terms with the latter and of course the sheer expense of large works is an inhibiting factor here.

But there are examples of elegant and comparatively low-cost solutions to the ubiquitous problem of mitigating the gross dehumanising spaces spawned by the imaginative bankruptcy of mediocre architects and planners. An excellent example of this is Chris Jennings' kinetic kite sculpture *Solentris* at Southampton General Hospital (*Fig 1*), the dispiriting architectural bleakness of which beggars belief and is almost beyond redemption. I got into hot water once for describing my first view of the buildings as a "cross between Dachau and Auschwitz on a bleak day". Of course it offends gentle sensibilities to suggest any link, even visual, between the death factories and a British hospital, but sensitivity is not too finely honed to be outraged that such bleak and shoddy edifices should be permitted in the first place.

Cost is not the crucial factor. Inventiveness or ingenuity is. In this particular case an artist has had to be wheeled in to "humanise" what the warped values of governments and the imaginative bankruptcy of health authorities and architects have wrought. A vast eight storey "lightwell", one of many (and which compound the spiritual meanness of the building), has been transformed through the addition of a kinetic sculpture in which a large space has been animated comparatively inexpensively. It ought not to have been necessary if architects were prepared to work with

1. Chris Jennings, *Solentris*, Southampton Hospital, 1986 (C Jennings)

artists in projects *ab initio* and, it has to be said, if artists were, on the whole, a little more flexible and business-like, then artists acting as bandages to cover up the cracks would be less necessary.

Solutions which succeed both as art and in environmental terms are rare because, apart from anything else, the timidity of commissioners and committees is against them. When artists are eventually allowed to do public art, pressures conspire that it should be low key and subordinate to, rather than dominating, its context. And this engenders the question, which it is becoming very important to decide, of whether it is sufficient to go on viewing public art simply as a process of siting/imposing individual artworks in an environment or whether we ought to be requiring greater attention to enmeshing art, in tandem with fine crafts, into the environment, whether rural, urban, interior, or whatever, in a more fundamental way. Just why is it, with all the cash, the proselytizing and the sheer volume of activity in the public art area, so little work has emerged of which one can honestly say that it is correct in scale and context, with good chances of survival in the aesthetic and also in the physical sense. It is impossible to even find artists in this country who are capable of engaging in large scale environmental and land regeneration projects, such as are common in the USA, yet there is an urgent need for them and large amounts of new "art money" to be picked up if artists can learn the skills of manipulating the elements of large spaces.

Over a year ago I asked a number of people, well placed to know, which of the huge quantity of artworks in hospitals (resulting from the substantial "Art in Hospitals" movements of recent years) they thought satisfying and successful in the above terms. The consensus was one or two pieces only. The situation has only improved slightly during the intervening period. Although accepting that "Art in Hospitals" is a slightly special case, one would expect a little more than this, and of course the pressure to compromise is a marked feature of this particular movement.

It sounds pompous to say but it is nevertheless true, that we are concerned in our public art provision with the quality of life. We accept that we are, in various circumstances, contributing to the provision of works differing in cultural weight and social and aesthetic relevance, but what is sad is the ease with which we can identify an almost universal common factor (apart from the inevitable cobbling, financial compromise and the lack of professional esteem of the artist!). This is the circumstances in which resulting work is viewed. It seems that, however immaculate the work, it is subsequently compromised in its immediate environment by insensitive maintenance, bad decor, signage, etc. Take as an example the painting of the corridor and waiting areas by Sarah Tisdall (*Figs 2 and 3*) or the Ray Smith laminates, also in Southampton General Hospital. Recently photographed more than three years after completion, they are still fighting against ghastly lighting, institutional furniture and grim sur-

2. Sarah Tisdall, Waiting Room, Southampton General Hospital

3. Sarah Tisdall, Intensive Care corridor, Southampton General Hospital

rounding paintwork. At least to the tutored eye the art might as well not be there as its very existence serves to compound the bleakness. Can anyone feel that it transcends its skirt of furniture?

In introducing these examples, I have two purposes in mind. The first is to indicate the importance of negotiating, not only the financing and siting of the work itself but also the circumstances of its subsequent display, and even after an appropriate time has elapsed, to establish a mechanism to review whether the work needs modification, replacement or removal. The second point follows naturally from this, which is that an Arts Association should work with its funding partners to ensure that the design and craftsmanship of what surrounds the art is of a similar quality to the art it wishes to support. Hardly anyone would fail to endorse the principle that if we desire the esteem of designers and architects and their support for a good quality art, so that they lobby *for* it, it is logical for us to support them.

However, logistics seems to dictate that we in the Visual Arts fight our aesthetic battles and they theirs. That the result is often an aesthetic blight which negates the purpose of the work seems to be regarded as beyond our ability to control, and seems accepted in Britain as inevitable: but it has implications beyond that. If I as the expert in a commissioning process, countenance an artwork in a room with gross chairs, bad lighting

and worse curtains, am I not working *against* colleagues concerned with fine craftsmanship in my own organisation, in a way that I would wish should not happen to me? Am I not also working against bodies like the Design Council and those many others articulating principles of good design? I think of the example of Simon Hornby who is Chairman of the Design Council and also of W. H. Smith. He knows that sensitive industrial design makes sense and he habitually employs fine artists and craftspeople in his shops and notably also on commissioned work for siting at his Headquarters at Swindon. What can he think of our sensitivity towards his design concerns when he sees us place fine art in contexts which are ergonomically and socially blighted? But that is just a room in a hospital. If we survey most of public art in Britain it remains bedevilled by failure in scale, failure to emancipate itself from the hideous English taste continuum and a failure on the part of most artists to be imaginative problem-solvers on anything like the scale on which they have been for many years in the United States and elsewhere.

As a corollary of fighting to support sound principles of what we could call "contextual design" I find myself constantly fighting to secure a decent professional deal for artists, and the sad thing is that we are frequently in conflict with those whose own professional interests are well protected, architects being a notable example. Excellent examples are the failure of professional partners in commissioning to recognise and not only to pay properly *for* but to negotiate in a professional way *with* artists. As an example of this I will cite a very local case — that of a swimming pool. It seems unlikely that a swimming pool could burn down but in Winchester one assuredly did. Belatedly in the building programme, but long before basic structural work was completed, an enthusiast suggested that the city might benefit from the research and development work that Southern Arts had been doing into the possibilities of British artists employing Portuguese-made tiles in public art projects here. In the course of visits to arrange exchanges of artists between England and Portugal it had occurred to me that the design of Portuguese tiles, the production of which is prolific and cheap, had become both in industrial and handcraft terms extremely debased. I saw an opportunity for British artists to give Portuguese tile design a shot in the arm, while producing low-cost, large-scale, durable and easily cleanable artworks for public spaces here. With financial help from the Gulbenkian Foundation, Southern Arts commissioned the artist Ray Smith to undertake a detailed study of possibilities. It is likely that we shall be doing far more of this kind of background enabling work, including marketing and information in future, rather than grant-aiding projects directly. The research indicated that in theory at least, there were enormous benefits to be gained from having large-scale artworks produced in Portugal. Even considering travelling costs for artists and transport costs for the finished product, it

4. & 5. Ray Smith, *Tile Mural*, River Park Recreation Centre, Winchester (P Carter)

108

still made financial sense. In order to test the system, some small-scale commissions were undertaken and I was actively seeking to effect two larger-scale commissions, one for a mural, the other for an environmental piece (which would ideally involve tiling a curved ceiling—the Portuguese excell at this, extending their decorative schemes into belvederes and domes). Through our contact, Winchester City Council, as builders of the re-designed Pool, were persuaded to make provision for a tile mural, about 80′ × 8′, along the poolside, below the raked seating of the spectators' gallery. Southern Arts' contribution was a lot of advice and information plus a £1,000 grant to enable the artist to present a number of finished design proposals, plus £1,000 towards completion. The total project cost, coming from the City Council and other sponsors, including Hampshire County, was approximately £11,500. This included the artist's fee, design and production costs in Portugal, transport and installation. It could hardly have been done more cheaply using kitchen tiles. The mural having been installed to everyone's apparent delight (*Figs 4 and 5*), I was shocked to discover that a second mural had appeared on a large wall behind and above and completely dominating the first. Crude, cliché ridden, badly executed and imaginatively bankrupt this was on a wall that everything in the building indicated should have been left blank (*Fig 6*). With the Ray Smith fish mural and the plethora of painted pipework below the roof, there was obviously enough visual stimulation. The author of the intrusion was none other than the architect, who with a group of helpers had added the second mural as an afterthought. The horror was compounded when I learned that someone had also drilled into the Portuguese ceramic tiles to fix holders for the poles to fish people from the water!

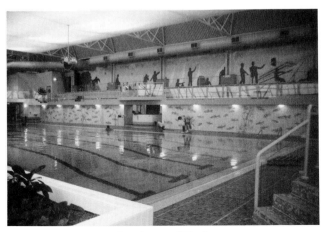

6. River Park Recreation Centre, Winchester

I use this tale to illustrate the extent of our involvement in background research but also to indicate that architects are by no means invariably the best friends of public art. It is all the more remarkable that this kind of gross interference with another's work is done by the member of a profession which guards its own prerogatives so jealously. Of course, in the interests of balance we must nod in the direction of those architects who do more than pay lip-service to including art in from the beginning. Nowhere has this been done more successfully than in another project in my own region, where Richard Burton (an exceptional architect and now the Chair of the national *Percentage for Art* Steering Group) has from the very beginning of the project for a new, low-energy-consumption hospital on the Isle of Wight, with the help of Southern Arts, the Gulbenkian Foundation and the Department of Health, been developing the notion of the hospital as an art centre for the Island. As a result of Peter Coles' study *The Arts in a Health District*, commissioned by the above partnership, artists and craftspeople have been working on a scheme involving a combination of integrated design for utilitarian purposes and discrete artworks for more traditional contemplation. The second stage of the Portuguese tile project is one element in this. The main stairway and lift entrances will be treated as an entity according to a design *The Tree of Life* by Ray Smith. It will be executed by him with two apprentices funded by Southern Arts and the Gulbenkian Foundation, thus ensuring not only an exciting artwork but also a diffusion of skills.

Finally, even if this essay ends on a bleak note, to return to the swimming pool. The moral of this story is that organisations such as my own, as much as the artists themselves, need to emancipate ourselves from pressures to participate in fragile, informal arrangements for the sake of getting exemplary projects off the ground. In this case there was no contract and no articulation of artists' rights. This was just about satisfactory when the art in public places movement was in its infancy but now we need to professionalise ourselves, which means money up front and contracts, so that the artist is never the only one in a scheme out of pocket. In a hard-nosed, increasingly commercial world, I feel we've made the case for art in public places as a good investment for public and private sectors. Now it's time for both to start budgeting and paying properly for it. Organisations such as mine have only the resources to act as the enabling organisation in terms of advisory and information systems and perhaps helping to fund feasibility research. Without a vast tranche of new money the sheer volume of demand makes any other response tokenistic and arbitrary.

SOME MURAL PROJECTS

Amal Ghosh

Mural art has usually taken the role of story telling. The ancient church windows in Europe, the cave temples of Ajanta in India and elsewhere, told in story form the religious imperatives of their culture.

In Europe most murals traditionally were done by the male members of the community. In Southern Africa, the women of the Ndebele tribe have produced a wall art for centuries, of remarkable richness and vitality. The Warlis of Thane District, North of Bombay, India, paint with rice flour on mud walls. Only women are allowed to paint these beautiful intricate symbolic paintings on the wall. The function of these paintings are to keep evil out and also to make the living space beautiful. It is in this spirit that painting on walls becomes a living art.

The story of a young man, told in Barnett's book on Community Murals, who stood for a long time gazing at the portraits of the leaders and artists of black people on the Wall of Respect in Chicago, when asked what he was doing, replied "I am getting energy". This sums up the potential achievement of wall painting.

In one of my own recent vitrious enamel murals for Charing Cross Hospital (*Figs 1 and 2*), elderly people's ward, I was given the brief to recreate the life and environment of local people. Nurses, doctors, consultants and, most importantly the people themselves determined the content of the mural. Their need to connect to the past became the main source of the design. Researching the theme, I came to know intimately many landmarks and past incidents; even the local football team took a central role. It gave me an insight and empathy with the people in the ward and their community. Affinity with the community should be one of the main sources of inspiration for community murals. This does not exclude social realism, or trees and flowers, but demands a dialogue and consultative process which results in not a compromise, but a sense of

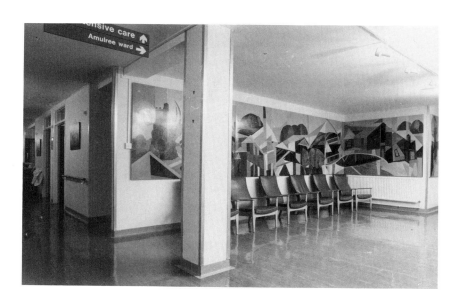

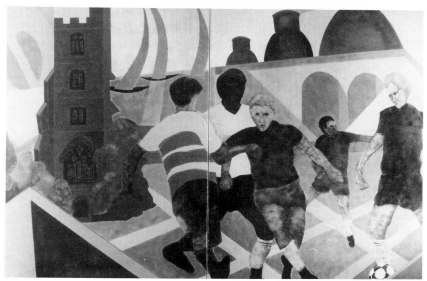

1. & 2. Charing Cross Hospital,
London. Vitreous Enamel Panels, 1987
(A Ghosh)

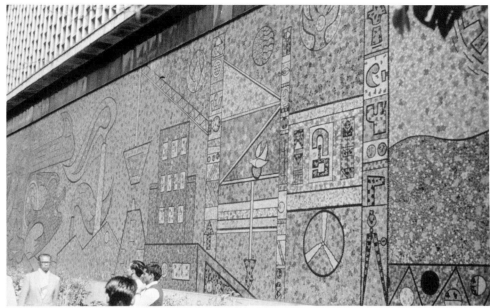

3. United Commercial Bank, Calcutta, detail of mosaic painted cement tiger, children's park, West Bengal, 1982 (A Ghosh)

genuine satisfaction for both the artists and the members of the local community.

My mosaic mural for the Commercial Bank of India in Calcutta (*Fig 3*), in contrast, was a very detached and intellectual exercise. I was selected in an open competition for the project. The architects were still designing. As it was the head office of a bank a proclamation of power and authority had to be projected. The architects and I jointly chose black marble for the facade and for my mosaic mural I selected matt tesserae, to contrast and complement the glossy marble of the facade. The design was based on symbols and was created with the unifying idea of the bank's link with industry and commerce. I used extensive shapes and symbols related to commerce and agriculture from the ancient world, and abstracted them to develop the design.

Fernand Léger's dictum of 1951 was in the forefront of my mind: "An abstract art must adapt itself to walls, a monumental art is that which anticipates walls."; and again: "I have scattered my objects in space and I have so arranged it that they all balance each other, making them stand out against the surface of the canvas. It is a play of harmonies and rhythms based on background colours and surface lines, distance and contrasts".

Léger described the mural as "Art on public display". Léger, to me, has been a source of continuous inspiration.

Further, two very different commissions will illustrate the range of expertise needed in dealing with clients and mural space. During 1979/1980 I was asked by the then Lord Chancellor, Lord Elwyn Jones, to design and execute twenty two stained glass panels for the stateroom in the Palace of Westminster. The designs were based on the heraldic shields of twenty two previous Lords Chancellor. A group of my students participated in this exciting project. The timescale went completely haywire. Extensive research by the House of Lords Library unearthed far in excess of twenty two ex Lords Chancellor. I will not go into detail about the fascinating debate which followed and the exclusion of some very colourful and notorious ex Lords Chancellor. To maintain the momentum over this length of time was difficult, as was working with a diverse group of students, and of maintaining the very high standard of craftsmanship that surrounded the work. I was aware of a very different kind of responsibility, that of having a public commission which touches and becomes a part of history. A project like this is best executed in a team. The dynamics and vitality of the work needed the interaction of committed people. We made a point of discussing each work collectively and consequently the end result was harmonious and unifying.

In 1982 I was commissioned to make a door and architrave in vitreous enamel for Manchester Cathedral. The room within the cathedral was sparsely furnished. A single large window lit the room. A very understanding architect and the Dean of the Cathedral left me to a design task which had to deal with the tranquillity of the room and subtle sacramental symbols. I worked on two experimental panels to judge the quality of the light on different colours, and their influence on the environmental quality of the room, which was a place of prayer and worship. Finally, I came on a solution of pastel colours and pale gold. The gilding had to be specially formulated to obtain the correct colour. The subtle colours with primrose gold rung the right note and the door, with its architrave, became an integral part of the space in the room. The commission was adequately funded, consequently, I could concentrate on design and experiment with ideas. After extensive research on an idea, the resulting design acquired a strength which matched the expectations and aspirations of the client and myself.

I also believe that the function of the mural painter must surely be to challenge the accepted norms of gallery art, and to reshape the social environment. Art, for a very long time, has been an accepted domain of the privileged. The function of art used to be for the service of the community and the artist was very much a part of that community. In recent years, art critics and art dealers have become more important than the artist. The vast art market, with its inbuilt system of promoting artists as a

commodity, can only be effectively challenged if and when artists stop relying on the commercial art market, and develop an art form more integrated into the needs and aspirations of local communities. Then mural painting will not be an isolated activity of the limited few.

Historically the division between the architect and artist has always existed. But because the spirit of community belonged to both there was a common meeting ground. Eventually, however, the division of labour became so rigid that consultation between architects and artists mostly consisted of commissioning artists, without giving them any say in the structure or space they were expected to work with. It is rare in this country for artists and architects to co-operate on the concept of the whole building. And in the few instances where this has happened it is so sudden that the continuity needed to design for the modern technological building does not exist, and consequently the resulting art is frequently tame and non-committal. Looking at recent buildings by Sterling, Rogers and Foster, where exciting technology is integrated with new departures in design, one is apprehensive about what kind of art can really function in such a context. According to Vitruvius, the three classical conditions of good building are commodity, firmness and delight. The third condition "Delight" has come to have a very limited vocabulary in modern architecture, with neglect of the potential use of colour and design that could be incorporated with integral mural art.

In the few instances where collaboration between artist and architect has worked, the artist ceased to be a decorator and becomes, alongside the architect, a joint manipulator of architectural space. Up to now, the predominant emphasis has been given to painted murals for interior or exterior wall space. Most mural artists have worked on existing walls of past architecture. But the continuous use of old building space for murals has created a false notion of tradition. It has, for the mural artist, narrowed the scope and motivation to experiment and explore the new possibilities of incorporating art within the new architecture. I believe that the artist should work towards an affinity with the new technology in architecture. Here the wall space has to co-exist and share with new materials and shapes, and the artist has to undergo a change of attitude. A multi-disciplinary and versatile mural artist has more chance of success with this new breed of architectural development.

Chapter Eleven

THE ISLINGTON SCHOOLS ENVIRONMENT PROJECT

David Stone

I would like to explore links between art and the school environment in relation to the arts team of which I am the director, known as the Islington Schools Environment Project. The team had its origins in the work of a small group of tutors and students from St Martins School of Art in the eary 1970s. This group carried out a number of small schemes in schools, where they produced wall and floor murals and play-sculpture based on their observations of the children's activities and games. The children responded to their new playground with great enthusiasm. They produced a number of lively paintings, which re-interpreted the murals in an imaginative way. These paintings were an indication that changes in their environment made a strong impact on the children.

The next obvious development was to involve the children in the collaboration, in a spirit of mutual appreciation, throughout the planning and making process. This led to a two-and-a-half year scheme at Laycock Primary School, where, like a number of other artists and groups, we began to operate as artists in a facilitator mode.[1] This work resulted in the creation of a clear, commonly shared purpose — to improve the social and physical environment of the children. This became an objective which could unite various professional and voluntary groups, directly and indirectly involved with the children's welfare. The combination of educational, social and environmental purposes created the possibility of a broad funding base, which could be used to create a small organisation.

Currently, the Project has a staff of four: myself, Patrick Allan, John Bremner and Amanda Ryan. We are all qualified teachers and are employed full time by the Inner London Education Authority. We have a part time consultant landscape architect, Edwin Knighton and an Artist/ Blacksmith, Tim Ward, with a part time assistant, Lesley Jeapes, all of whom are self-employed and paid through funds raised from trusts and the Inner City Partnership (Department of the Environment). The majority of the Project's overheads are met by the ILEA, but Project members assist Islington schools to fund-raise for the material costs of their schemes. The Project "turns over" more than £100,000 per annum.

The purposes which can be identified as social are most apparent in the organisation of each scheme. Schools are encouraged to organise a committee, which will be a consultation and decision-making body. The committee will consist of a child representative from each class in the school, playground assistants, teachers and parents. Although superficially the transformation of the playground is the object, the long term success of the scheme as an "ongoing" environmental process will be dependent upon the continual involvement of the users. Our role is initially to act as a catalyst and then support local initiative. In an important way, this changes the hierarchical structure of the school and promotes equality through representation.

Another important responsibility we have is to communicate the decisions and proposals passed by the school committee to the appropriate departments in the Local Education Authority, taking into consideration any building regulations and matters relating to Health and Safety.

Our first working contact with staff and pupils is to carry out an extensive and in-depth survey of the environment of the school, both in terms of its physical character and the games and social behaviour of the children. It is hoped that through the creation of a stimulating playspace, the children will benefit through improved relationships and behaviour, resulting in a decline in negative behaviour such as racism and other forms of victimisation. The children are involved in a wide range of educational activities through their involvement with the survey. These may include plan drawing, simple surveying and scale model making, photography, mathematics, chart making, diary writing, discussion and analysis. This work will form the basis for an exhibition within the school. The information may lead to class discussions on matters such as territorial conflicts, racial or gender tensions or unconscious inequality of existing facilities and space. The classroom teacher will play a key role in this work.

It is important that the committee consider the whole playground, so that the relative importance of social factors and aesthetics and funding are weighed up, in order to create an action plan which is relevant to the

needs of the children.

The environmental purposes of the Project stem from the notion that, for most of us, the environment is an impenetrable, unchangeable entity, which is not only external in existential terms, but also in the way it is constructed and contrived. Alienation is a common experience and there is little opportunity to be involved in the complexities of the planning and design. It has always been a priority for me that the work that I do within the Project contributes to the regeneration of the inner city and in particular the provision of safe and stimulating play environments for children.

In comparison to the scale of much of the building work which is going on in many of our cities, our schemes are modest. However, the scale of the scheme is secondary in importance to the experience of change which occurs during the process and eventually becomes part of local mythology. Through a process of design and making, the children are involved in transforming their relationship with their immediate surroundings, which, up to that point, had probably been one of unquestioning acceptance. In this way, the work has become a potent local symbol of transformation.

As human beings, we need to have the control and opportunity to express ourselves within an environmental context. The evidence of this need to shape and control is reflected in the mass of gardening which occurs in private dwellings, from window boxes to communal gardens. There are also individuals who have gone far beyond a simple communing with "nature" and have elevated themselves and realised private fantasies amassed from "objets trouvé", carefully arranged and painted. The efforts of these individuals are largely unrecognised and derided and may not constitute Great Art. However, this and other work which could be described as fantastic architecture, the most well known example being Simon Rodias' *Watts Towers*, inspired our first collaboration with an architect. Our purpose was to create a garden which would have a special character and "sense of place". Through a combination of architectural form, sculptural elements, and planting, we hoped to stimulate the children's imaginative play at the same time as providing a garden for the school to use in a conventional manner.

In the production of the *Moon Garden* (so named by the children) at William Tyndale School (*Fig 1*), Angus Brown, supported by the Cement Research Department at Central London Polytechnic, supplied the technical experience to produce the architectural forms which give the garden its overall character.

The forms were produced by placing children's balloons filled with water into a mould filled with light-weight foamed cement. The balloons being the heavier, sank. When the cement had dried and the mould was opened, the balloons were popped, leaving a cellular organic interior to

118

1. *Moon Garden*, William Tyndale
School (ISEP)

the wedge-shaped forms. Larger structures were made by the same process, but with larger balloons, made for the purpose. Ferro-cement was applied to the "roof" of the forms to create small domes. The garden consists of a series of these structures, which form retaining walls, with children's sculpture and planting in between. We acted as technicians in the production of the architectural forms and in general saw the project through from beginning to end, which took about eighteen months. Probably the most unique element of our contribution as artists was that we assisted the school community to imagine what the final garden might look like, through audio-slide events and detailed models, displays and workshops.

An inevitable drawback of an environmental improvement scheme is the constraints imposed on the artist by complications of funding. Very often the desire to create a complete and coherent scheme is frustrated by inadequate financial resources.

A scheme born out of such difficulties was the Penton Primary School *Lizard Maze* (*Fig 2*). The project began with a member of the team working at the school for two days a week for one academic year. The school playground was large, exposed and had roads on three sides. Through her surveys, she found that there was a general feeling on behalf of the staff and the children that the playground would be improved if it were less exposed to the general noise and distraction of the traffic. She also began to research themes for the playground with the children. Out of this work came the idea of a maze which seemed a particularly relevant

119

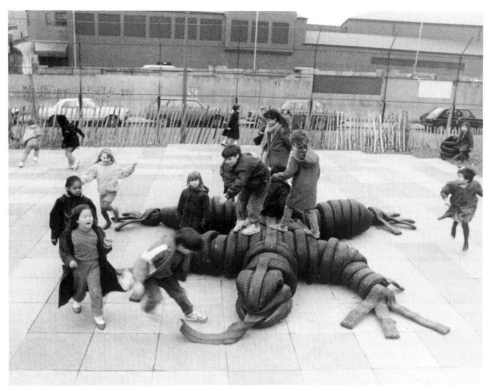

2. Centre of *Lizard Maze*, Penton Primary School (ISEP)

theme, as the school needed to be more enclosed. The area chosen for this scheme was in dire need of development. It consisted of a large area of hard ground, which was once grass and an extremely dangerous steel climbing frame with protruding concrete footings. The project had a number of false starts, which frustrated the school community as we did not have the expertise within the group, at that time, to deal with the landscaping aspect of the scheme. This situation was resolved through the assistance of Community Land and Workspace Services, who are a group of Community Architects. Through a preliminary thirty hours, which is a free service to voluntary groups, we managed to come up with a plan which satisfied the requirements of a difficult site and a modest budget.

The proposal incorporated a large paving slabbed area, in two tones of grey and laid in the form of a maze, which was taken from a child's design. Surrounding the maze are a number of decorative plywood panels, designed by the children, a large climbing structure and extensive

120

planted areas of shrubs and young trees. The lizard provides a central feature to the maze and along with the other six lizard heads at the entrances, gives the maze a unique character. The lizard is constructed from cut and riveted car tyres and represents a technical peak in a long history of using this cheap and readily available material. The lizard was chosen as a theme because of its textural compatibility with the tyres'and its immediate appeal as a play object. It also functions as a minotaur substitute within the maze.

The educational purposes of the Islington Schools Environment Project have over the years been developed to compliment those of teachers in schools. There is a major thrust in the teaching of art towards working from direct experience and encouraging pupils to work on self-determined assignments. It is very common for schools to use the environment as a resource for social, geographic and visual studies. The work that we do with the children can be classified into two modes, individual and group response. The individual response is characterised by an exploration of private thoughts and feelings resulting from an experience of a place. An example of this would be for the children to make a list of responses, including associations resulting from their feelings about the place. Then they make a preferred list of thoughts and feelings which could result if the place were transformed. This will provide a departure point for design work and form the criteria against which the group will evaluate their proposals.

The second mode is the group response, which is characterised by group discussion and relies upon and develops the children's interpersonal skills. The objective is to achieve a concensus of agreement for a theme and a process which will lead to a collective art work.

The schemes also bring together a broad range of educational activities. For example, in a project to make a gate for Robert Blair School, with Tim Ward, who is a sculptor with a history of blacksmithing, we had to relate to the classroom teacher's theme of "time", which was on-going throughout the year, and yet give a strong visual stimulus for design work. We decided to base the project on a series of visits to a small local wood in the heart of Islington and work from a collection of items found on the ground. These included a large number of leaves of various varieties, lichen, fungus, twigs, snails, and a toad (which was returned unharmed). Over a six month period, working one morning a week with a rotating group of twelve pupils, I worked through a series of simple print making processes, with the aim of bringing the children's attention to the variety of forms present in different species of leaves. We also had a trip to the theatre to see the Whirligig Theatre's production *The See Saw Tree*, on the theme of conservation, which stimulated much thought and discussion with the children.

As the printing progressed, the children began to work in small

groups with the printed leaves and began to try out various arrangements in the form of a gate. Left to their own devices, the children tended to produce symmetrical designs, which had an immediate appeal, but tended to plagiarise traditional ironwork and lacked the richness of the original experience. At this point, we decided to change to a new medium, clay, and concentrate more on the actual sensation of being in the wood. Amanda Ryan and myself worked with the children on a clay re-invention of the floor of the wood, using the children's lino blocks to press into the clay. Then Tim Ward and I produced a wrought iron gate based on this design. The children had a viewing hatch open to the playground. The gate, the product of this process represents a piece of organic Islington transposed through the children's experience to another context and another material. The design and making was an event which provided a broad range of experiences in environmental and art education.

In the process of the work I have described, it has been necessary to collaborate with specialists and perform roles which go far beyond the conventional parameters and definitions of "art". The Project developed as a response to a stark and polarised period of Art History on the tail end of Modernism. It has been an attempt to draw together elements of Art, Education and the Environment.

ENVIRONMENTAL ART

"I have a normal relationship with railings" [1]

Not all public art is spectacular or consists in major works on prominent sites. Art can also be a series of low-key interventions within wider projects for urban renewal. It is a case of integrating the visual awareness of artists with the work of planners and engineers, in a cared-for environment. This may include some commissioning of work to focus identity, and a range of small-scale solutions to problems of urban design.

Environmental art has been successful in the economic regeneration of the Blackness district of Dundee. It has played a similar role in the refurbishment of Smethwick High Street. Additionally, art has utilised temporary sites of dereliction to turn wastegrounds into arenas for creative activity. Whether at the level of a whole district, a street, or vacant lot, the aim is to give a sense of environmental well-being.

Art has been part of redevelopment in the USA as well as in Britain. In both countries, blanket clearance of old buildings is no longer favoured, and rehabilitation is both cheaper and more sympathetic to the social fabric. The lessons of mass redistribution of a population, and the consequent desertion of inner cities after dark, have been learned expensively, and mainly in human misery.

Sacramento, California, in 1979, through its Housing and Redevelopment Agency, integrated art with urban renewal. This model was followed by Los Angeles Community Redevelopment Agency in 1985. In both cases, the City may take a developer's attitude to the integration of art in a project as one criterion in selection. Since the Los Angeles policy was enacted, about twenty projects have been undertaken, using a *Percent* funding base.

In Britain, some initiative has been taken by the Department of the Environment in restoring and conserving sites, and transforming urban wasteland, though art has been only a marginal aspect. A number of

123

publications show a policy commitment, and demonstrate good practice through case studies.[2]

Despite some notable successes, central government in Britain seems oblivious to the contributions made by artists. In a report on *Improving Urban Areas*, issued in 1988,[3] the Department of the Environment gives Smethwick High Street, Sandwell, as an example of good practice. It lists the contributing elements as: the involvement of local interests, a sense of priorities, systematic identification of the area, a link with other development plans, clear focus and functional improvements. It mentions, in passing, as a "special feature", one of the key aspects of the project; the collaboration between Sandwell's architects department and the Town Artist, Francis Gomila. Yet without the artist's work the scheme would have remained ordinary, and a large part of the community involvement would have been absent. Out of about thirty paragraphs of description, the artist is given only one. No doubt the expenditure was of the same order (artists are cheaply hired in Britain), though the impact of murals and sculpture is one of the most immediate facts of the place.

The scheme was undertaken through 1987 – 88, and included the refurbishment of 21 shops, through grant funding. Sandwell Metropolitan Borough Council was awarded a commendation by the Royal Town Planning Institute for the project. Its origin was in the disastrous urban policies of the previous era, when one side of the High Street was torn down to make room for a new road. The area became predictably run down. Improving the economic viability of the street and surrounding area was linked to making a more attractive environment, not just to replacing roof tiles and drains, or making car parks. British Rail repainted a footbridge and station. The Old Toll House has been refurbished as an architectural monument (housing the artist's studio), and 80,000 shrubs have been planted to screen the road. The barrier also includes paving and seating, though the air will hardly be free of exhaust fumes.

Although it is shutting the door after the planners have bolted, the scheme is successful, and the vacancy rate of shops is now very low. Specialist Asian shops are doing well, and serve the local population in which many are less mobile and for whom the glamour of shopping precincts is not alluring. The murals and mosaics give the street a particular identity, itself an attraction.

Sandwell Council appreciate the role of art in the programme. Their publicity material describes the project as a "unique combination of Art and Urban renewal". Gomila, appointed Town Artist in 1985, was involved from the design stage, in an "integral" role. The murals are not cosmetic attempts to make the street brighter; they are the vehicle for community engagement, and they reflect that community in their design.

The shopkeepers were given a choice as to colour and design. The artist, through negotiation, channelled the expression of choice into a unified plan, allowing individuality and difference, but also the sense of a whole facade. He writes:

"to allow people to choose between two colours is one kind of choice. But to allow people to choose any colour is quite different. People need time to adjust and react to this, requiring different examples to assess and evaluate. . . . Some took an active part in projecting their image and pride in their trade, other contributed by suggesting actual designs, whilst some were quite happy to accept the majority decision."[4]

The result is a series of very colourful decorative panels, each with a different design. Some reflect the ethnic tradition of the shopkeepers, for example through enlarged stencil designs used for henna decoration (*Fig 1*), and the type of retailing. There is also a *Tree of Life* mural in coloured brick integrated into a gable end. At ground level there are mosaics in similarly colourful patterns. On a nearby site, Francis Gomila installed a sculpture of dancing figures, a celebration of mutual effort and reward (*Fig 2*).

Smethwick shows what can be done. It is a success in both economic and aesthetic terms. It is not the only example. In Dundee, the Blackness area was semi-derelict by the late 1970s. Unscrupulous planning and an unexplained fervency for demolition left whole areas devastated, and created a plethora of car parks. There had been a few murals during the 1970s, following the lead of community artists in Glasgow. Bob McGilvray, for example, painted two gable-end jungle scenes titled *Intro* and *Outro*. Neither survived the addiction for demolition.

1. Francis Gomila, refurbishment of Smethwick High Street shop front, 1987 (F Gomila)

125

2. Francis Gomila, *Waiting for Haley's Comet*, Smethwick, 1987 (F Gomila)

In 1981, a new initiative was launched jointly by the Scottish Development Agency, the City of Dundee, and Tayside Regional Council. The twin aims were environmental improvement and economic growth. It was assumed that the two were linked, that an area undergoing rehabilitation, and becoming visually more attractive, would be more likely to attract new industry. The long term aim was that economic growth would become self-sustaining, once public funding had covered essential improvements to begin the process. The plan was to seed-fund an environmental transformation, in the hope that, at a certain point, enough momentum would be generated that the area became a growth point, itself able to bring in new business.

A survey took the views of local businesses, eight out of ten of whom responded. A number of companies directed attention to the lack of confidence engendered by poor surroundings. Visitors, customers and the workforce felt the area to be a remnant of former industry (with employment declining by 15 percent over the five years to 1980 and a decrease of one third in the number of manufacturing firms in that time) rather than site of present or future prosperity. Some incentive had already been given by improvements begun in 1980, suggesting further potential.

The environmental work itself created new employment, including about eighty jobs each year through the Manpower Services Commission. It also showed that someone cared about Blackness. Although in retrospect there might seem a lot of car parks in the area, their reconstruction was carried out by MSC teams using well chosen materials, frequently brick paving in two colours. Walls were sympathetically designed, and a long wood fence on Lochee Road was painted with abstract designs by Peter Flynn, and seating provided at intervals. Such work is not art in the sense of pictures and sculptures, but does involve an aesthetic sensibility.

The differential in cost between a wall or a fence which is carefully designed and made of discerningly chosen materials and one which is

126

'standard issue' is minimal, and out of all proportion to the benefits gained. These are simply that an area has a degree of individuality, and that consideration is evidently given to the place. It is factors like this which induce confidence.

Over a million pounds had been spent by the SDA and local authorities when the major scheme was launched in October 1981. This covered basic improvements and car parks. The new initiative went further, looking to a complete transformation of the area designated as the Blackness Business Development Area. The stated aims were to:

"safeguard and expand job opportunities;
improve the operation of the area and the firms within it;
create business confidence;
encourage private investment."[5]

Eight million pounds was allocated for the scheme, most of it related to economic needs and refurbishment of industrial property. There was a promotional campaign, a review of services such as waste disposal, and a register of available properties for development. Within this context the place of art was central, if low-budget. At the same time, a mural in St Peter Street, by the Artists' Collective, was used as the frontispiece for one of the programme's publicity brochures.

This brochure stated:

"The merging of the skills of tradesmen and artists has produced many interesting and novel designs and provided focal points throughout the area. . . . The standard of workmanship has been extremely high and the attention to detail extraordinary. The establishment of the Public Arts Programme was an innovation as it encouraged artists to participate in the overall design process and produce designs integrated into the total environmental improvement."[6]

The involvement of artists clearly enabled a more intense and serious approach, and one in which old craft skills were reclaimed. The early integration of art into urban design avoided cosmetic solutions.

Within the overall redevelopment, a Blackness Environmental Arts Team (BEAT) was formed in March 1982, with five full-time artists employed by the MSC. Funding was from the SDA, with sponsorship from the City Museum. The team were committed to a group approach, overturning romantic notions of artists as Bohemian individualists. They worked closely with local communities, and established the value of an aesthetic approach to the urban environment. Schemes were formulated through negotiation, between the artists and the City authorities. Feedback was encouraged through distributing questionnaires and holding discussions and workshops with local residents.

The aims were threefold: to help artists learn new ways of working within such a co-operative framework; to improve the quality of the environment, and to involve local people. In the process of achieving these, the artists gained experience of the processes of planning and building by the City Council.

Early projects included three tile mosaics at the entrances of blocks of flats (*Fig 3*). The blocks were a legacy of 1960s urban blight, faced with grey pebbledash, and unusually grim. The entrances were small slits, dark and secretive. The mosaics, using images such as birds and flowers, in bright colours, gave each block a different identity, and drew attention to the entrance. At the same time, new planting and fences improved the surrounding areas.

One of the team was designated a community liaison worker, to inform residents of proposals and seek suggestions and opinions. Such feedback was taken by BEAT to planning meetings. Whilst local authorities are sometimes inept at gathering public opinion, or hamstrung by local politics, artists have certain advantages as free agents. They may be able to make a more direct contact, without representing the body which is also seen as rent collector and tax gatherer. They are able to spend more time in conversation, and hold informal workshops where practical skills can be shared and critical views allowed to surface without contrivance. Several such workshops were held at weekends, and local children were involved in the design stage of play areas and mosaics.

Just as in Easterhouse, where the skills and commitment of a team of artists gradually won over the community, so in Blackness. Again, as in Easterhouse, art played a role in encouraging private firms to take initiatives. The total art budget within the Blackness programme was around £30,000 per year, a very small sum in the broader context, but this resulted in such high quality of design and implementation that it gained three Saltire Awards or Commendations.

One of the most integrated projects in the Blackness programme was at the upper end of Lochee Road, where a vacant area left by demolition was turned into a series of play and seating areas, with two brick murals on gable ends (*Fig 4*). Local children contributed mosaics (*Fig 5*) within the labyrinth of walls that articulate the space into different areas for different purposes, making the site appear larger as one walks through it. The brick murals (also nominated for a Saltire Award) were more expensive than painted murals, but of far greater durability. The brick finish is practical as well as aesthetic. The designs are simple, using three colours (the same technique as, later, in Smethwick High Street) and low relief. The colours have a particular resonance with the light in Dundee, a silvery light reflected off the Tay and enhanced by the predominant use of granite in older buildings, such as tenements and mills.

Other interesting commissions include a series of four ceramic

3. Blackness Environmental Arts Team,
Tile mosaic at entrance to flats,
Blackness, Dundee (M Miles)

4. Blackness Project: brick mural and
play area, 1986 – 87 (M Miles)

5. Blackness Project: brick mural and play area: children's mosaic, 1986 – 87
(M Miles)

6. Stanley Bonnar, Refurbished public lavatory, West Port, Dundee, 1987
(M Miles)

reliefs by Keith Donnelly (a Saltire Award winner) showing stylised
naked figures, in Bellfield Street, and the rebuilding of a public lavatory at
West Port by Stanley Bonnar (*Fig 6*). Whilst before it served the needs
only of men, now there are entrances and facilities for women too. The
centrepiece is a pyramid with softly coloured surfaces and designs,
flanked by ironwork, imaginatively reminiscent of the entrances to Paris
Metro stations. Alastair Smart's *Whales' Teeth* sculpture at Polepark
recalls local folklore and history, inscribed on three giant teeth.

There has been very little vandalism in Blackness, which cannot be
entirely attributed to a law-abiding population. Some of the credit can be
claimed by the work of artists and craftspeople. The combination of street
furniture, small scale sculptures and general aesthetic improvements,
within the broader rehabilitation and economic support of Blackness, has
given the local community the feeling that their place matters, and that
they have an identifiable territory, a place with a specific character. The
economic success has been real, with an influx of new employment as well
as improved housing and facilities.

The success of the Blackness Project persuaded the local authority
and SDA to commission a report on the potential for a City-wide plan of

130

aesthetic works. The feasibility study was carried out by Bob McGilvray, co-ordinator of the Blackness Public Art Programme, and his brief was to identify sites for further commissioning, generally demonstrating the potential for public art in Dundee.

The general principles of the report included improving the image of the City for visitors and companies, and building a strong working relationship between artists, the community, and the City authorities.

The Specific aims were:

"Improvement of the environment for the residential and industrial communities . . . an atmosphere of optimism for visitors to the City; To highlight the heritage of the City and increase public awareness of the City's own identity; To establish visual symbols of regeneration; To foster, promote and maintain our artistic heritage."[7]

The City has begun to think of a tourist potential, and a new hotel has been built on the waterfront, unfortunately of a stunningly bad design. Captain Scott's ship *Discovery* (built in Dundee in 1901) is an attraction in the waterside area earmarked as a tourist development, and the areas of dereliction are slowly diminishing.

Housing developments are part of the City's improvement, in one case converting an old jute mill, Upper Dens Works, into flats for single people and childless couples, those who are at the bottom of housing waiting lists. The mill itself was a sturdy granite building, of minor architectural interest but with panoramic views over the City and the Tay. Outside, a series of stone walls and terraces, and a bandstand, enhance a slope to the top of the hill; inside a number of artworks were commissioned from students graduating from Dundee's MA Course in Public Art. These included a perspex window designed from symbols of the City's heritage, a ceramic mural based on the patterns of old watercourses at the site, and a sculpture based on the game of chess.

In another housing scheme nearby, at Hillcrest, two groups of students made mosaics in exterior landscaped spaces. The presence of a specialist course in public art has enabled graduates to work in the carefully managed Dundee Public Art Programme, bringing to it newly developed skills.

The feasibility study highlighted nine other possible sites, such as the approach to the mainline station, gateways to the City, and the new High Technology Park, in which a sculpture has since been commissioned. The main City Square was also researched. The example of Portland, Oregon was given as a square brought to life by sculptures, imaginative street furniture and landscaping. As a result of the report, a number of works and projects have been commissioned in the central area of Dundee.

The lesson of Dundee, and the Blackness Project, which took about

five years to complete, is that artists can work as part of a team. They can collaborate with a local authority's architects, designers, planners and landscape architects. When they do so, the whole feeling of an area can be transformed, and it is often the subjective response of a visitor, customer or potential investor which is significant for future growth.

Two recent developments may point a way ahead (one of many in what may be a pluralist approach): Doncaster has appointed an artist to work in its planning office for two years; and Wakefield has appointed an environmental artist. Public Arts, the commissions agency for West Yorkshire, was instrumental in arranging both placements. The environmental artist is attached to their office, and working on sculptural transformations of industrial eyesores.

The spaces open to environmental art range from large areas to single lots made vacant by demolition. The Forest of Lothian may soon see one of the most extensive projects, involving collaboration with the Forestry Commission and British Coal, co-ordinated through the agency Art in Partnership, based in Edinburgh.

In contrast, a project in Glasgow is based on one vacant lot. Fifteen sculptors worked on site, in 1988, using sixty tons of sandstone left after demolition. This project, at College Lands, was sponsored by Miller Homes, who are building flats on the site, and resulted in twenty-two sculptures. Many of these will be re-sited permanently in the new development or elsewhere in Glasgow. The styles range from traditional monumental to abstract. Local publicity was favourable, in a city which has adopted the principle of a *Percent for Art*, with headlines such "City sculptors shape up well".[8] Acceptance by local people may have been related to their seeing at first hand the skills and energy of the artists. Kate Thomson, the project co-ordinator said:

> "I think a lot of people have realised just how much work is involved in sculpture having seen us start with big blocks of stone . . . one American couple had completely the wrong idea. . . . They had heard [of] a prison nearby and . . . said how much more liberal things were than in their country."[9]

The sculptors worked long hours in bad weather, and completed the project on time. The result was an open-air exhibition with much to do with the place and little with the hermetic world of the galleries (*Figs 7 & 8*).

Temporary projects like College Lands can lead to permanent sitings or commissions, and by being topical and newsworthy are able to increase awareness of the role of artists in urban change. The artists there were not involved in the planning or design of the subsequent development, but did influence the builders to purchase works and make an aesthetic presence in the new flats. This is one element in urban public art, the employment of artists in local authority planning offices is another. A

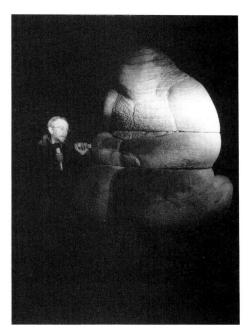

7. Peter Bevan at work on *Sandman*,
Glasgow, 1988 (A Park)

8. Linda Reddy and Calum Stirling
assembling Stirling's *On Common
Ground*, Glasgow, 1988 (A Park)

Percent scheme would have room for both.

Looking to the next decade, will there be a widespread recognition that artists have a valuable role in urban renewal? Do artists have the skills required to integrate into a planning or design team? Is art education adequate in this respect or do the art schools foster outdated, romantic notions of individualism and anti-social behaviour?

Whilst new skills, of communication and negotiation, and an ability to work in a team and not as a prima donna, are needed, so the old tradition of experiment, a kind of anarchic enterprise, is still vital. Art is imaginative work, giving form to ideas and feelings. These things are too often marginalised in industrial societies. Artists can reclaim those areas of human life, and bring them into our cities. In some cases it may be through major monuments, but more often through a wider awareness of visual quality and through a developing sense of place. Smethwick, Blackness and College Lands show different scales of operation with different objectives, but each utilising what is there and acting to focus attention on visual and creative sensibilities. The new initiatives in West Yorkshire open the way for a more integrated approach which may set a pattern for *Percent* budgets. In all these cases it is aesthetic quality and artistic energy which save the work from being classified as "bland municipal design" or art of a lowest common denominator.

Public art will evolve through a plurality of attitudes and models of practice. The existence of a few exemplary projects gives hope that, one fine day, our cities will be places for people, where the daily business of living takes place in a context of an environment conducive to well-being. It is an old idea, but one which was lost during the industrial revolution and urban expansion of the nineteenth and twentieth centuries. Now is the time to reclaim it. Artists can rediscover the beautiful in the city, acting as urban explorers or artists in residence, and they can work with other professionals towards a coherence of urban design. They are better placed to relate to communities. Above all, they bring to the environment what Baudelaire called the "Queen of the faculties": imagination.

PUBLIC ART IN THE COUNTRYSIDE

"Long live the weeds and the wilderness yet"[1]

Vast areas of Britain remain rural. Most are agricultural and a few still wild. Our ideas of "natural beauty" are culturally formed, made in the mind. Most of the landscape has been made by people's hands, or more recently by machines. It is a construct, not Nature as such. It is also threatened by pollution, development, and modern techniques of farming. It is a habitat, for animals and people.

Art relates both to habitat and tradition. Art, too, has a role in conservation, can be a vehicle for ecological awareness. In this context, the most exciting new development in public art is the work of Common Ground. Since the launch of its New Milestones Project in 1985, which led to the commissioning of sculptures for rural places, this ecological group has evolved a strategy for introducing public sculpture into the countryside. The results are equally a contribution to the tradition of art and to growing awareness of what is valued in the landscape.

Common Ground is an "umbrella" organisation for its various projects, rather than a national campaign. Its organisation and funding are decentralised. Although the project officer for New Milestones acted in some respects as a commissioning agent, there was no given policy to be interpreted in every case. The ethos of decentralisation allowed a feeling for the difference of localities, and need to develop ideas in specific relation to a place. Places have as much character as individual people.

Parallel to the New Milestones Project, Common Ground promoted the Parish Maps project. Artists were asked to make imaginative maps of a place, and local groups throughout the country were encouraged to devise maps of their Parish. These showed places of fond memories or historic significance, perhaps something very ordinary, but which held meaning in a personal and particular way. They covered all those things a normal map would leave out, but which, in other ways, are the place.

Public art means art related to place. The New Milestones Project sought to express the meaning inherent in a place imaginatively, and in a way accessible to ordinary people. The works have no labels or signs to place them in an art-world context; they are discovered, usually by walkers, as part of the landscape. Just as a milestone or wayside cross becomes a small scale landmark, taking its meaning from where it is, so these commissions focus a place. In the course of this, they may encourage people to conserve it for future generations.

The work commissioned through the New Milestones Project has reflected a plurality of style and medium, united by the need to relate in theme and material to place, and be a sympathetic part of the landscape. All the commissions are the result of local initiatives, and not a scheme imported from outside. The commissioning process itself has been a catalyst in raising shared awareness of ecological issues.

Andy Goldsworthy's entrance to Hooke Park Wood will last for a generation or so. In other cases, such as Peter Randall Page's stone carvings near Lulworth, the work will become part of a tradition of monuments in landscape going back to the middle ages. The twentieth century has seen a pillaging of the countryside, but our imaginative capacity still has something to offer. New Milestones asked what monuments we would leave for the future, out of our imagination.

The Project was launched in Dorset in 1985, as a three-year pilot study. Dorset was one of two areas considered. The other was Yorkshire. Funds allowed only one scheme to be set up, and Dorset was chosen for personal and logistic reasons. It is a County rich in ancient history, seen in the burial mounds, earthworks and field systems, and in a continuing agricultural tradition. The drovers' roads, the parish boundaries, and sunken lanes are survivals of the past despite modern large-scale farming. The County has literary associations with Thomas Hardy and John Fowles. It was also a place in which very little arts activity flourished: in some ways a disadvantage, due to the lack of supporting networks, but in others an advantage in that it allowed a fresh beginning, clear of the detritus of modern art.

Often isolation breeds a strong community feeling. Dorset is a longer distance from major centres of population than the map implies; travel is slow, whether by road or rail. It is an area of outstanding beauty, the coexistence of Nature and man-made structures, of the wild coast and rolling barley fields. Within it, there are strong local allegiances, the necessary point of departure for an art rooted in place and conservation. Such factors may have outweighed the cultural isolation of the County. The success of the three year programme, enabling a nationwide launch in 1988, suggests it was so.

Joanna Morland was appointed as project officer, based in Dorchester from 1986 to 1988. Her role was to advise and encourage the

136

communities and landowners in commissioning art for their localities. It was not a case of raising funds for preconceived solutions, but of helping people to evolve their own ideas, and trying to match initiatives with appropriate artists and methods.

She wrote that the aims were:

> "to encourage and assist Parish Councils, local groups and individuals to commission sculptures or craftwork which celebrate and draw attention to an aspect of their place—its history, geology, topography, natural history, people and stories." [2]

Once a commission became possible, funds were raised from arts and other bodies. The landowner usually made a significant contribution. General running costs of the project were supported by bodies such as the Henry Moore Foundation and South West Arts.

Consultation was of major importance in each project, and most were long-term in the making. Artists were selected from an index compiled by Common Ground with assistance from an advisory panel of artists and administrators. Abilities to talk to local people, find a sympathetic way of conceiving the work, and relate to the place (its form, its history, its population), were as important criteria in selection as craft skills and a track record of exhibited works.

One of the first commissions was by Andy Goldsworthy at Hooke Park Wood near Beaminster. The Wood is managed by the Parnham Trust, directed by furniture maker John Makepiece. There are experimental timber buildings, with an ecological objective, and a general desire to develop new technologies for roundwood, and manage the woods responsibly for the future. Timber is not planted and sawn down in great swathes, but carefully farmed, periodic thinning allowing mature trees to grow. This leaves smaller timbers which are used for making furniture or in the construction of small buildings. The leisure resource of trails for walkers and the commercial factor of timber production and use are not contradictory.

Andy Goldsworthy's previous work in landscape, using found materials for temporary constructions documented in photographs, showed his sympathy for natural forms and rhythms.

The starting point of the commission was the need to mark the entrance of the wood clearly, and to be able to close the track overnight. This implied a gateway of some sort. In November 1985 Goldsworthy discussed the project with John Makepiece, and began to think of possible forms. The following April he made several visits, constructing small round entrances in the woods from fallen branches. This was the genesis of the double rings. Previous ideas were for a sunken ring, or a great arch, but the site required something quite modest in scale, yet easily seen from the road. Some timber from the wood had grown curved due to

slipping soil, and could not be used for furniture, but this was ideal for making the rings, and was cut for the purpose.

The curved small Douglas firs were the obvious material. A skeleton ring was first assembled on the ground for each side, then raised onto the site and completed by pegging in more timbers until an equilibrium was reached. Two timbers with weights composed of hollowed logs filled with molten lead form the barrier, which can be balanced up or down to open or close the track, and easily operated by one person.

Construction was a team effort, involving the artist, a group of student assistants, and the foresters. It was also a genuine collaboration in terms of the idea; the eventual form evolved slowly from the materials which were very much part of the place. The role of the artist was to gather and lend a sense of form to the materials, rather than radically alter their properties. Hence the sculpture is part of the wood, literally, as well as a landmark. Holly bushes are planted at each side to help the structure to blend further. It is the opposite of a statue, but no less efficient in marking the entrance.

Simon Thomas, a young sculptor at the Royal College of Art, undertook another commission, at Lulworth, from July 1985. He worked with timber from an oak which had fallen nearby 25 years before, having made smaller carvings in beech. Being naturally seasoned, the oak was excellent to carve, and made a direct relation of the sculpture to the place.

This commission, and one by Peter Randall Page, was the result of an initiative by Wilfrid Weld, owner of the Weld Estate. The estate includes Lulworth Cove and Durdle Door, two popular beauty spots which become very crowded in summer. One aim was to disperse people along footpaths, giving them a feeling for the landscape as well as the coast. There is a long-distance path, and a series of bridleways running through the estate. One of these (from Ringstead Bay to Dagger's Gate) lies between a Site of Special Scientific Interest and modern grain fields. Research already carried out on the SSSI had shown that woods were first cleared for farming during the Bronze Age, when the light plough of the ancient peoples was suited only to farming lighter, hilltop soils. Field ridges can still be seen, across from the larger fields of wheat and barley of today's commercial agriculture.

Simon Thomas had previously worked in abstract forms, but decided to use a simple figurative motif that would be accessible, and relate the theme of the work to the place. He chose the form of a wheat seed. Four giant seeds, each about 40 inches long, are placed in a field near the bridleway. They form a group, but are sited informally, leading the eye in different directions to and from the hills and sea (*Fig 1*).

The grains of wheat are recognisable as a symbol of agriculture, and used in many representations, such as the twin ears of wheat in national emblems, or in advertising for bread. The image has a reflection in mass

1. Simon Thomas, *Wheat Grains,*
Dorset, 1985 – 86 (M Miles)

imagery. But it also has a greater resonance, as symbol of fertility. Seen
from a certain perspective, the grains take on strongly female charac-
teristics, signs of the fertile abundance of Earth. The levels of inter-
pretation are the more accessible given the smooth and well-crafted finish
of the grains.

The four oak sculptures are fixed into concrete bases in the chalk
substratum, and are about the same size as the sheep who enjoy rubbing
up against them. They have begun to weather, with small cracks, and an
accumulation of water in the centres. In time they will disperse into the
earth, but not for a generation or so.

These sculptures focus attention on the present production of wheat,
and on the myth of fertility. Part of their attraction is having this duality of
meaning. It is not only a cultural metaphor; the production of wheat and
consequent manipulation of the landscape has formed the "place" over
4,000 years. This whole tradition is the context of the work.

Peter Randall Page undertook three sculptures, in 1985 – 86, along
the same bridleway. His *Wayside Carvings* are set in niches in drystone
walls, in the embankment. Each is a spiral shell form in local Purbeck
limestone, carved on the estate. They have become familiar landmarks to
many local people, and appear to be appreciated by walkers. Flowers
have been frequently placed in the niches, giving them the character of
wayside shrines, as are found in India or in Southern Europe. The top of
one of the carvings has become slightly more polished, indicating fre-

quent touching, like statues in medieval churches.

Randall Page spent time looking at the landscape, and thinking what kind of sculpture could fit into it. Both he and Thomas were given the use of a cottage on the estate. It seemed pointless to compete with the scale of the natural environment, better to complement it by making something intimate. Two questions preoccupied Randall Page: the image and the setting. It was the choice of setting which was the catalyst for starting to carve the pieces:

> "The crucial idea was siting the carvings in niches. That came early on in my thinking about the project. The images were separated by a formal device, like a picture." [3]

This allowed the scale of the sculpture to be quite different from that of the path or the view beyond, something that acted to bring the walker to a moment of stillness in the midst of the moving elements of sea, air and earth (*Figs 2, 3 and 4*).

The scale was a mid-point between the landscape and the small creatures who live in the marginal areas of the countryside. Caring for the environment means having a relation to it, and a sense of appropriate scale is one aspect of that. It is a part of a wider interest in things. Randall Page has said:

> "As an abstraction, the concept of Art doesn't interest me; I've always been more interested in my relationship as an individual with the rest of the world. This can be focused in a simple activity, like carving." [4]

2. Peter Randall Page, *Spiral Shells,*
Dorset, 1985 – 86 (M Miles)

In Dorset, making three simple, and quite small carvings enabled the expression of complex ideas which had been forming through his earlier development. At the same time, it produced images which have a symbolic function, and are directly related to the place in theme and material.

3. Peter Randall Page, *Spiral Shells*, Dorset, 1985 – 86 (M Miles)

4. Peter Randall Page, *Spiral Shells*, Dorset, 1985 – 86 (M Miles)

Scale had preoccupied him in another commission, at St George's Hospital in Tooting. There, he made, helped by a craftsman, a series of pieces in Welsh slate, evidently hand-built and of a size between the super-human scale of the hospital and human beings, a "bridge" to humanise the environment (*Fig 5*).

The question of putting sculpture in landscape is fraught. Some artists in America have used earthmovers to make violent scars on the land, as art. Randall Page, in contrast, was concerned to put "good things" in the landscape, with sympathy and in the tradition of a relation between humans and the earth. It is worth recalling that the whole landscape of Southern England is already a cultural object. It is man-made, cleared of its original forests. Given that it is not wild, it seems reasonable to put sculpture sympathetically in the landscape to encourage a sense of value and caring.

It is the scale of the *Wayside Carvings* and their integration into the earth bank, being seen only at close hand, which allows them to be successful. It is also their simplicity. The dry stone walls are as much part of the countryside as the ploughed fields, and the sculptures reside quietly in their niches. Each is a shell-form, like a snail.

The images can be read at many levels. There is the literal: forms which remind the walker of the small creatures so easily trodden under foot, like the land snails which crawl over the path and the stones of the wall. There is the allusive: the shells are akin to the fossil shells which can be found on the beaches of Dorset. The Purbeck stone from which they are carved is itself composed of millions of tiny shells. There is the mythical: the spiral is one of the most ancient images, found for example at New Grange in Ireland, and on Mycenean pottery. At the symbolic level, the spirals stand for the inter-penetration of death and rebirth, the cycle of agriculture.

Peter Randall Page sees carving as part of the expression of a thought process, as well as a satisfying physical activity requiring respect for the material as much as an idea of the form. Underneath, his subject-matter grows from the feeling of being part of Nature and also detached from it. He has spoken about this on a number of occasions:

> "Our feet are embedded in the earth, but we have an extraordinary illusion we are floating above it all. Carving becomes a process which helps me to be in touch with that—a sense of being a part of the world. It seems that even on the most scientific basis we have evolved like everything else in the world and are part of it. There are parts in us that have an understanding of the world from inside. That's what steered me towards carving even before I read about those sorts of ideas."[5]

Much of his work has been about relation: of man and the rest of the earth

5. Peter Randall Page, *And Wilderness is Paradise Enough*, St George's
Hospital, Tooting, London (P R Page)

and its creatures, about man as conscious being able to be apart, yet still a
product of evolution, part of it all. The New Milestones Project was a
turning point in his development, bringing such ideas into prominence
through the *Wayside Carvings*.

The following year, 1987, he made a work for a shopping develop-
ment in Basingstoke to mark European Year of the Environment. He
selected three forms from a list of endangered species. They were a
spindle tree seed pod, a chrysalis, and a land snail. They were carved in
Kilkenny limestone, a hard stone which takes a good, polished surface,
and which is dark bluish grey with flecks of white (*Fig 6*). The piece gave
an opportunity to remind people, in the course of their everyday life, of
small creatures which could easily be forgotten, and which, once lost,
would be gone for ever.

He had intended an inscription from Gerard Manley Hopkins to be
inscribed on the plaque:

"What would the world be, once bereft
Of wet and of wildness? Let them be left,
O let them be left, wildness and wet:
Long live the weeds and the wilderness yet."

6. Peter Randall Page, *Chrysalis* (in progress), for European Year of the Environment sculpture, Chineham, Basingstoke, 1987 (P R Page)

But it was rejected by the property company as too radical. Perhaps it could have been seen as a comment on their own greed in developing the site at all. A more suitable form of words was found.

The contrast between the two commissions illustrates the good context offered by the New Milestones Project. Because it was based in the place, and began from an initiative by Wilfrid Weld the landowner, there were no contradictions. The shell forms are part of the place materially, and thematically. They do not need any plaque, and have none.

Christine Angus was commissioned in 1987 to make a work in Purbeck stone for the junction of five paths on a hilltop at Manor Farm, Godmanstone. The farmers, the Bests, had contacted Common Ground the previous year, and were in process of turning the farm from chemical to organic methods.

Mature trees stand on three sides, and to the west is a view across fields to a copse. Newly planted cherry and beech trees will complete the site. The sculpture is secluded, yet invites walkers into its clearing. It does not have an overtly figurative form, but a feeling of forms partly formed

144

or partly eroded, like the stones of an archaic work. One stone bears an inscription of the number of trees planted, and the date. It acts as a marker. Another is more hidden at the corner of the clearing, low on the ground, one stone around another, the horizontal surface worked to a finish, an almond shape within the rough oval. The main piece is a pillar. It is based to an extent on those in the local Norman church, but has its own character and is seen from a distance. In time, trees will grow round it, subsuming it into a grove (*Fig 7*).

The commission was not without its problems, not least those of carving outdoors in bad weather. But there has been strong local support, for example when over a hundred people came to a fund-raising picnic at the site, or when a neighbouring farmer planted daffodils adjacent to the site. The Parish magazine was a useful means of communication. The carving was completed in 1988, and is already a waymark on the Driftway.

At a conference in Dorchester in July 1988, the New Milestones Project was launched on a national basis. The first new development is in Cleveland. Others will follow. The aims remain as in Dorset, where it has been shown that local initiative can lead to art which is both aesthetically and ecologically valuable.

One of the most ambitious projects undertaken by New Milestones is the series of stone walls by John Maine at Portland, under construction during 1988. Portland Council had recently completed a new sea defence barrier, after years of being at the mercy of freak tides and storms. The sea

7. Christine Angus, *Turning Point,* Dorset, 1987 – 88 (M Miles)

145

is a permanent reminder of Nature as destroyer as well as creator.

Maine was based in Chiswell whilst making another work in 1986, and his idea for the site developed slowly. The sculpture is something emerging from the site, not an imported object. The stone is local, and a local mason has acted as assistant in building the series of terraces, echoing wave patterns, running across the slope. The land is a bog, due to bad drainage. The sculpture may help stabilise it, being both art and engineering.

Rural public art is a new idea, and a very old one. The categories and definitions of Art are as useless as the notions of Nature. What matters is a sense of place, and that the work will assist people in valuing their place.

Much of Britain is still rural, though ravaged. The lust for money is destroying the habitat of many creatures as well as the small places valued in people's memories. The landscape has been man-made for millennia, but now it is fast becoming an extension of urban waste just as it has become a vehicle for the bizarre fancies of an urban population who see it as Edenic idyll. If art can reverse the process it has a more important role than being confined in galleries.

Yet rural public art may also help art reclaim its territory: that of the shared myth. Despite the secularisation of society, the agricultural cycle, the callender of feasts, the rites of John Barleycorn and the Green Man, all remain. Images like the spiral shell remind us at different levels of small creatures and great questions, of Life and Death and Regeneration.

PROSPECTS

Chapter Fourteen

COMMISSIONING BY LOCAL AUTHORITIES

"Till we have built Jerusalem
In England's green and pleasant land."[1]

Art consists in unique objects of no utility. Local authorities provide services, many of them utilitarian. How can the work of artists and the needs of local authorities be brought together for mutual benefit?

Relation entails common intention and sympathetic means. The intention may be the creation of a locality, as more than a name on a map; the means a series of opportunities for artists to work in the locality, through residencies, commissions and interaction within council departments.

At the same time, art involves creative risk, and without it becomes bland. A municipal art of the lowest common denominator, "basic design" guaranteed to arouse the minimum response, would fail to make a creative statement of the kind that helps give identity to a place. The key to successful art at a local level is that it transforms spaces into places, creating areas for people to interact, not margins in which the public scurry. Creative risk can be accommodated where procedures of consultation and exchange of views are well developed. Even "difficult" art can be well received.

Since the 1960s, there has been a proliferation of works of art in public sites. Artists have undertaken residencies in industry, and art projects have been set up in hospitals and schools. Public utilities, such as the London Underground and British Rail, have commissioned artists to design surfaces or produce sculptures. Shopping malls often include murals or mosaics. New towns, and areas undergoing refurbishment in old towns, have become sites for major projects. Public art commission-

ing agencies have gathered expertise and advised potential clients in the public and private sectors. Developers have begun to use art to improve their image, and local authorities to use the grey area of legislation called "planning gain" in the Town and Country Planning Act, and in various Department of the Environment guidelines.

There are three main pathways for patronage at local level:

an initiative taken directly by the local authority;
the use of an agency as intermediary;
initiatives put forward by Regional Arts associations.

In most cases, funding will be from a variety of sources.

The patronage generated may be channelled into two ways of employing artists: residencies and commissions; and a third, more recent possibility, as yet to be fully tested: the creation of posts for artists in planning offices and as part of project and design teams. If *Percent for Art* schemes are widely adopted, this latter approach may prove the most appropriate.

Residency means taking part in the day-to-day life of an area by living in it and acting as a catalyst to the creative aspirations of the whole community, either for a given period or by holding a permanent post. The first appointment of a town artist was that of David Harding in Glenrothes in 1968. Since then there have been many more, particularly in Scotland.

Commission means working for a given site, and taking into account the three factors of *users of the space*, *its history*, and its *physical character*. All these will have particular qualities which differentiate one place from another. There will be patterns of employment and leisure, events recalled by local people, and specific building materials, colours, a scale, prominent landmarks.

Working as part of a design team or being involved in the planning of a major new public building requires skills of negotiation. It means going beyond the concept of artist as individual creator, playing god or genius with full control of the means available. Architects never had quite this freedom, always working for a client and often piloting projects through planning and heritage committees.

Artists will need to learn new skills of working in a team. This need not be an obstacle, and the social and communication skills of artists have already been well demonstrated in many residencies. The advantage of such collaboration is that visual awareness and the quality of imagination can be included in a project from the beginning: the end of cosmetic solutions to urban disasters. For that end, a readjustment of the caricature of the artist as Bohemian outsider seems a small price.

If artists were to be increasingly employed in the design stage of projects, the need for residencies and commissions would not be diminished.

There would remain many parts of the environment already blighted, many spaces to turn into places. Residencies will retain the value of bringing people into direct contact with how artists work. Imagination is not only suited to permanent monuments, it is an activity, open to participation. The example of artists' work counteracts the dullness of industrial production and office routine, colour against the grey.

One of the first authorities to integrate art into urban policy was Milton Keynes.[2] Whilst much public art of the 1970s was concerned to patch up old areas in decay, here was the opportunity to begin afresh in the building of a new town, with ample green areas.

Liz Leyh was appointed town artist in 1974, with funding from the Arts Council for the first two years, subsequently from the Development Corporation. She has carried on her own studio work in a space provided, as well as working with the community. Her *Herd of Cows* (1979), in painted concrete, is sited in a field at Stacey Bushes. Her work covered a spectrum of community interest, including industry, schools and the handicapped. She worked with the Hospital Action Group, who made a monumental question mark for the space where a hospital should have been. Participation was a central aspect of her work, encouraging people to exercise influence over their own futures. This contrasted with the more remote activities of the town planners.

Milton Keynes established a wider form of commissioning through a project called Prints for People. Whilst there are many agencies supplying the inoffensive corporate art required by commerce, this scheme gave people a chance to have prints in their homes. Commissions in public sites are one form of patronage, but the picture loan schemes developed by a number of local authorities enable people to have more intimate contact with art, at a more engaging level than through reproductions. Such schemes also support artists through purchases and publicity.

There are also major commissioned sculptures. Outside the Council offices is a red-painted piece by Bernard Schottlander, formalist art of the 1970s. Wendy Taylor was commissioned by the Development Corporation to make a stainless steel Moebius strip twelve feet high, installed in 1981 adjacent to a mirror-faced building. It looks very futuristic in the anonymous way which results from a conceptual approach to architectural space. Both these sculptures seem distant from lived experience. They make formal relationships with the buildings to which they are a counterpoint, lend a kind of identity, but not one which has evolved naturally out of human interaction. They may have looked very good on the drawing board, but people do not live on drawing boards! In contrast is Andre Wallace's *Whisper,* two bronze figures in the town centre (1984). This is directly accessible, almost populist, and has enough character to easily become a familiar landmark (*Fig 1*).

Milton Keynes is an unusual case. Most localities have evolved over

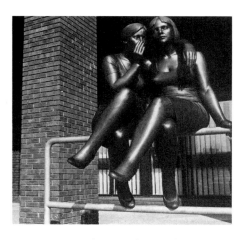

1. André Wallace, *The Whisper*, Milton Keynes (B Jardine)

several centuries and have been affected by industrial expansion and decline. Swindon is in some ways typical of such an environment. Midway between London and the West, an old railway town, its engineering industry has been replaced by computers and insurance.

In 1975, Swindon began its programme of community-related arts. One of the first murals, painted by volunteers working with an artist, was *George and the Dragon*, based on Ucello's painting in the National Gallery, London. This remains a popular local feature, and was repainted in 1984. It has never been seriously vandalised, and its subject allows interpretation at different levels. At first glance, it is colourful and has an accessible story. At another level, it could be a symbolic image, or a critique of post-Renaissance civilisation, with St George as modern, rational and technological man, overcoming his primitive past, or repressing his emotional self.

Other murals treat local history and personalities. Ken White's *Golden Lion Bridge* marks the former site of a canal bridge, and includes images from archive photographs. That, too, is a popular landmark. Canals were important in Swindon before railways, and murals have reminded local people of a past which can be a source of pride without, necessarily, becoming nostalgic. Local history is the history everyone and everywhere has. Artists can focus that, in the process, by establishing value in the locality's past, encouraging conservation of "ordinary" environments.

Passengers gliding through Swindon in their Inter-City comfort may not realise that what appears a very ordinary town has one of the most developed programmes of public arts. Thamesdown Council, with support from Southern Arts and commercial sponsorship, have built up a collection of permanent and temporary works, and community arts

workshops. There is now an annual sculpture residency, and there are plans for a new gallery, and studio conversions. By 1987 there were 23 murals, nearly all in good condition, and several public sculptures. All this is in a context which also includes street theatre, performance art, and a policy that art should be at the centre of urban life.

Thamesdown represents a model for local authority commissioning, working through its visual arts department and with support from the Regional Arts Association. The latter enabled the ferment of local enthusiasm to find appropriate forms by injecting professionalism as well as money. Following the local authority's lead, there has been patronage from the private sector. W. H. Smith Ltd commissioned three running figures in bronze by Elizabeth Frink, something they no doubt regard as an increasingly valuable asset (*Fig 2*).

The *Great Blondinis* by John Clinch (1987) is a focal point of the Brunel shopping centre. Public sculpture can be popular and fun as well as retaining aesthetic standards. Perhaps the most important factor in this work was the collaboration between the artist and six craftsmen from the British Rail Engineering Workshop. 14,000 people were once employed there; now none. The sculpture, in cast aluminium, was the swansong of these craftsmen, and stands as a monument to their skills.

Public sculptures in shopping developments have not always been successful. In another part of Swindon, a group of boulders seem forlorn, their concrete base chipped away (*Fig 3*). The shops in the plaza are closing, due to competition from a newer development elsewhere. The whole site is a monument to bad planning, and greed on the part of developers concerned only for a quick profit. No intervention by an artist is likely to change that.

However in Swindon, the provision of public art is increasingly related to residential areas, and a policy is evolving for a series of major sculptures as "landmarks" in otherwise bland housing zones. The lack of character is also the handiwork of developers, and perhaps the authority is acting after the event, but it is seeking collaboration between artists and its landscape architects in humanising such sites. It is in such suburban expansion that there may be most scope for "planning gain" and the implementation of the provisions of Section 52.[3]

In 1987, Thamesdown commissioned Public Arts (based in Wakefield) to make an independent report on the Landmarks project.[4] This will contribute to the planning of future projects for public sculpture, informed by good practice elsewhere. It was a catalyst in Thamesdown's adoption of the *Percent for Art* principle.

The landmarks scheme grew out of a strong programme of residencies, which began with John Buck in 1985. He made a set of *Bathers* sited in Westlea Park. His aim was to:

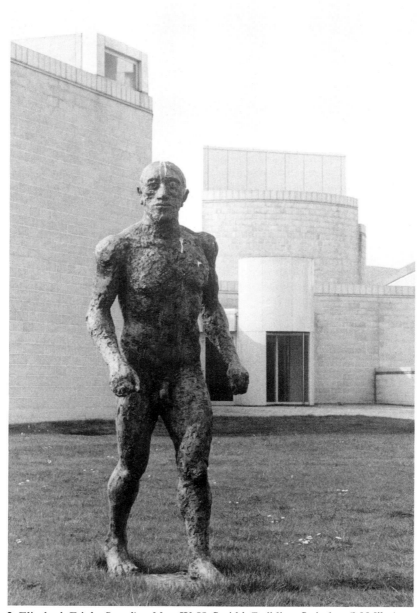

2. Elizabeth Frink, *Standing Man*, W. H. Smith's Building, Swindon (M Miles)

3. Standing Stones in a plaza in
Swindon: evidence of decay, 1988
(M Miles)

"contact local groups to find out whether they welcomed the idea of a sculpture and if so what kind of subject matter they envisaged . . ."

He found responses encouraging, though some meetings, he wrote:

"indicated just how many barriers needed to be broken down between Art and the public. Nevertheless that was the very thing this venture was designed to achieve . . ."[5]

A maquette was exhibited in the community, and parallel with the work on the commission he held regular open workshops. The three bathers were well received, though there is a local sport of removing their ears. The local Visual Arts Officer keeps a stock of spare ones.

The *Bathers* and the *Great Blondinis* are both highly accessible, figurative sculptures. Whilst Minimalists are reduced to hysteria by such work, their preciously individualist attitude was precisely the problem with some early attempts at public sculpture. This does not mean that more "difficult" work cannot be introduced, as part of a broad programme. Much will depend on the intention behind the work, perhaps a richness of idea extending beyond formal properties, and the ability of the artist to present ideas and listen to other people.

Hideo Furuta made a stone carving in 1986, depending very much on delicately balanced masses, in a square in a newly developed suburb in West Swindon. It was an uncompromising piece. It had no figurative connotations, and he carved it entirely on site, with hand tools (*Fig 4*).

There was controversy when he exhibited a log piece outside a sports centre at the beginning of his residency, and the local press carried photographs of councillors complaining about the waste of ratepayers' money. By engaging in debate, and tirelessly talking to people about how he works, and by doing all the carving on site, thereby showing his commitment and skill, he brought out the "silent majority" in his favour. He proved it to be possible to create public works in non-prestigious

4. Hideo Furuta at work on carving during residency in Swindon (Joliffe Studios)

locations, which have a poetic and contemplative power.

Julie Livsey was sculptor in residence during 1987. She made the *White Horse Pacified*, in steel and concrete, again for a recently built estate (*Fig 5*). It looks out towards the green downland, on which other, older white horses are carved, standing for quite different values than those of consumerism. The borough landscape architects worked with the artist to conceive a unified plan for the site. The other element of interface in Livsey's residency was the provision of workshops, talks and activities which brought her into the daily life of the area. Living there for a year, with children in the local school, helped integrate her work with the community.

Residencies and commissions generate questions such as why money should be spent on art instead of other services. Given that local authorities are under financial pressure from central government, and that people feel the rates to be "their" money, it is a fair question. There are answers. Artists offer an example of more fulfilling work, less alienating than the production line. Initially there may be resentment of their freedom, but that freedom is itself a necessary example. In the midst of a society where much is mediocre, art stands for a different sort of future. It is creative and imaginative, keeps alive the memory that everyone has such areas in themselves which they can reclaim. A society in which such strivings ceased would be moribund.

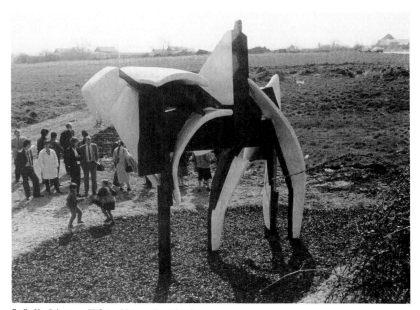

5. Julie Livsey, *White Horse Pacified*,
Swindon, 1987 during unveiling
(M Miles)

Recent extensions of Thamesdown's arts planning have included a residency by Simone Alexander, developing art in a multicultural society, and ideas for studio conversions in older industrial buildings. The more spectacular events, including adventurous performance works by Alistair Snow, an artist who is also Visual Arts Officer, take place in the context of continuing workshops which give opportunities for everyone to make art of some kind. It would be hard to find a better example of local authority direct initiative in the arts.

In some other parts of Britain, public art agencies act as inter-mediaries for local authorities and private developers or commissioners, bringing patrons into contact with selected artists.

West Yorkshire is a locality with a major provision of public art achieved in this way, through Public Arts. They advise, initiate and are generally pro-active for a public art policy including a *Percent for Art* commitment. Agencies have the benefit of access to a national network of contacts and expertise.

Public Arts was formed as a private company in 1986 to continue the commissioning strategy of West Yorkshire after the abolition of the metropolitan county councils. It has two main aims: to initiate projects

for art in public, and to develop a broad educational potential from and through such projects. It is committed to equality of opportunity, and all commissions are advertised. The response is usually massive, demonstrating that there is no shortage of artists willing and able to work for public sites and in a relation to the locality and community.

Public Arts is well resourced from base grants, from the regional funding of the Arts Council (through Yorkshire Arts), from the local authorities, and from the Gulbenkian Foundation. This enables it to mount a programme with sound ethical principles and strong community links, to be pro-active rather than merely responsive to approaches. A permanent staff enables it to set up projects with strong liaison, and monitor implementation and feedback. It also allows sustained persuasion, the result of which is the adoption of *Percent* schemes in Wakefield and Sheffield.

An innovative project in Doncaster, arising from discussions established by Public Arts, is the appointment (1988) of an artist to work as part of the planning department. Funding has been raised for at least two years for the artist to identify appropriate projects, and set an agenda for future development of public arts in the area. Priority will be given to the potential for community involvement. With so much criticism of public art as cosmetic embellishment, or at odds with its surroundings, it is by putting artists and planners in one team that a unified approach to a better environment can be evolved. It also enables them to explore the different languages used, to identify common ground and perhaps for each to understand the realities with which the others work. If art is a model of work which alludes to a less alienating future, the planning office is a key location for it.

After all, urban blight was never an accident; it resulted from the separation of responsibility for the environment into over-specialised and remote hands. Planners and architects have for some time been trained in a way which gives no access to the conceptual or experiential awareness of artists. Further, by dividing responsibility, accountability is also diminished. It seems to be no-one's fault that a town is wasted. It is.

Public Arts has initiated and co-ordinated commissions always with community benefit in mind. The Mirfield mural (1987) by Lynne Gant was composed from information brought in by local people. Memories ranged from the general strike of 1926 to the recent miners' strike. Although the community contributed subjects, Public Arts recognises the professional role of the artist. Graham Roberts, its Director, stated:

"We fund professional artists and professional art practice only. The community will be involved . . . but the actual work produced must be solely the work of a professional artist of high ability. We exert quality control and we have a reputation of trying to get the best money can buy."[6]

Two other recent projects demonstrate the diversity of commissions. John White's kinetic sculpture of a man reading a book is in Cleckheaton Library (*Fig 6*). Insertion of a coin causes the figure to cross its legs, open a book and appear to be reading. The artist said:

> "I was looking for an image that was both humorous and relevant to libraries . . . I've called the figure Bob, because he seems to be everyone's favourite uncle . . ."[7]

There is a place for this kind of popular sculpture, just as for less humorous pieces. Public art is a "broad church" of necessity, just as people have a variety of needs.

Graham Ibbeson's *Miners' Memorial*, at Conisborough (*Fig 7*), is a tragic reminder that death is part of the lifestyle of any mining district. It is easy to philosophise about life as a temporary light in an ocean of darkness, but more difficult to come to terms with death as a fact of everyday life. The memorial recognises those killed at the Cadeby and Denaby Collieries, and reactions have been mixed. Some of the press reports have called the sculpture ugly, complained about the cost, or suggested that relatives would not wish to be reminded of their loss (an argument seldom used when it comes to war memorials). But a local community newspaper puts another case:

> "Deaths in coal mines are no different from deaths in war, lifeboats, the police force . . . When the sites of Cadeby Colliery and Denaby Colliery completely vanish so will the memory of the brave men who gave their lives to keep the wheels of industry turning and the home fires burning. The cost of the statues bears no relation to the courage of these men. The words 'Lest we forget' are frequently used to remind us of the deaths of two world wars and man's indifference to his fellow man. The statues outside Conisborough Library should be looked upon by the people of this area as their way of saying 'we will never forget'."[8]

Resentment at public art happens when it looks like the privileged culture of the middle classes colonising the street. But the *Miners' Memorial* shows that content can overcome such class barriers. Feedback is vital to agencies seeking to create successful commissions. Each agency has its own policy, but all are concerned with setting good models of practice.

Within such a broad programme of projects, there is room for work which is more experimental. Public Arts have commissioned artists to work in the environment and to produce temporary work for the Wakefield 100 Festival in 1988.

Temporary work allows humour more easily, without time for the wit to wear out. Petra Cox made *Picnic Lunch* for the Festival, in artificial

6. John White, *Happy Reader*, Cleckheaton Library (Public Arts)

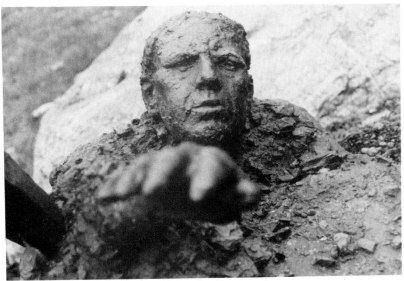

7. Graham Ibbeson, *Miners' Memorial*, Conisborough (Public Arts)

grass, fibre glass, polystyrene and paint, sited on a roof (*Fig 8*). Other summer projects included community arts workshops and several tem-

porary sculptures, including a queue of sofas waiting to use a telephone box.

Sculpture in the greener environment includes Andrew Darke's *Oak Wedges* (1987) at Calms Wood in Dewsbury (*Fig 9*). Darke worked on site for five weeks in order to create two sets of oak stakes echoing the rhythm of the landscape. The site was part of the Kirklees Garden Festival, and had been transformed from a dangerous waste ground into a public park.

8. Petra Cox, *Picnic Lunch*, Pontefract, 1988 (Public Arts)

9. Andrew Dark, *Oak Wedges*, Kirklees, 1987 (Public Arts)

161

10. Charles Quick, *A Light Wave*, Wakefield Westgate Station, 1988 (Public Arts)

In 1988, Public Arts organised the commission from British Rail for Charles Quick's *Light Wave* at Wakefield Westgate station. On the platform, with a bed of gravel, are a series of "waves" made from blue-painted wooden slats. At night, light shifts through the structure, emphasising the movement of trains and spectators (*Fig 10*).

Agencies also act as consultants in funding. An example is the partnership between British Rail, the London Borough of Lambeth, and the Department of the Environment, in the refurbishment of Brixton station. Kevin Atherton was commissioned to make bronze casts of local people to stand on the platforms, mingling with real passengers. This was handled by Public Art Development Trust, based in London.

PADT's objectives are:

"To promote opportunities for younger artists, help realise the potential for art to enhance the environment and at the same time stimulate public awareness of this capacity for art to contribute positively to our surroundings." [9]

These are achieved in a variety of public and private sector contexts, including several London hospitals, and by bringing artists together with other professionals, such as architects.

Art in public sites sets an example to developers, but does not always lead to happy solutions. Two examples introduce a note of caution: a sculpture by Peter Randall Page in Basingstoke, and some large pieces of rusty steel in London.

At Chineham, on the outskirts of Basingstoke, is a new supermarket development, including other shops and a library (no doubt the "planning gain"). The developers commissioned a sculpture to mark European Year of the Environment, perhaps to boost their public image. The sculpture is a sensitive, and powerful, re-creation of three endangered species, in Kilkenny limestone. Photographed on Dartmoor by the artist it looked mysterious and beautiful. But installed on site it contradicts the buildings, and looks marooned (*Fig 11*). The developers did not build the foundations according to specification, a needless lack of care. It could be argued that the sculpture, despite whatever damage to the green heritage is already done, will remind people that the land and its creatures are worth looking after. On the other hand, a poignant quote from Gerard Manley Hopkins, intended by the sculptor for the inscription, was rejected by the clients as too controversial. Intention does determine ends. Here greed seems to have won over green issues and the commission seems a cosmetic disguise, despite its high aesthetic quality and appeal.

Broadgate Development in London is the site of a steel piece by Richard Serra. The spectator is reduced to a very passive role, like the toy figures in an architectural model. George Segal's grim, grey group of walking figures is another reminder of how little humanity counts within the corporate environment, reminding us of the anonymity of urban lifestyles (*Figs 12 and 13*). The sculptures are displayed as if in an open-air gallery, using the building as a backdrop. It is the neutrality of the gallery and modern art's supposed "value-free culture" which underpin this scheme.

Public art is not confined to the industrialised or highly urbanised parts of Britain. The South East is a mainly rural region, but a new public art policy is slowly gathering momentum, substantially fuelled by South East Arts.

There are few precedents in the South East, and there is a problem in that some vested interests see public art as something associated with

11. Peter Randall Page, *Endangered
Species* sculpture for European Year of
the Environment, Chineham,
Basingstoke, 1988 (artist and family at
the unveiling) (M Miles)

12. George Segal, *Crowd*, Broadgate
Development London, 1987 (M Miles)

165

13. George Segal, *Crowd*, Venice Biennale, 1988 (B Tegg)

depressed areas. Early commissions were not always successful, for example, a work by Antony Gormley for the new development of Singleton Village, near Ashford. The artist, residents, and the local authority are all unhappy with what is clearly a disaster (*Fig 14*).

The commission began in 1979, when it was nationally advertised, and intended as part of an optimistic expansion. Gormley proposed a boulder, with a bronze and concrete cast of it. In the atmosphere of the time it was a fairly mainstream piece of contemporary art, having no relation to the site. The piece was arbitrarily placed by an artificial lake. There was no consultation with the community, most of whose houses were at the time only in planning stage. Gormley wrote:

> "To act in time and be acted on by time. My job is to get as close to matter as possible: seeking out the genesis of an object's identity: finding a way of getting to know it and representing it in such a way that its relationship with the world is active: it becomes an object to be planted: a gift from the past to the future." [11]

The boulders are heavily defaced with graffiti, and part of the bronze

166

is removed. The paths round the lake are often flooded, the circuit is broken by additional building right to the water's edge, and the lifebelts are missing. It would be difficult to find a worse mess in such a pleasant landscape.

The Walderslade commission (1989) is quite different. The site, outside a new hotel, is not ideal, but the commission is being handled for Kent County Council and South East Arts by Public Art Development Trust. One motivation for it is to redress the balance of Singleton; another is to create a "landmark" at the culmination of fifteen years of development around Walderslade, instigated by the County. Landscaping will be planned in accordance with the needs of the sculpture, and both the local authority and the hotel see the commission as a way to enhance the tourist potential of the area.

Kent have also appointed an Arts Development Officer, demonstrating further commitment to a spread of arts awareness. The Walderslade scheme includes an outreach programme, with workshops in local schools in which a student from the Kent Institute of Art and Design has a placement.

South East Arts have been promoting public art during the 1980s, with increased emphasis on seed funding for education, increased awareness, and models of good practice. This covers residencies as well as commissions, such as a rural residency in 1987 in association with Common Ground, and the appointment of an "urban explorer" in Gravesend in the same year.

Michael Fairfax was living temporarily in a caravan amidst woodlands near Uckfield in Sussex. His task, following a brief agreed with the host, a local farmer, was to create sculptures integral to the wood, marking a farm trail. This was in response to interest in the countryside from ramblers and tourists, and an attempt to channel that interest so that other areas of woods were left in peace. The "great storm" of October 1987 took place during the residency, destroying countless trees. By some chance, Fairfax found his major sculpture intact, with an oak bough resting neatly on its apex (*Fig 15*).

The residency was extended to allow him to work with fallen wood, making a "memorial to the trees" with damaged but growing wood. It was a new kind of residency, less dependent on community reaction, more on working with the qualities and materials of a given rural place. The artist was rather isolated during the work, but able to know the place intimately, through growth and destruction, in his nine month stay.

John O'Reardon was urban explorer for Gravesham Borough Council (Gravesend, Kent) for eight months. He worked with schools to develop new skills, such as mosaic, and with the local team of architects on publicity material for architectural walks through the town. Not only does the countryside need conservation; most towns have numerous

14. Antony Gormley, *Boulders,*
Singleton, Kent, 1979 (photographed
with graffiti, 1988) (M Miles)

15. Michael Fairfax, Sculpture
produced during woodland residency,
near Uckfield, Sussex, 1987 (T Bunney)

gems of ordinary but careful building, with detailing and local colour. He built up an archive of several hundred photographs, to increase visual and environmental awareness, and made drawings for an exhibition. The local authority, initially unsure what the residency would mean, where overwhelmed at its success. The material accumulated will provide a stock of images and ideas to last for some time. The artist here did not set out to "do his own work", but to use his visual acuity to explore the place, with a freshness that comes more easily to an outsider.

Both the rural residency and the urban exploration set interesting new models, moving away from the idea of residency as "commission plus board and lodging". To make good use of such opportunities, artists need to suspend their normal routine of studio confinement, and place their mainstream development in a secondary position to the needs of the place. This does not at all prevent them making art of high quality as well, but is a spreading of effort into broader, environmental concerns.

A new pattern of local authority commissioning is emerging. It hangs to some extent on *Percent for Art* schemes, though that is only one way to fund a better environment. More use of Section 52 is another avenue as yet little explored, perhaps because it depends on negotiation and co-operation on the part of developers, not on defined legal powers to refuse developments on aesthetic grounds.

Adoption of *Percent* schemes is increasing nationally. Awareness of the appeal of public art as environmental improvement, giving a sense of place, is spreading. There is not yet enough critical debate on the language, the subject or the process of public art, and there is only minimal coverage in the fashionable art press. Yet the climate is changing.

Local authorities may become the largest source of arts patronage, through *Percent* schemes, during the 1990s. They will need the expertise of the agencies, and they will need to work in liaison with Regional Arts Associations. So much has depended (during the '80s) on the work of a dozen or so individuals around the country, working on minimal budgets for administration and publicity. A higher profile and increasing professionalism will be possible as the patronage of public art increases. There is also a key role for education, to prepare artists and architects (and engineers and planners) to work together, and to prepare the administrators and advisers to enable *Percent* schemes to be successful.

In time, the private sector may take up the lead given by local authorities in commissioning art for a sense of place. As yet, it is the initiatives of local government, commissioning agencies and the Arts Council (and its regions) which have brought public art to wider notice. It has sometimes been a courageous effort. There have been mistakes, inevitably in such a new field, but the general direction is encouraging.

169

Chapter Fifteen

"PERCENT FOR ART" SCHEMES

"If there were only water amongst the rock "[1]

1988 was the year for conferences on public art. It was the year the Government became aware of votes in "green" issues, and the year the Arts Council of Great Britain formally adopted a policy endorsing a *Percent for Art* policy. The British debate on public art gathered momentum.

The British experience is a long way behind that of America, where schemes range from 0.2 percent from the Wisconsin Arts Board to the 2 percent of the San Francisco and the Sacramento Arts Commissions. In 1988, eighty authorities (state and city) had mandatory *Percent* schemes, with a further 20 adopting voluntary programmes of support. Forty-two states had a programme of some kind within their boundaries.[2] Not only are some schemes generous sources of commissions, but care in drafting policy is also evident. This gives artists the status of responsible professionals, encouraged to achieve the highest aesthetic standards, and ensures wide participation in the selection process.

Some national governments have introduced legislation for a *Percent* policy, including Canada and France. Italy brought in 2 percent provision as early as 1949. Britain's disinterest follows from a legacy of philistinism, the puritan ethic of austerity and plainness, and current policies of decreasing the activities and expenditure of central government (at odds with the increasing central control of areas such as education and taxation).

But a new attitude is emerging, amid greater awareness of environmental abuse and what can be done about it. Articles advocating public art have appeared in the art and architectural press (and in the medical press on art in hospitals). Not only artists, but architects and designers have called for *Percent* schemes. For example, Theo Crosby advocated the *Percent* idea to:

170

"provide a new and serious market for artists . . . for clients it would offer something enjoyable and positive, and often surprisingly profitable".[3]

Even the Minister for Arts has given support:

"I am actively encouraging putting art in public and private buildings. I am glad to see that there is much effective co-operation between the owners of buildings, developers, and artists in devising schemes which have enriched the environment."[4]

It is a beginning.

As early as 1983, a Select Committee recommended that both public and private sectors should consider giving up to one percent of the costs of new building projects for art. So far, only a small proportion of local authorities have adopted the idea, though the number began to increase rapidly from about 1987. Some large towns and cities, such as Edinburgh, Glasgow, Swindon, Birmingham and Sheffield, and some Counties, such as Oxford and South Glamorgan, have agreed in principle to operate *Percent* schemes. Amongst the first initiatives was that pioneered through the London Borough of Lewisham by Conrad Atkinson whilst artist in residence. He continued a successful campaign in Edinburgh, whilst artist in residence at the Talbot Rice Art Centre (*Fig 1*), and was instrumental in persuading the local authority to adopt the policy. They are now evolving suitable long-term mechanisms to implement it.

1. Conrad Atkinson, Installation at Talbot Rice Art Centre, Edinburgh, 1986 (J Rock)

To take one of the above cities as example: Sheffield, the fourth largest city in England, has as yet a poor record of cultural provision. It has no arts festival, no resident orchestra, no building of prime architectural merit, no venue for dance and no publishing house. It plans to host the international student games, or Universiade, in 1991, and sees this as an opportunity to build a stronger provision.

Artists may be commissioned in the games sites. A study by Simon Evans for the City Council states:

> "The vast programme of new building the city is undertaking for the Universiade will bring with it many opportunities for sculptures, frescoes, and other art structures . . . for public places." [5]

Parallel with the Universiade is a policy for a *Percent for Art*. In the overall budget for the games this would generate a large fund. It is these local programmes which will be the basis of British public art in the '90s, in the absence of any immediate prospect of central government legislation. In such large projects as the Universiade it will entail a partnership of public and private sector interests.

Sheffield's draft policy statement (1988) gives reasons for its support for the *Percent* scheme:

> "Art as part of the environment spells environmental improvement. It means revitalisation. It creates interest. It provides a human touch. It engages people. Art involves the community . . . Art employs. Art talents . . . are underused in society. At the same time old skills and crafts are being lost. Art helps investment. It is a sign of a place being alive and not barren. Art content in cities . . . helps produce more relaxed spaces . . ."

It emphasises the need for artists to be employed in the planning stage of development.

Sheffield is one of a handful of authorities to recognise the place of artists in the planning stages of projects. Other strategic leads are necessary if the *Percent* concept is to become widespread.

If more local authorities adopt *Percent* schemes, the provision of public art will be a major, possibly *the* major, source of patronage for artists. In this context, the role of agencies is likely to increase in importance. They are almost the only repositories of information and expertise specific to public art. They have detailed knowledge of planning and contracting procedures, access to a national network of contacts, exchange of information and insight through meeting together as Public Art Forum, and a commitment to the best models of practice.

The most recent agency to be established is the Public Art Commissions Agency in Birmingham. It advises on art for the International Convention Centre (opening 1991) and looks to an international collabora-

tion for artists, architects and organisations. The budget for the Convention Centre is large: in effect a *Percent* scheme, allowing major commissioning.

Its policy is to develop a programme of public art in the Birmingham area by:

"ensuring that work of the highest quality is produced in a context of full and appropriate consultation with the community for which it is intended".[10]

One of the first commissions is Raymond Mason's crowd scene representing the city's history. Other projects include a vast environmental design by Tess Jaray, in co-operation with the city's planners and architects. Working with sculptor Tom Lomax, Jaray is designing brick paving, seating and street furniture (*Figs 2 and 3*).

2. Tess Jaray, Designs for litter bins, Centenary Square, Birmingham, 1988 (P Cumming Associates)

In March 1988, the Arts Council of Great Britain adopted the *Percent for Art* concept, ten years after its first promotion of art for public places. It accepted that there was no prospect of legislation, and favoured "gradual persuasion" at a local level.

To pursue a campaign of promotion and education, the Arts Council, in liaison with Regional Arts Associations and the Crafts

3. Tess Jaray, Proposal for paving in Centenary Square, Birmingham, 1988
(P Cumming Associates)

Council, set up a Steering Group under the chairmanship of Richard
Burton.[6] The group was given a brief to explore arguments and strategies
for the *Percent*, over a period of two years. The headings for enquiry
were: Local authorities; Urban Development Corporations; the business
community; artists and craftspeople; architects and planners; education;
planning law; legislation and regulation. A legal report was obtained
from a leading QC in planning law.

The two thrusts of any campaign for more art in public places are
Percent schemes and "planning gain". The latter is a grey area, even to
many employees of local authority planning departments. Art is not
exactly included in the definition of planning gain (and promotion of the
arts is covered by other local authority responsibilities), but it is not
exactly excluded either. If landscaping is a frequent requirement in grant-
ing planning permission, is sculpture that different? It seems open to
authorities to encourage commissioning by developers, but not to coerce
them. Local development plans may offer more scope, since authorities
have some freedom as to what is written into them, but thus far this free-
dom has been little used for art.

174

This does not mean that aesthetic taste can be determined by a local authority committee. A central government guidance note states that, aesthetics being a subjective matter:

"Planning authorities should not impose their tastes on developers simply because they believe them to be superior. Developers should not be compelled to conform to the fashion of the moment . . . or be asked to adopt designs which are unpopular with their customers or clients".[7]

The definition of "unpopular" may be rather open, especially if quality is more expensive than mediocrity!

How can aesthetic standards (as opposed to taste) be regulated? State styles, such as Italian Fascist or Russian Socialist Realist, are not pleasant examples. Rather than attempt to determine mechanisms of control, it may be that encouragement of a rigorous critical debate is the solution. If public art received the extent and sophistication of criticism given art in galleries, the standards would rise. One problem is the lack of vehicles for such criticism in the art press.

Precedents in the USA are often cited as models of practice. Seattle is one example generally thought to be successful.[8] In recent years a number of American city councils have devised and adopted lengthy policy documents, setting out aims and procedures. In many cases, artists are involved in selection processes, as well as representatives of the community. The scale of patronage is impressive, and the fashion of the 1970s for large, steel objects in the plaza appears to be giving way to a more pluralist attitude.

In Chicago, there are over 60 sculptures in public places in the area of the "Loop". Some are early twentieth-century commemorative statues; others are works by internationally known artists, commissioned in the past twenty years.

In 1974 both a Chagall mosaic, the *Four Seasons* at First National Plaza (*Fig 4*), and Calder's *Flamingo* in Federal Centre Plaza were installed. Chagall donated the "concept" for the mosaic, which was made by craftsmen from hand-chipped fragments of stone and glass. In 1988, parts were removed for repair and reconstruction following weather damage during Chicago's icy winters. *Flamingo* was less controversial than the Calder piece in Grand Rapids, though similar in scale and character. Perhaps it fitted more easily amidst the city's extraordinary mix of architecture.

The commissioning policy has been heavily dependent on private donations. In several cases, the work was given by the artist, including the Henry Moore in Michigan Avenue. Picasso's untitled sculpture (1967) was donated as a design, with funding from a variety of charitable foundations for its construction in steel for a site on Washington Street.

4. Marc Chagall, *Four Seasons Mosaic*,
Chicago, 1974, under repair, 1988
(O Gonzales)

5. Jean Dubuffet, *Monument with
Standing Beast*, Chicago, 1984
(O Gonzales)

Similarly, Miro donated the design for his *Miro's Chicago* (1981) in mixed media at West Washington Street. Its construction was funded by the City and private sources. Dubuffet's *Standing Beast* (1984) was commissioned by the Illinois Capital Development Board, but with major contributions from private sources (*Fig 5*). This mix of state initiative and private money has produced a gallery of post-war art in the city's streets.

Not all the works are specific to their location, but neither were many of the statues of a previous generation of commissions. There was a flowering of such works during the early twentieth century, many in art deco style, matching the architectural heritage of the city. A typical example is the 30 foot high *Ceres* in cast aluminium by John Stoors (1930) at the Board of Trade Building in LaSalle Street. It was commissioned by the architects Holabird and Root, who designed several Art Deco skyscrapers. Being sited on the top of the building, its detail is lost to all but air-borne viewers.

Chicago's architecture can be overwhelming. Oldenberg's *Bat Column* (1977), a baseball bat rising to 100 feet, sits comfortably with the predominant verticality of the whole environment (*Fig 6*). Oldenberg spent his childhood in Chicago, and based the structure of the sculpture on pervading memories of the city's verticality, and on bridges and elevated structures he observed when researching the commission. The *Column*, in painted cor-ten steel, stands outside the Social Security Services Building, and was commissioned by the Federal General Services Agency through its Art in Architecture Programme.

Sol Lewitt's *Lines in Four Directions* (1985), was funded by the

176

6. Claes Oldenburg, *Bat Column,*
Chicago, 1977 (O Gonzales)

National Endowment for the Arts and Art in Public Places Inc., as well as
private sources. It consists of painted extruded aluminium, installed on
the end wall of an eight-floor building. It is divided in quarters, with lines
running vertically, horizontally and in two diagonals, one direction for
each quarter of the surface. In contrast to so many murals (and com-
munity murals began in Chicago), it is restrained and sophisticated. The
light causes shadows from the aluminium slats, which change through the
day. It offers a pause for reflection, perhaps, whilst also being a giant ver-
sion of Minimalist art as seen in galleries — almost a "designer-mural".

Cultural benefits are taken more seriously in the USA than in
Britain, and seen to contribute to the commercial desirability of a town.
The Phoenix 1990 plan was formulated in response to low forecast
growth and the relocation elsewhere of two companies (one to Seattle),
amongst other factors. A *Percent* programme was seen as vital in ensuring
the cultural growth of Phoenix, in turn attracting commerce. The "look"
of the city was to be upgraded by giving attention to the identities of dif-
ferent neighbourhoods, by improving gateways to the city through art
and landscaping, and by a major commission.

Thus the plan has three levels:

the community (neighbourhood);
the traveller (roads and airport);
and the centre (where an artwork could become a symbol for the city as
the Calder had at Grand Rapids).

Los Angeles has several precedents of employing artists in the redevelopment of residential districts, and the arts are its second biggest industry, above tourism. In 1985 the city adopted a comprehensive policy for the Downtown area. The rationale was stated as:

"Public art can become a major source of identity for a city. From the *Statue of Liberty* in New York to the *Watts Towers* in Los Angeles, civic pride can take concrete form in works of art. Public art can uniquely contribute to the life of a city by sensitively and creatively manipulating the man-made environment in places where city inhabitants, employees, and visitors congregate . . ." [9]

The current Los Angeles programme for Downtown Public Art grew out of the 1984 Olympics, and the need to improve the visual appearance of the city. The city became aware of Public Art, and a comprehensive set of guidelines on the subject was drawn up by Mark Pally, Director of the Community Redevelopment Agency (CRA) (*Fig 7*).

A $1\frac{1}{2}$ percent scheme provided the buildings of the New Museum of Contemporary Art, and most of its exhibits. It is an unusual programme in not confining Public Art to public spaces, but enabling all forms of public access to the arts. Before the new museum was completed, a Temporary Contemporary was set up in a disused police warehouse.

Within the scheme, artists are selected locally, nationally and internationally. The types of work range from studio-based to time-based, to installations, to permanent monuments. The scope of the programme goes beyond earlier efforts, such as the regeneration of McArthur Park. The budget can be used in a variety of ways, not confined to the immediate source. In other words, funds can be pooled for major investment, as in the new museum, or channelled into areas of particular need.

Some excerpts from the Policy (*Downtown Art in Public Places*, accepted by the City in August, 1985) illustrate the programme's procedures. The document begins with a general commitment of the city:

"to the involvement of the arts in the daily lives of its residents by implementing a wide variety of projects ranging from on-site installation of public art to facilitation of temporary exhibits and festivals to the development of cultural facilities . . ."

It also seeks a provision which:

"is diverse and of the highest quality; that will, over the decades, reflect the City itself and the minds of its citizens; that will improve the quality of life in the downtown area and be a source of pride to all City residents."

A distinction is drawn between eligible and ineligible costs. The first includes art, and all aspects of its production. The second includes (hence

7. Marc Pally at Public Art stand, Los Angeles International Contemporary Art Fair, 1986 (P Hill)

excludes from funding) signs which are not part of an artwork, mass produced objects, reproductions, things designed by architects and landscapers, and services or utilities. Hence no street furniture or regulation shrubs are paid for as art.

Three methods of selection can be used:

open competition;
invitational competition;
direct selection.

The choice is the developer's. But the selection is always done by an Art Selection Panel or an Art Consultant. The whole is monitored by the City's Arts Advisory Committee (AAC).

Panels may have 3, 5 or 7 members. The number of artists on each is regulated as 1, 2 and 2 respectively. The others are arts professionals (such as administrators or curators). The 7-member panel includes a developer or architect, and one member of the Project Redevelopment Committee. So how do they select the selectors? The document states:

"CRA staff will assist the AAC in determining panel composition by maintaining a file of potential panellists. Staff will contact invited panellists, confirm plans and arrange for panel briefings and selection sessions."

Selectors are paid for their services.

Artists commissioned are given briefing sessions, so that they:

"will develop a perspective indicative of the complex and variegated forces that come to bear on any one project."

They are involved in discussions with the developers and architects. The process also involves "future users" of the space; the CRA is, however, open to projects initiated by artists in and for their locality.

179

The programme seeks to integrate art into the visual fabric. The aims formulated by the Community Redevelopment Agency include forming a programme unique to Los Angeles, increasing access to art, involving the public, offering unusual opportunities to artists, encouraging women artists and minority groups, placing artists in design teams, and encouraging a pluralism and variety of solution.

There is no real distinction between public art and gallery art, since access and encouragement apply to both. There is recognition of the role of art in giving identity to the city, as in Phoenix, and the scheme is intended to "reflect the City itself and the minds of its citizens".

The selection process is the only way that the "minds of the citizens" can directly express a view. The Programme document states that the "process" should consider the:

> "complex set of needs that converge in the urban environment. Community members, developers and artists must have faith in the integrity of the selection process . . ." [10]

Artists play a significant role in the process, and dealers or agents with a profit-linked interest are specifically excluded. The procedure tries to balance the interest of consultation with that of professional expertise, though the composition of panels is heavily in favour of professionals rather than users of the space. This may represent an attempt at safeguarding the City from too experimental an attitude on the part of artists, or simply be the consequence of bureaucracy.

In time, any programme of sufficient generosity has room for calculated risk and a few disasters. The Robert Morris earth sculpture *Johnson Pit # 30* at Kent (Washington, 1979), with its black stumps of trees as a comment on man's treatment of nature seems, in retrospect, a participation in the ravaging to which Morris objected. It raises the question of whether public art is site-specific, or gallery art turfed out. *Johnson Pit # 30* is both: something conceived entirely in the art-world debates of the time, with a fashionable allusion to ecology, yet specific to its site because it is the site which is altered. Part of the problem has been that art-world debates are impoverished when compared with the unifying philosophies of previous ages, from which their public art was created.

In a pluralist society, with global news, what does art do? Jerry Allen writes:

> "Public art addresses a context that is both broad and heterogeneous. It enters an environment which removes art from the privileged and specialised status of the museum into a much wider realm which involves entertainment, politics, urban sociology and economics." [11]

Most *Percent* schemes retain the specialist role of the artist, rather than

developing community arts in which everyone becomes an "artist" for the day. They are generally concerned with open spaces used by a variety of groups. Selection is part of the solution, but full access may be possible only if there is a shared language, emanating from a shared value system.

One aim of the recent two-year planning process towards a *Percent* policy for Dallas (Visual Dallas) is to "ensure widespread community support" [12] for a programme which integrates artists into design teams.

As in Phoenix, one of the motives is financial. The document cites a local journalist:

> "For those who cannot see beyond the bottom line, there are strong economic reasons for maintaining a vibrant cultural and artistic community. The arts mean money, big money."

There is an interesting contrast between the depreciation of most city assets — its capital expenditure on roads, bridges, etc., which need eventual replacement — and art collections, whether indoors in museums or outdoors in plazas. The Dallas plan notes the appreciation in value of the Henry Moore at City Hall, bought for $400,000 and now worth some $3,000,000. Such figures are notional, but a used road is not worth very much!

Visual Dallas is a $1\frac{1}{2}$ percent plan, with $\frac{1}{4}$ percent going to conservation, $\frac{1}{4}$ percent for community education, and 1 per cent for art and artists' services. A budget for education ensures, in the only effective way, an outreach programme, perhaps the difference between acceptance and rejection by communities. To oversee the whole programme a voluntary committee of "citizens" will be constituted.

The research group toured Dallas extensively, urban explorers in their own city. They observed an aridity in the central area, designed for international business but dead after 6pm:

> "Block after block of buildings with blank walls are at street level, windowless facades pushing the narrow sidewalks against the traffic." [13]

Against this they proposed the concept of the marketplace in which people congregated, their busyness being a direct, personal matter, not the remote transactions of computer screen and fax machine. The new sensibility created by transforming the fragments of commerce, automobile fumes and housing districts into a whole entity might also reverse the trend of violence. It was in Dallas that John F. Kennedy was killed.

The plan is far-sighted in seeing art more as a catalyst than a monument. As people engage in public art, through consultation and criticism, they become more aware of the visual environment, and may accept more responsibility for it. From that come higher expectations of city planning and urban design. One reason for urban blight is that there was no critical

reaction, only a meek acceptance of the acts of specialist planners. Visual Dallas states:

> "As citizens participate in the public art process they, too, become actors rather than reactors. In this they assume their rightful role as members of the team, giving a new order and identity to their own visual environment."

Outreach activities began in the formation of the plan. About thirty-five special interest groups were contacted, and seven departments of the City. Slide presentations were given and a few pilot projects initiated. For example, artists were invited to work with engineers on erosion control structures on local waterways. Five local artists were involved in this. Parallel to Visual Dallas, a plan was evolved for public transport, and an inventory made of the 104 extant artworks in the City.

The two innovative aspects of the programme are its insistence on education, including arts in schools, with commissioned artists being obliged to take part in such activities; and the emphasis on collaboration. Significantly the erosion project set the scene for bringing together members of different professions working with the environment. The groups noted in the plan include artists, architects, and landscape architects. Public funding for development requires, under the plan, the involvement of appropriate collaboration, with artists included at the design stage and on equal footing. This goes far beyond the cosmetic solutions of the past decade and is a real hope for future development of a holistic approach to the environment.

The sums involved in American *Percent* schemes are large, and each project is adequately funded. Whilst a British commission of, say, £20,000 seems impressive, in New York, for example, the budgets have ranged, since the adoption of a *Percent* in 1983, from $10,000 to $400,000. By 1988, $3,581,339 had been allocated for 34 projects.

Apart from New York City's percent scheme, there are separate programmes for Battery Park City, land reclaimed from the river at the southern tip of Manhattan, and for the public transport authority. In addition, there are over twenty private and public sector organisations and groups offering sponsorship for temporary public art.

Most of the current projects in New York are collaborations. The city is already well provided with large public sculptures, by Picasso and Dubuffet amongst others. Some projects could be described as environmental design, and are partnerships between artists and architects. Andrea Blum is working with Cavaglieri & Sultan on proposals for the East 107th Street pier (*Fig 8*), and Scott Burton with Koenen associates on proposals for the Sheepshead Bay Fishing Piers. In both cases the art presence is integral to a holistic approach. At East 107th Street:

8. Andrea Blum (with architects Cavaglieri & Sultan), Proposal for refurbishment of East 107th Street station, New York City, 1987 (E Ripling) (by permission of New York City Percent for Art Program)

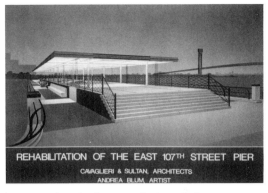

REHABILITATION OF THE EAST 107TH STREET PIER
CAVAGLIERI & SULTAN, ARCHITECTS
ANDREA BLUM, ARTIST

"Working as a team, the architects and artist have redesigned the colour scheme, the paving pattern, the roof penetrations, the edge of the roof, and the railing details . . ." [14]

Valerie Jaudon, a painter, has produced designs for new paving at Police Plaza, between New York Police Headquarters and the Municipal Building. The design, in tan, grey and red brick, both relates to patterns of pedestrian movement, and reclaims the original 1910 pavement layout (*Fig 9*). A large circular design in granite acts as a focal point (*Fig 10*). The concerns, for an ease and pleasure of the space, and constraints, of function and circulation, are similar to those of Tess Jaray's proposals for a brick pavement in the Birmingham Convention Centre project. Jaudon writes of her design:

"Surrounded by the Civic Centre and the Brooklyn Bridge, this art project is intimately woven into the fabric of downtown Manhattan. My goal is to unify the three-acre plaza by using materials and proportions already at the site and by drawing attention to its major visual axis. I also want to clarify the sense of place in each area of the plaza and make the pedestrian traffic passages more human in scale. . . ." [15]

The proposal received a design award from the Arts Commission. Projects funded through a *Percent for Art* go beyond the sculpture as counterpoint to a building. A lot of examples are low-key interventions, either within residential areas or in public utilities. Environmental art is as important as major monuments or emblems.

Battery Park City offers some of the more recent examples of collaboration. Artists Scott Burton and Siah Armajani worked with architect Cesar Pelli from 1983 on the waterfront plaza before the World Trade Building, at the insistence of the Battery Park City Authority, and against initial doubts from Pelli. Ned Smythe created the *Upper Room*, looking

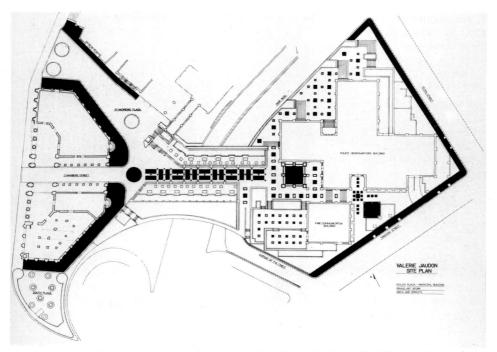

9. Valerie Jaudon, Proposal for Police Plaza Municipal Building, paving and planting, 1988 (V Jaudon)

10. Valerie Jaudon, Proposal for Police Plaza Municipal Building, paving and planting, 1988 (V Jaudon)

like an architectural fantasy but with a sculptural reading of space (a sense of object not function) in 1987. These projects involved each professional

184

relinquishing autonomous control in favour of co-operation. This may not always be appropriate, but seems very much so in new urban developments where the aim is to create a whole environment.

The American provision of public art has a long history: from the commissioning of Luigi Perisco to make statues of *Justice, America* and *Hope* for the Capitol in 1825, through the Federal Art Project of 1933, to the declaration in 1954 by the Supreme Court that public welfare included aesthetic matters, and the first *Percent* scheme set up in Philadelphia in 1959. Collaborations between artists and architects, some of the earliest being in Seattle for the National Oceanic and Atmospheric Administration, form the most recent episode in the story. No doubt more ideas will emerge in due course. The context is pluralism, not a quest for a single formula for funding or commissioning.

What can be learnt from the American example?

It seems that art is accepted as a part of daily life, and as an agent in improving the feeling of cities. It is also big business. The *Percent* schemes of the USA are simply a method of funding. By legislating at a state or city level, enough money is made available to ensure adequate fiscal provision, and that projects are professionally administered and effected. There could be other ways, but a mandatory provision built into planning law seems the only certain way to set aside money for art. It could be argued that, if art is beneficial, for example in reducing crime by assisting in rehabilitation of areas, then developers will fund it anyway. But without the precedents of past schemes, such benefits would not have been known. Where risk is involved, and art is inseparable from risk, a public sector lead is often necessary. Again, to ensure experiment and a creative evolution, the public sector needs to show initiative.

The new directions in American projects are outreach activities interlinked with education, and the integration of artists in design teams. Examples in several cities, such as Dallas, New York and Seattle, show the advantages of involving artists in the design stage of a project. It not only avoids cosmetic solutions, but brings in a dimension of lateral thinking, seeing artists as problem solvers.

Perhaps the most important encouragement from the USA is to be adventurous. If the scale of commissioning is wide enough, there is room for catholic taste. Public art needs research and development. In some disciplines this is provided by Universities; in art over the past few centuries it happened in studios, extending into exhibitions and critical response. Public art depends on live reactions, and real sites. Even with greater educational provision at advanced levels, the cities themselves will remain the testing grounds.

It may be only when a *Percent* scheme is introduced that enough resources are available to allow for experiment, and for outreach and access. Within a public sympathy built up through consultation and

involvement, over a period, there is room for "difficult" work, just as for more populist work.

Most American schemes regulate the composition of selection committees, ensuring representation of professional artists. They do not attempt to define an aesthetic standard in other than the vaguest and most open terms. To do so would lead to a sterile imposition of one taste. Yet aesthetic standards need to be high. It is critical debate that assists this. In the USA there seem to be more outlets for it than in Britain.

With eighty *Percent* schemes in operation in the United States, there is a wealth of experience. The idea would not have spread if it did not work. It does work, and is still developing in adventurous ways.[16]

FOR THE NEEDS OF THEIR OWN SPIRIT: ART IN HOSPITALS

Richard Cork

In 1984, impelled by a mood of uncompromising Orwellian pessimism, Richard Hamilton exhibited a large and austere interior utterly devoid of comfort. Determined to make his room reflect "the present consciousness of depression", he created an ambience familiar to anyone who has inhabited "a dentist's waiting room, a prison cell, a Labour Exchange or anywhere in an NHS hospital." Hamilton explained that the prevailing character of the early 1980s drove him to produce a work "inspired by the bleak, disinterested, seedily clinical style of the establishment institution", but once the visitor entered this disconcerting chamber Hamilton ensured that its medical overtones soon became dominant. Lit by faintly flickering fluorescent tubes, the first corner contained a stainless steel sink armed with aggressively pointed tap-handles and a cruel grid clamped over the plug-hole. Nearby stood an ICI bottle of Hibiscrub, described by its label as a "rapid bactericidal skin-cleansing solution for hand disinfection prior to surgery." The mood of tense expectancy was heightened by a blood-red plastic bucket placed in another corner of the cream-coloured interior, and then confirmed by the impersonal Bosch monitor winking soundlessly with green digits and crimson spots.

But the most chilling moment of all came with the view through the window set into a white partition. The wire-mesh glass disclosed an inner sanctum where a hard wooden bed lay empty, as if waiting for a patient to be placed inside the thin orange blanket lying on its uninviting surface. Closer inspection of this area revealed a gleaming machine suspended over the bed, like a scanner or an observation camera. Its sinister presence was accentuated by the warning notice attached to the back, which coun-

selled "CAUTION. TO PREVENT ELECTRIC SHOCK, DO NOT REMOVE BACK COVER. NO USER-SERVICEABLE PARTS INSIDE." An unavoidable shock was provided by the screen on the other side of the machine, however. Pointing down towards the blanket, it transmitted a continually replaying video-tape of Mrs Thatcher delivering a Party Political broadcast. Dressed in Tory blue, her face enlivened by a gash of pink lipstick and an immaculate blow-wave hairstyle, the Prime Minister gave an animated and characteristically forceful speech. But the sound had been switched off, and so the words she mouthed with such vigour looked like empty sentiments. The absence of sound also encouraged a more detached appraisal of Mrs Thatcher's performance, as a scripted propaganda exercise read by a consummate politician whose eyes continually darted towards the left of the screen to read her autocue with flawless expertise. A poignant visual contrast was established as well, between the Prime Minister's warm, book-lined and flower-adorned room with its rich damask curtains, and the stark emptiness of the interior at which she directed her message.

Hamilton's motive for including this specific political reference in his room seemed understandable enough. All the same, his target was wider than the shortcomings of a government whose attitude towards the National Health Service has often seemed uncaring and even destructive. For the atmosphere recreated in this cheerless interior is not simply the result of political dogma. It arises from a wider social attitude towards hospitals, which ensures that they present the visitor with an environment where everything seems calculated to unnerve and disorientate. "The essential characteristic of such a space", Hamilton wrote when his room was first displayed, "is the way it implies an impartial energy; we shall, if we wait our turn patiently, be given the treatment. This threatening mood is intensified by the suggestion that what is good for us might not be good for them; whenever I am X-rayed, the retreat of an operator to the cover of a protective screen before pressing a button makes me uneasy. When the doctor ostentatiously washes his or her hands the unkind thought that they are disassociating themselves from the unclean customer must occur to many of us. Surveillance is prevalent; one way mirrors and closed circuit video security systems are the ubiquitous overseers of public spaces."

Hamilton made an unfavourable comparison between the mood of his 1984 room and the "brash expectations" of "a confident, starry eyed Utopianism" which had inspired his first exploration of the "interior" theme in 1956, above all with his satirical yet exuberant collage *Just what is it that makes today's homes so different, so appealing?* Before then, however, other artists had already found in the hospital an image of desolation bordering on outright despair. Commissioned by Ancoats Hospital Medical Committee to paint a picture of the building's Out-

patients Hall in 1952, L. S. Lowry did not hesitate to reveal the disconsolate ugliness of a place which intensified the anxiety of the people obliged to endure its drab depression. Lowry, who knew precisely how to disclose the loneliness of the individual even when he depicted the urban crowd at its most proliferating, defines the acute sense of isolation assailing each of the patients assembled in this gloomy interior. The interminable waiting experienced by its inhabitants is made still more irksome by the surroundings they are forced to contemplate. Only the white-coated doctor retains a semblance of cheerfulness in this dispiriting locale, and he is set apart from the cluster of dazed, forlorn figures condemned to sit on the hard wooden benches. Some stare at the patient passing on a trolley, while most of them make no attempt to alleviate their isolation by conversing with their neighbours. No wonder the Ancoats committee eventually presented Lowry's painting to the local art gallery: the image he had produced was probably too disturbing to be hung in the hospital for long.

The alienation defined with such relentless insight by Lowry's painting remains, nevertheless, a sadly familiar phenomenon. The dismal truth is that the visual condition of most hospitals leaves an enormous amount to be desired. With few exceptions, they can be classified into two equally deplorable groups. There are the old and dilapidated buildings, beleaguered by poor lighting, dreary colour schemes and a general air of neglect which unnerves the people forced to enter their decrepit premises. Then there are the new, dehumanised alternatives, where brightness often appears alarmingly clinical and patients easily feel dwarfed by impersonal vastness. They may be functional, but they are certainly not beautiful. Hospitals, which are supposed to help us get better, often seem bent on making us feel a great deal worse.

Even the most up-to-date skyscraper buildings, of the kind that Philip Larkin likened to "a lucent comb" extending "higher than the handsomest hotel", have the ability to induce disquiet or even outright dread. Unlike welcoming hotels, Larkin wrote,

The porters are scruffy; what keep drawing up
At the entrance are not taxis; and in the hall
As well as creepers hangs a frightening smell.

There are paperbacks, and tea at so much a cup,
Like an airport lounge, but those who tamely sit
On rows of steel chairs turning the ripped mags
Haven't come far. More like a local bus,
These outdoor clothes and half-filled shopping bags
And faces restless and resigned although
Every few minutes comes a kind of nurse

189

To fetch someone away: the rest refit
Cups back to saucers, cough, or glance below
Seats for dropped gloves or cards. Humans, caught
On ground curiously neutral, homes and names
Suddenly in abeyance; some are young,
Some old, but most at that vague age that claims
The end of choice, the last of hope; and all

Here to confess that something has gone wrong.

The environmental malaise Larkin defined often announces itself from the outset, in the entrance, which should be the most inviting part of the building. A cornucopia of signs and notices invariably bombards the visitor, pointing in such a bewildering variety of directions that they seem determined to disorientate rather than inform. This avalanche of words and arrows immediately introduces the note of peremptory command which is so characteristic of hospital life, and the eye finds nothing to rest on as it struggles to make sense of all these conflicting signals. Even when visitors finally sort out which avenue to pursue, they are likely to find themselves negotiating the most unsettling area a hospital has to offer: the corridor. Whether cluttered with wheelchairs or disconcertingly deserted, as claustrophobic as a tunnel or so enormous that it diminishes the people passing through, this ubiquitous space usually stretches ahead into an intimidating distance. Long corridors were created for impeccable reasons by supporters of the Nightingale structure, which uses immense thoroughfares to light and ventilate the wards running off them. Corridors also promote contact between staff who naturally find themselves meeting there, and they help to minimise cross-infection and noise by ensuring that wards are separated from each other by a substantial distance. But they offer vistas of Kafkaesque proportions, thereby exacerbating the sense of deadening uniformity which hospital architecture is adept at promoting.

Nor does the visual assault lessen once a destination has been reached. It may even grow worse, for the rooms designated as waiting areas can display a devastating amalgam of irritation and dereliction. Hugh Baron, a consultant physician at St Charles's Hospital in London, has trenchantly summarised the prevailing horror of halls "filled with broken chairs, tattered magazines or blaring televisions, ashtrays, and countless notices, hortatory or admonitory, ranging from injunctions to tell the desk if you have changed your name or your family doctor to warnings about smoking, drinking, and the problems and consequences of life after sex." It all amounts to a damning catalogue of discomforts, and by the time hapless patients at last succeed in consulting specialist opinion they often feel thoroughly shaken by the experiences they have undergone.

As for the patients who occupy hospitals on a short or long-term basis, they have to suffer the effects of their environment without respite. Some may be fortunate enough to find themselves in a building where positive attempts are made to match medical care with surroundings equally dedicated to the promotion of well-being. But for every hospital which ameliorates its patients' ailments with the aid of congenial surroundings, there are thousands of others where conditions are miserably inadequate. And the tragedy is that these shortcomings are normally the result of chronic financial constrictions. After studying the social and architectural history of hospitals in Europe and America since their inception, John D. Thompson and Grace Goldin pointed out in their magisterial survey that "hospitals have a way of being conceived in glory, executed with ingenuity and humanity, then subjected in use to misuse and abuse, finally to be overcrowded and understaffed and always and forever plagued by insufficient funds. A hospital before death can become more decrepit than a man. The man dies, but a moribund hospital may live on for decades—and, what is so terrible, filled to capacity."

In such a context, authorities experience understandable difficulties in justifying expenditure on works of art. At a time when money for essential technical facilities is becoming more and more limited, in Britain at least, hard-pressed hospital staff find it hard to argue in favour of the contribution which artists can make to their working environment. But the fact is that the medical equipment and expertise offered by a hospital should never be viewed in isolation. The quality of a hospital's surroundings is a vital element in any attempt to restore a patient's health. Indeed, the spiritual well-being of people who are ill is now increasingly recognised as an important factor in their ability to make a swift and full recovery. If they are incarcerated in buildings which make them feel uneasy, or intolerably nervous, the odds are stacked far more heavily against their ability to get well.

In a widely influential and passionately argued book called *Limits to Medicine*, which concluded in 1976 that "the medical establishment has become a major threat to health", Ivan Illich pointed out that "the patients who have suffered cardiac infarction themselves tend to express a preference for home cure; they are frightened by the hospital, and in a crisis would rather be close to people they know. Careful statistical findings have confirmed their intuition: the higher mortality of those benefited by mechanical care in the hospitals is usually ascribed to fright." One of the main causes of their anxiety can be traced to the dehumanisation of language and professional attitudes. "In a complex technological hospital", Illich has observed, "negligence becomes 'random human error' or 'system breakdown', callousness becomes 'scientific detachment', and incompetence becomes 'a lack of specialised equipment'. The deperson-

alisation of diagnosis and therapy has changed malpractice from an ethical into a technical problem." G. F. Newman, who spent three years researching every aspect of the care provided in fifteen major hospitals before writing *The Nation's Health* in 1983, proposed that, in order to "help people get well, orthodox medical practitioners have to stop looking at symptoms in isolation (the honourable exceptions already have), they must resist responding to patients as if they were some mess thrown up in a paper bag, and start treating them as people . . . That doesn't simply mean the physical whole but includes the emotional, psychological and, yes, the spiritual body also." The same argument applies to the spaces which patients find themselves occupying. Hospitals should take the *whole* person into account, not just the localised ailment, and acknowledge that most people admitted for treatment are frightened by the unfamiliar clinical environment they are obliged to inhabit.

The innate conservatism of hospital staff, combined with an instinctive mistrust of anything which might disturb the prevailing institutional equilibrium, militates against the whole notion of experimenting with artists. But this hostility and inertia can be overcome. Experience has shown that once art is introduced to a hospital, even the most hardened sceptics come to appreciate its unique value. They realise, too, that there are many different kinds of art, none of which should be imposed on the hospital without proper consultation. Paintings on walls are only one possibility, and if they are deemed unsuitable other solutions can readily be found. Artists today are becoming far more sensitive to the particular identities of the settings they are asked to enliven. If a location seems to demand a sculpture, a mosaic, a stained-glass design, a decoration in ceramic or an image employing the resources of photography, any of these can be provided by the appropriate artist.

Hospital staff need not be over-concerned about disturbing the patient with unfamiliar images. Anything unduly alarming or disorientating should of course be avoided, and the power of association can sometimes cause people to feel distressed by a colour or a form which the artist intended to be viewed in a quite different way. But there would be no point in trying to place art inside and outside hospitals if its makers became oppressed by the obligation to play safe and automatically produce anodyne work. Excessive caution results in bland and unremarkable art, which might well be overlooked by the audience it is intended to delight. The overriding priority must always be to stimulate staff, patients and visitors alike with images which enhance their lives.

Hospital administrators ought never to make judgements as arbitrary as the censorship imposed on the painter John Hewett, who in 1985 was commissioned by St Bartholomew's Hospital to execute a mural in the swimming pool of the nurses' home. Having been encouraged to produce "something sporting and Grecian", he depicted a group of nude

male athletes in action. One of the figures was represented in a frontal position, and the hospital administrator Ken Grant received complaints about the prominence of the man's genitals. So Hewett, like many artists before him, reluctantly consented to make them "smaller and lighter". But Grant was still dissatisfied, and without consulting the artist he ordered that the entire mural be whitewashed. He attempted to justify his manoeuvre by asserting that the mural "could have been seen by parents who are bringing their seventeen and eighteen year-old daughters to see if this is a suitable place for them to do their training." In order to expose the absurdity of this argument, it is only necessary to consider the other murals executed in St Bartholomew's over 250 years ago. For Hogarth was quite prepared to depict not only nakedness, but severely wounded and diseased bodies in the monumental paintings he carried out for the Great Staircase. If Mr Grant had been the administrator in 1736, he would presumably have insisted that Hogarth exclude from his *Pool of Bethesda* canvas all references to gonorrhea, syphilis, Down's Syndrome and chlorosis. Or would he have whitewashed it completely, along with the painting of *The Good Samaritan* which Hogarth went on to produce, with the victim's gashed body openly exposed? Artists deserve to be protected from such zealous interference, and hospitals must always reserve the right to house work as uninhibited as Hogarth's irrepressible decorations.

Compared with the relief and hope which medical treatment often provides, art's potential contribution to a hospital may seem nebulous. It would be foolish to guarantee any curative powers for the work artists produce, and they would be entirely right to dismiss the suggestion that their work might somehow be transformed into a visual placebo. No artist should be expected to create images capable of "making people better": such a presumption is ridiculously naïve, raising expectations which art cannot fulfil. Moreover, viewers react to painting and sculpture in notoriously unpredictable ways, and some will always remain indifferent to visual imagery. But if art cannot claim to restore health, or even to elicit a positive response in the onlooker, it still performs a vital role within the medical context.

For hospitals contain a huge potential public for the artist's work. Michael Stewart, chairman of the admirable Paintings in Hospitals charity which administers a loan scheme for an ever-growing collection of modern art, has emphasised that "every day more people walk through the wards and corridors of a single large hospital than enter the Tate Gallery." Although some patients may be too ill, senile or busy to notice, many of them have an unusual amount of time to spare for contemplating their surroundings. They may also be highly susceptible to art's influence. The inhabitants of a hospital are, after all, undergoing a profoundly abnormal experience. Deprived of the reassuring props and rituals which

support their usual existence at home, they are at their most vulnerable. Accordingly, they may well be more open to intense experiences and emotions. Their reactions are often heightened, and art is well-placed to take advantage of their receptive state of mind. Through the workings of the imagination, it can provide exhilaration, solace, vicarous satisfaction and redemption in a multitude of forms. It may thereby be able to play a crucial role in the all-important spiritual battle which patients often find themselves experiencing. "Illness gives one a licence, a generosity and often a pity for oneself, that in a precariously organised being can have the most disconcerting results", explained Laurens van der Post. "It brings the individual face to face with a purely individual problem. He may have long lost sight of himself in the social pattern, but in illness his eyes are turned inwards. He is struggling with a condition that primarily can annihilate or change only himself. And that private inward world, which has hitherto seen in the balance of his actions merely an attempt to silence or crush it, finds in this struggle which he wages, not for abstractions it cannot understand but for himself, the hope that he is changed from an enemy into an ally. It brings to his attention doubts, desires, memories which his actions have long since ignored, and clamours for a wider share in the future life he is to lead."

Ideas about the patients' needs, and how art might satisfy them, have varied enormously over the centuries depending on the religious inclinations and medical priorities of the authorities controlling the hospitals concerned. The structure of belief which brought Grünewald's Isenheim Altarpiece into being is clearly very far removed from the convictions which lie behind Rivera's immense fresco for the Hospital de la Raza over 400 years later. But both these works, for all their evident and multiple differences, are united by their makers' hope that people viewing them might in some way have their perception of life altered by encountering these images. Mark Rothko, who often feared that explaining his art in verbal terms might cause "paralysis of the mind and the imagination", nevertheless succeeded in writing a poignant and heartfelt definition of his own faith in the ability of painting to sustain and enrich the onlooker's innermost being. "If I must place my trust somewhere", he once declared, "I would invest it in the psyche of sensitive observers who are free of the conventions of understanding. I would have no apprehensions about the use they would make of the pictures for the needs of their own spirit. For if there is both need and spirit, there is bound to be a real transaction."

I have adopted a phrase from this remarkable credo as the title of my essay in the belief that it summarises, very movingly, the role that art can play in our lives. No spiritual needs could possibly be more acute than those harboured by hospital patients, and an artist's work is able above all to humanise their surroundings, infusing its soulless and impersonal ambience with an affirmation. Matisse, who painted some of the

twentieth century's most impressive images for architectural settings as disparate as a Moscow mansion and a Philadelphia museum, explained in a celebrated statement that "what I dream of is an art of balance, of purity and serenity, devoid of troubling or depressing subject matter, an art which could be for every mental worker, for the businessman as well as the man of letters, for example, a soothing, calming influence on the mind. "Far from aiming at an art of superficial decoration or entertainment, Matisse aspired towards "a higher ideal of grandeur and beauty" by raising decorative art "to the level of philosophy". Nothing could be more ideally suited to a hospital than a top-flight Matisse, and the immense *papier collées* which brought his career to such an exuberant conclusion can stand as prime examples of the vitality and sensual celebration art can bring to the spaces it animates. But Matisse's lifelong pursuit of "*luxe, calme et volupté*" is not the only kind of vision capable of transforming medical dreariness into a more heartening alternative. The many distinct requirements of a hospital can be met by a corresponding diversity of images: whether formal or intimate, permanent or changing, festive or austere. Each building has its individual wants, and ways can be devised of satisfying them if the artists are sufficiently supple and responsive to the specific challenges presented by the sites they are given.

As more hospitals become obsolete and new ones are planned, the opportunities for art will grow. But they can only be seized if all concerned — the health authorities, hospital staff, architects and artists — have a vision of the possibilities that could be realised. For the hospitals of the future offer far more than can ever be gained from trying to improve the ugliness and inadequacy of existing buildings. Artists could work hand in hand with architects on the designing of new buildings, and learn how a genuine collaboration can be achieved. Just as the administrators of the Hospital Church at Illescas commissioned from El Greco an elaborate and innovative installation which fused painting, sculpture and architecture in a proto-Baroque unity, so tomorrow's hospital builders could make visual art an integral part of the structures they create. Such collaboration should eventually become widespread, but it must never deteriorate into routine predictability. Each new hospital ought to be regarded as a special event, offering its own particular set of challenges to artist and architect alike.

Nor is this simply an idle hope. Architecture is undergoing profound changes at the moment. More and more if its practitioners are now realising that extreme functional austerity can be replaced by richer and more humane approaches to building. Ornament is no longer automatically regarded as a crime, and young architects today are becoming more open-minded about the possibilities inherent in working with artists. This change of thinking will, in turn, help artists to develop a more positive attitude towards working in architectural contexts. Rather than fearing

the threat of compromise and loss of autonomy, they could learn to view the prospect of large-scale projects with the same enthusiasm as the artists of the Renaissance. It would, of course, be foolish to fantasise about recreating the cultural vitality of Quattrocento Italy in our own time. But a rebirth of belief in a fruitful marriage between art and architecture in the late twentieth century and beyond is not a wholly irrational dream. It all depends on the strength of our desire to see art play a central part, not just in museums and galleries, but throughout society. Hospitals deserve to become a special focus for this development. Many critical moments in our lives occur there, from birth through to death, and they ought to take place in surroundings which honour their true significance.

This essay originally formed the introduction to Richard Cork's Durning-Lawrence Lectures, delivered at University College, London, in autumn 1987, which examined the history of art made for hospitals from the Renaissance to the present day. They form the basis of his book, For The Needs Of Their Own Spirit, to be published later this year by Yale University Press.

EDUCATION FOR PUBLIC ART

"pernicious aren't they, these public art courses that keep springing up!"

So said the co-ordinator of a major public art event. She may have spoken for many. There has been some doubt amongst public art administrators as to the implications of courses bringing public art into institutional education.

There are legitimate questions as to how education should approach the practice of public art. There are understandable, if unfounded, fears that courses undertaking "live" work will deprive artists of commissions. There are some examples of bad practice. Yet there is clearly a need to prepare graduates for a career which includes making art for public places.

Courses may have the positive effect, in the long term, of extending and developing the field of public art, and of developing awareness of the public role of artists. Questions as to codes of practice are being addressed, and those "pernicious" courses may in time be seen as making a central contribution to the growth of successful public art. They may be the subject's research and development area, and may bring about changes in the balance within art education as a whole.

Fine Art has established one of the most adaptable models of higher education. The keynote is lateral thinking and transferable intellectual skills. By solving one set of problems, students gain a method of problem-solving that can be applied to many others. This is underpinned by the vital activity of taking creative risks within the ethos of a liberal education.

This model can be extended into public art courses. However, a series of new, identifiable skills can be introducd in order to prepare students to work in public contexts. Essentially these are skills of communication, but they reflect a new attitude. If the text uses words such as presentation, negotiation, consultation, then the sub-text is a new

approach to what artists do. The new role implies a willingness to work with others, not all of whom may be artists, and to come out of the studio cubicle into a less isolated world.

ENDING THE ISOLATION

British education reflects the wider fragmentation of life and knowledge. Not only is labour subject to division, but so is everything taught in schools and Colleges. Art, design and architecture, all part of a concern for the visual, are split into separate courses, sometimes in separate institutions. It is not surprising that artists, designers and architects have little history of working together in our society. Only if mutual respect of differences is learnt at the formative stage of first degree courses, will such a divide be overcome in professional practice.

There are other professions and their training to consider, such as landscape architecture and engineering. Most major projects of urban refurbishment will include in the team a civil engineer and a landscape architect. No doubt their education has a similar narrowness, and that of town planners, if judged by the product, seems to be pure tunnel vision.

Our environment will remain an impoverishment until artists work with other professionals and with the users of the space to transform it into something cared for and conducive to well-being.

Such sentiments may seem fanciful in a time of opportunism and a culture of self-interest, but it is the purpose of education to encourage a sense of value, and that is one thing to which artists can contribute. Art also acts as a focus for feeling and human sympathy, both qualities lacking in much urban development. It is not inconceivable that such qualities could be integrated into the practice of design and architecture, and in the way cities are planned or parks planted — not inconceivable but perhaps at present fanciful.

If links are to be made, then a greater understanding of variance in educational strategies will be needed. There are four main areas of divergence.

For the most part, fine art courses are practical in emphasis. The balance is heavily in favour of learning by doing and for doing, and for judgement of things, not ideas. This is not to devalue the importance of ideas and content in work. The more interesting courses have moved well away from being craft courses in art, and motivation, discourse and context are increasingly debated. Yet the emphasis remains on practical work, and on completing that work. However experimental, nearly all the work in degree exhibitions is finished.

In an architecture course there is no equivalent "finished" work. Architecture students do not receive a degree for making buildings, only for drawing them. They make models, visit sites, and have lectures from

structural engineers, but the emphasis is conceptual.

Architecture degree courses revolve around projects to a greater extent than fine art courses. For the latter, these may be plentiful in the first year and thin out thereafter, whilst for architecture the whole course may be structured through a series of projects and a greater input of lectures. Hence an architecture degree is a more conceptual affair conducted through a progression of briefs on which students not infrequently work in groups.

The type of drawing done by art and architecture students also differs. The classic art drawing is expressive, deals with feelings about the world and self. The classic architecture drawing is the product of systems and perspectives designed to eliminate feeling in favour of "objectivity". It may be that one reason for the awful inhumanity of much post-war architecture is precisely this exclusion of the area of feeling from how buildings are conceived. The neatness of architectural drawings and plans does not permit much risk. Without risk, where is the space for expression?

Whilst most fine art students work very much on their own, creating unique objects out of singular experience, architecture courses involve team work. Projects may begin with a group briefing, end with a group criticism, and in between involve delegation of tasks within a cooperative effort. In art schools, only in film is there an equivalent team approach, although many monuments of past art were produced by more than one person.

The ideology of individualism has caused fine art to set up a model of solitary confinement in the studio, and cast suspicion on any "interference" by other than the author of the work. This does not sustain much scrutiny as a philosophy, especially when it is considered how ideas and images are derived from cultures.

By contrast, architects, however much they make a name for themselves, always work with others to create a building the authorship of which is multiple. They may affirm a hierarchy, but they still work through committees, patrons and contractors.

So there are four major areas of difference out of which each subject could develop an understanding with the other:

the balance of conceptual and manual work;
the extent of project-based learning;
the attitude to drawing;
and group working.

It may be useful to see what such an understanding might comprise and what benefits would be available on each side.

The key to all this will be to make connections based on mutual respect.

The practical bias of art may benefit from the abstract thought of architecture, lending increased weight to ideas and intentions, just as architecture needs to see that by working with the hands there is another kind of learning. It is a question of bringing the rational and intuitive into an equilibrium, without diluting the quality or character of either.

The present progression in fine art from project to self-initiated work suggests a model of evolution. Since much other thinking in our culture favours linear development on the ape to spaceman pattern, it is not surprising if students see working alone as a more mature practice than working on a project. However, public art is by its nature a set of projects, and education for it will find a way of developing projects to greater complexity instead of diminishing their importance.

Comparing drawings about feeling with those about information shows that each has a limitation. Only certain things are communicated. Drawing is research, and there is no one way to do it.

The most contentious area (but the most crucial) is that of group working. The individualist ideology is so strong in fine art that it will take a long effort of persuasion to overcome the objections to collaboration. For example, staff will ask how it can be assessed, if only as a way to rationalise their hostility. Group working also implies projects, since there will be an agreed aim, and this opposes the dominance of self-initiated work. Original ideas will be modified by the group, and the authorship be multiple. Who then takes the credit? The answer is found in other subjects, such as film and drama, where work can only be achieved through co-operation, yet classes of Honours degrees are awarded.

Education for public art, involving communication skills as well as aesthetics, cannot be evolved without team-work. All public art projects in the professional sphere involve people doing things together, consulting, negotiating, and sometimes producing the work. Still, there is a need for professionals to better explain to others what they do, and acquire the skill of listening.

BEGINNING TO WORK TOGETHER

Whether public art is taught as a course, or a set of projects within a broader course, it is necessary to say what is the content of that education.

Public art generally involves a brief, however open, and it involves negotiating a proposal through from idea to actuality. There is no such thing as purely self-initiated public art. There are, certainly, examples of artist-initiated projects, but they involve other parties, such as the owner of the wall on which a mural is painted, and the users of the space, and sometimes other artists or assistants too.

Public art requires all the aesthetic skills of any art, the articulation of space, the expression of colour, and so forth. It additionally needs non-art

200

skills which have not traditionally been part of fine art courses.

They are essentially communication skills. Artists are more articulate than they are often given credit, but there are particular abilities required, for example, to present a proposal to a funding body. Fine art courses are increasingly incorporating modules on business and professional awareness, but these are not specific to the problems of public art.

The communication skills may be categorised as presentation, negotiation and consultation.

As a foundation for learning these, a critical history of public art would provide material for discussion. Site visits would enable a common experience of work in context. However, words will not alone be enough. Projects need to simulate live conditions.

Presentation involves setting out an idea in a visual and textual form which is accessible, so that a lay audience will know quickly and accurately what it is. It involves speaking to a proposal effectively within a short time.

Role playing has many advantages in this context. It is difficult to teach social skills in the abstract, since they depend on human interaction. But if people are working together then the whole capacity of interaction is already present. To assign a role enables a person to play it without the self-consciousness of being "themselves" in public. A simulated selection panel for a commission may include roles such as local councillor, visual arts officer, businessman, resident, artist, critic, or academic.

Negotiation is another vital area of expertise. This includes all the aspects of steering an idea from inception to completion. If an artist initiates a project, it will need to be funded, it will need a site, it will need to accommodate and respond to the views of the community, and so forth. A public work is a negotiated product. It comes out of what are often long processes of discourse, from contractual and legal matters, to relations with the owners and users of the place. Whilst a student may begin a painting simply by setting up a canvas, no public work enjoys that simplicity.

A good understanding of schemes such as the *Percent for Art*, and the planning law (section 52 of the Town and Country Planning Act, and the concept of "planning gain"), will be needed. These are not difficult to find out about. There are also many professionals who can share their experience of negotiating a project, costing it, implementing and documenting it. Above all, negotiation is about clarity of intention.

One area which may become increasingly important is sponsorship. This means the ability to put to a potential sponsor the benefits they would derive by paying for a piece of public art, and to explore the ethical arguments involved. Is there any "clean money", and what is the extent to which money has strings attached?

Consultation overlaps with negotiation, but may be taken to refer

more to working with the audience. It is a skill to set out questions in such a way as to gain the information required without influencing the answers. There is a social skill here, which will need specialist tuition.

Besides presentation, negotiation and consultation, documentation and research are necessary skills.

To document a project may involve photographic processes as well as the accumulation of texts (interviews, press cuttings, critical reviews) and conversations with artists and commissioners. There is no reason why the resources available in art courses should not be used to document actual public art projects. This could be a valuable support for those artists who will be at other times specialist visitors to a course.

Research means finding out about a place. This has three aspects: the physical location and its material identity; the people who live in or pass through the place; the local history. The latter will involve visits to museums, libraries and local newspapers — all may have archive material which could feed into the subject matter of a work. The study skills are not very different from those used in architecture to make a study of a site.

Two principles seem helpful in designing projects: to always use real places; and to accept as valuable the educational process of taking something to design stage but not production.

The notion of an unreal site seems pointless as well as semantic nonsense. Conversely, everywhere that has been inhabited or husbanded has a history, has a location and users, so real places are the obvious basis for projects. Often the aim will be to lend the place an identity. The product will normally be a presentation of images and back-up information. There is no reason to expect to go out and construct a sculpture or paint a mural. Architects go through a whole course without making a building and that conceptual level is likely to be the model most often used. What has to be avoided is filling the towns and fields of Britain with student work. This idea may be difficult to put across in a context where finished products have been emphasised, but public art courses will inevitably break that mould.

Alongside project work there needs to be time for the same studio work undertaken by any fine art student. Projects are the vehicle for new and additional skills, but these make sense only in partnership with aesthetic sensibility and creative risk. To create an artificial division between artists and public artists at the level of education would be a potential disaster leading to bland municipal art.

Studio work is vital, but there is scope for another kind of practical education: that of work experience. Placements can be arranged with established artists and public art groups. By being involved in a well-run project (and careful monitoring is advisable) a student will see at first hand all the problems faced and rewards achieved, and have "hands-on" experience with whatever techniques are employed. After all, some

things cannot be simulated, such as painting a large mural in Keim silicate or making an extensive environmental sculpture, but work experience can give a direct interface with working conditions, and perhaps with an audience or participating community.

The most contentious area of all is that of student commissions. Temporary pieces may escape this, but there are enough examples of students working on live projects to raise a few hackles amongst the commissioning agencies. Artists seem less ill-disposed on the question, but students after graduation become artists, and courses need to bear in mind that if they flood the market with cheap student work, their own ex-students may go hungry.

It would be naïve to say that courses will not be offered commissions or that they will decline such offers. Sometimes a commission from a local organisation or business may help build valuable community links for a course, and may represent an authentic desire by commercial interests to assist education. So many Colleges exist in isolation from their surrounding populations that any attempt to link the two is welcome.

Nevertheless, the charge will be made that courses are depriving artists of work by undercutting on cost. Student work will be cheaper. Students are not professionals. Courses have a responsibility to adhere to codes of practice agreed nationally and in liaison with commissioning agencies and artists' organisations if they are to answer such criticisms. Somehow, the need for live student work has to be reconciled with the interests of the profession. The first part of the answer is that courses are, in fact, extending awareness of public art generally, and thereby expanding the market. For example, Kent Institute of Art and Design, Winchester School of Art and Kingston Polytechnic have Public Art study within their Fine Art degree courses. A college is able, in co-operation with its Regional Arts Association, to extend the scope for public art in a region where it has little history of practice. It can also organise seminars and conferences to benefit local artists and generate interest from potential commissioners. From a cake of increasing size, there is a slice for all.

Students on the MA in Public Art Course at Duncan of Jordanstone College of Art (Dundee) work on a "live" group project each year. In 1986 and 1987 these were mosaics for outdoor sites in a housing redevelopment area (*Figs 1 and 2*). The project was supervised by staff with extensive experience in the Blackness Project, and well integrated into the Dundee public art programme. Hence the context was well regulated. For the students it gave valuable real-site experience, working with the contractors, and equally valuable experience of being part of a team, seeing the design through from inception to completion.

Both the Kent Institute and Dundee benefit from the unusual resource of an Architecture Department within their College. In both

1. Students of Duncan of Jordanstone College of Art (MA in public art) group mosaic project, 1986 (R Forbes)

2. Students of Duncan of Jordanstone College of Art (MA in public art) group mosaic project, 1987 (M Miles)

204

3. Students of West Surrey College of Art & Design, playground mural, Guildford, 1987 (M Miles)

institutions there are joint projects between Public Art and Architecture, based on real sites. These are invaluable as a preparation for professional life.

Courses which undertake live projects have a responsibility to ensure high standards and maintain adequate supervision and tuition. Many student projects are in the Welfare State, for example in schools. Two students from West Surrey College of Art and Design painted a mural in a school in Guildford in 1987 (*Fig 3*). The school could never have afforded to commission a professional artist, and the students raised sponsorship in kind from local businesses. The children contributed design ideas which were scaled up by the students.

Mosaic is a popular skill in schools, partly because it can occupy so many children. John O'Reardon (a graduate of the Dundee MA course) seeded the skill in schools in Gravesend whilst Urban Explorer. At Heath End School in Surrey, Robert Jakes made a *World Mosaic* during a residency funded by South East Arts as part of its art in schools programme

4. Robert Jakes, *World Mosaic*, Heath End school, Farnham, 1988 (R Jakes)

5. Robert Jakes, *World Mosaic*, Heath End school under construction, Farnham (R Jakes)

(*Figs 4 and 5*). Such projects are inexpensive, and begin to establish for school children a link between art and environment.

A realisation that people can take responsibility for, and enhance, an environment can begin in schools. The skills and awareness necessary for professional practice of art in the environment can be learnt in Colleges, once they develop courses which include public art. Perhaps we can look to a near future in which the public dimension of art is part of the subject from secondary school through to MA courses.

Only with such educational preparation will schemes such as the *Percent for Art* be successful. Enough artists have learnt the hard way; it is time to structure courses to include those extra skills and the additional critical awareness artists need to work in a public context. This carries the implication that there will be some live work done by undergraduates. The profession may reasonably be asked to accept this as a necessary consequence of what will lead to higher quality in the long term.

Wherever possible, live work should be part of a well-established programme of public art, involving professionals. Work experience can be gained by placements — as with the placement of a student from the Kent Institute of Art and Design with Public Art Development Trust in relation to the Walderslade commission (1988 – 89).

Where there are commissions, it is possible that, given the energy and freedom of student work, plus professional monitoring and guidance, there will emerge new possibilities for public art. Just as education may suffer the danger of academicism without change, so may public art without new blood, and that transfusion will come from Colleges, seen as a research and development area for the practice.

Some questions remain. Should the debate on public roles for artists catalyse a broad change in all fine art education? In other words, should all courses be rebuilt to include the public context?

Most public and community art practice has grown up outside educational institutions. That history needs to be better documented, and its participants should now be invited to bring their experience into education. The resources of institutions are considerably greater than those of individuals, and could be utilised to develop new modes of presentation using new technologies. The level of critical debate will also rise, as courses evolve theoretical components to match practical ones. This can only be for the good, and demonstrate the benefits of education for public art.

The next generation of public artists will be better prepared and better informed, and will have been encouraged to question and speculate on that practice built up under difficult (often marginal) conditions. Is it possible that there will be a rediscovery of major subjects in public art, or a more intense search for appropriate languages? Education is likely to be the key to a richer texture of work.

Most major changes in society depend in some way on education and this is no exception. The beginning of a relationship between art and architecture in education could be a catalyst, and no doubt it would need to be one of many, contributing to a less fragmented sphere of knowledge.

AFTERWORDS AND REVERIES

THE LOST OR BROKEN TRADITION?

"For you know only a heap of broken images"[1]

Once there was a tradition in which all things held together, or so it has been said.

The allusion is to a world-view in which the aim of knowledge is synthesis and the role of art and architecture to give form to the idea of Unity. Is it myth or history?

The sub-text of asserting a past unifying idea, is that there is no such idea today. In seeing it as a lost tradition, the statement is concerned with the poverty of the present, its fragmentation and rootlessness. It makes no difference if it is myth or history; enough that it is absent. Nothing holds together. Art and architecture are separate disciplines. The arts have no common content.

Anthony Gormley has spoken of a lost tradition, meaning the loss of potency in public images[2] and Tess Jaray of "spiritual and symbolic constants that must reflect some fundamental and continuous human need, irrespective of time or culture".[3] Peter Randall Page has described public sculpture as "having an intrinsic value" in that it draws attention to the recurrent questions of human existence and "the imponderables of life".[4] Those "imponderables" have been described as "Life, Death and What remains of the Beloved".[5] The implication is that there may be a universal content of art. But have we in some way lost sight of it in our public images?

On one hand is an imagined past with a holistic world-view, and on the other the modern world, with its divisions of labour, knowledge and life.

What is projected onto the past, such as a golden age, is as interesting

211

a field of study as what is documented about the past. All history is, after all, invention. The stories change because they are our subjective impressions.

The past leaves monuments, as vehicles for our impressions. Were art and architecture once united? To say so is an aspiration rather than a description of a past mode of daily life. A model of past practice showing that some degree of unity was once possible would act to remind us of what we may reclaim. Even a dream, or exactly a dream, reminds us of our potential to imagine a better future.

Byzantine culture offers such a model, which we may briefly, and perhaps a little subjectively, explore. Its art and architecture manifest the spirituality which was its unifying force. They show remarkable continuity. It was (and is) a traditional culture, based on a development of precedent rather than an urge to innovate. The style of the sixth century differs only slightly from that of the eighteenth.

When Justinian presided from a chair set on the porphyry circle in the floor of the church of Holy Wisdom (Agia Sophia in Constantinople), he sat at the centre of the World, and gazed on a fusion of architectural and pictorial space in one of the most extraordinary buildings ever constructed or decorated. On the exterior surfaces there is nothing remarkable; inside it is awe-inspiring and enfolding. The manipulation of surface, and the welling of space in the centre, slowly filtered through arcades to the edges, together deconstruct the solidity of the walls. Solid stone becomes insubstantial light.

The entire inner fabric is a metaphor for the spiritual, as matter is transformed into light and the inner life is where the divine resides in Man.

The vault is the sky of Heaven. That of Earth is blue, but Heaven is brighter, thus gold. What is brighter is nearer the absolute. What is nearer truth is less descriptive. It is almost too much for the spectator, for reality in the Byzantine mind is God, and the rest is transitory and specular.

Even in its present state as a tourist museum, the space exerts a presence, becomes a place. A sympathetic act of imagination may allow us to sense it as it was intended. The gilded dome is in poor repair, but an idea of its sumptuousness is lent by Saint Mark's in Venice.

The tesserae were set at slightly varied angles to pick up a shimmering reflected light from the numerous lamps, which themselves flickered and were mirrored in metal discs hung from the ceiling. Masonry and glass were thereby transformed into the immaterial. Light is the basis of Byzantine art, disdaining matter and appearance in keeping with the mystery of faith.

The meaning of the building is in its spatial qualities, and these depend on both architectural elements and on surfaces of marble and mosaic. The surface and the wall cannot be differentiated. The feeling of

212

Holy Wisdom is as indivisible as the quality it celebrates.

The mosaics at Torcello are half a millennium later. The image of the Mother is set in a pictorial space and language distanced from the representational. What stands in the resulting realm of otherness enables the spectator to re-experience a metaphysical reality (a memory of the original unity, before creation and the Fall).

At Torcello, the Mother of God is arrayed in deep blue like the night sky, on a ground of gold. She animates a surface which echoes sky and womb, in its figuring and its building, its surface (or colour) and shape. Beneath Her feet are the Apostles. There is an ambiguity of spatial reading: the ground is a solid mineral, the cloak like a deep space, yet in the flickering of lamps, the gold transforms from matter into light and the contours of the figure become substantial. This paradox (not unlike the clouds of colour in a painting by Mark Rothko, with their ambiguity of figure and ground) is at the centre of the work's meaning. The mosaic gives no illusion, is too stylised for that, but becomes an equivalence of a deep, meditative space experienced inwardly through the vehicle of the sensible.

The decoration here cannot be separated from the supporting vault any more than that of Holy Wisdom. It is more than putting pictures on walls, it is symbolic architecture working with a symbolic two-dimensional language.

Byzantium lends us a model of both kinds of unity: the particular and the general. Art is combined with architecture, and the World (as a construct of thought) held in cohesion by a general religious idea. This is not to say the society was without corruption. There was the same capacity for cruelty and lust for power as in any society. What differentiates Byzantium from our own culture is its projection of a value system based in the absolute, and its spiritual cohesion.

If we look to Byzantium as an example of a lost tradition which interests us, it may be useful to see how, in another past, it was rehabilitated after centuries of rejection.

The Byzantine state fell to the Turks in the fifteenth century. Not until the Romantic movement was there any revival of interest in the Byzantine past, and not until the mid nineteenth century an attempt to rehabilitate Byzantine art and architecture as high culture. Lord Lindsay's book, *The History of Christian Art*, was the first to separate the Byzantine from other early Christian images. Ruskin was influenced by Lindsay's championing of the Christian Fathers as men of learning. In the *Stones of Venice* (1851 – 53), he refers to "those stones called barbarous" as "the most subtle" of architectural compositions.

Independently, European artists rediscovered the near East. Descamps and Gérôme, amongst other Orientalists, travelled in Turkey, painting a romanticised interpretation of what they saw, with the

eroticism required by their audience in the Salons. In the 1880s and '90s the Symbolists turned to Byzantium as a source of mystery and the esoteric. They did not produce a new, integrated tradition of art and architecture, though Puvis de Chavannes combined narrative and faith in his mural cycle of Sainte Geneviève in the Pantheon. His pupil, Henri Martin painted murals in Toulouse; Gauguin's *Where do we come from, What are we, Where do we go?*, with its yellow corners looks like a fresco. Levy-Dhurmer's *Peacock Room* for a private client in Paris (now in the Metropolitan Museum), and Redon's murals at the abbey of Fontfroide are reworkings of oriental subjects, far away from the moral and financial scandals of the third Republic.

In Vienna, Klimt was directly influenced by the Byzantine mosaics at Ravenna. His University murals utilise gold to give a linear, flat emphasis, and Hygeia has the statuesque quality and frontality of a Byzantine Empress. He understood the fusion in the Ravenna mosaics of colour and surface, light and matter.

What these examples have in common is their turning to exotic and ancient worlds, rich in the perfumes of incense perhaps, but still standing for a symbolist or mystical alternative, as a vehicle for dissatisfaction with the present. The Symbolists are refugees in the spiritual past, fleeing the barbarity of modern life. *Fin de siècle* art is as private as art can be; it is an art of withdrawal, of the *soirée* and the *séance*. By contrast, Byzantine art offered inwardness in a common form and rite.

The period of cultural history which saw the rehabilitation of Byzantine art saw a similar move to revive another great spiritual culture: the Gothic. A nostalgia for medieval England was manifested in the Pre-Raphaelite Brotherhood, and was still evident near the end of the century in the Arts and Crafts Movement. King Arthur and his knights became, through poetry, painting and illustration, popular representations of a bygone and better time, a less strenuous era, one fixed through literary device in stasis.

By the end of the nineteenth century, the Gothic had been sentimentalised in the popular imagination. The faeries were banished from under green hills to the bottom of the garden, and pagan Britain was reduced to the banal spectacle of Morris dancing. The newly invented medievalism concealed a sense of loss; it was the antithesis of the modern urban and industrialised world so lacking in beauty or a sense of value.

Alfred Lord Tennyson gives many vivid images in the *Morte d'Arthur*, such as the description of "Avilion":

"Where falls not hail, or rain, or any snow,
Nor ever wind blows loudly; but it lies
Deep-meadowed, happy, fair with orchard lawns
And bowery hollows crowned with summer sea,
Where I will heal me of my grievous wound."

214

The longing for such a place of re-integration combined with images of idyllic landscapes characterises the Victorian disillusionment. Matthew Arnold suggested the cause of other-worldliness as:

". . . this strange disease of modern life,
With its sick hurry, and its divided aims,
It's heads o'ertaxed, its palsied hearts . . ."

and

"this iron time
of doubts, disputes, distractions, fears."[6]

This is the context of the reclamation of the past and the re-unification, if there was one, of art, craft and architecture: a time of greed, fragmentation and philistinism.

A product of nineteenth-century medievalism was the renewed taste for Romanesque and Gothic architecture as manifested in St Pancras station and the Houses of Parliament. There were competitions to decorate the new Houses of Parliament. This could have been the beginning of a new public art, but the energy became dissipated and the required subjects were academic. The first was announced in 1842, with subjects from British history, or Spenser, Shakespeare or Milton. Cartoons in monochrome were required by June 1843. Benjamin Haydon, reduced to pawning even his spectacles, offered *The Curse of Adam* and the *Entry of the Black Prince and King John into London*. For years he had campaigned to reintroduce history painting into public buildings, but was rejected, partly because symbolic narrative looked suspiciously like Catholic art.

G. F. Watts, at the beginning of his career, submitted *Caractacus*, and won one of three first prizes of £300, enough to pay for a long visit to Italy. The cartoons were displayed; one of the visitors was the fifteen-year old Dante Rossetti. None of the proposals was carried out, and while Watts was abroad his cartoon was cut up.

Watts entered another picture for the fourth competition in 1847. Had he been given the opportunity, he might have become a muralist, but official taste seemed as yet unprepared for a full reversion to public imagery. His chance came in 1852 with the new Hall at Lincoln's Inn. He completed the fresco (for the cost of materials) in 1859: *Justice: a Hemicycle of Lawgivers*. He used egg tempera on fresh plaster, but this Pre-Raphaelite technique was a vehicle for a decidedly Raphaelesque composition based on the *School of Athens* but not as good. The same source had been used by Overbeck in 1836–40 for his insipid *Triumph of Religion in the Arts*. Leighton picked up the idea with the *Arts of Industry Applied to Peace*, and to *War*, for the Victoria and Albert Museum (1872–80). His sketch of *Peace* was shown at the Academy in 1873,

where it attracted the following criticism in the Art Journal:

> "He has seen the beauties he paints only remotely, as though in the work of some other painter, and not in the world about him." [7]

The fashion for Gothic Revival architecture in Britain did not bring about a re-invention of Gothic sculpture, even less for a full integration of art, craft and architecture on the medieval pattern.

William Morris and his friends had taken a step towards collaborative efforts in 1861, with the Foundation of Morris, Marshall, Faulkner & Co: Fine Art Workmen in painting, carving, furniture and the metals. They reversed the Renaissance division of art and craft, with the aim of working in architectural contexts. Their prospectus states:

> "The growth of Decorative Art in this country, owing to the efforts of English architects, has now reached a point at which it seems desirable that artists of reputation should devote their time to it."

In 1906, the writer of a popular monograph citing the above noted:

> "How remarkably quickly innovations which at their time caused a great sensation pass away out of remembrance. Do not these words sound almost identical with the advertisements of our modern artistic workshops?" [8]

Morris and Ruskin have been credited with bringing the arts and crafts together with renewed unity of purpose. It was very nice for Jane Morris to wear a dress reminiscent of the middle ages, and for Morris and the Pre-Raphaelites to enjoy their fancies of Camelot or paint murals in Oxford. But this was not a new cultural unity. William Morris was a socialist and a practical man, but also a subscriber to the general vogue for a fabled past.

It is important to distinguish between the revival of the past as a pretext or circumstance for a new unification of art and architecture, and original models where a living world-view brings both naturally into its service.

In Byzantium nothing was revived because all was part of tradition, just as in tribal societies a thing is held to have value because it partakes of how things were in the days of the ancestors. [9] Where time is a matrix, the concept of revival does not occur. Revivals are an expression of a poverty of thought, a compensation for a notion of something lost.

Today we see a fragmentation of thought and the arts. The "strange disease of modern life" appears increasingly a terminal illness. Amidst such chaos, it is natural to recognise a sense of loss by compensating with a projected unity in an imagined past. Hence the notion of the lost or broken tradition.

A return to tradition may begin from a present sense of loss, and

attempt to compensate with a contrived past. But the tradition itself is real, and perhaps there are psychological constants, as artists such as Tess Jaray have suggested. Such continuity may also be expressed in "great subjects" which retain a compelling meaning outside their time.

Can there be a return to great subjects in art? The question embodies two major ideas: that there are great subjects, and that we have lost them. If there are great subjects, where do we find them? How do they claim a universal status? Is there some basis in the psyche which allows us to share a Common Wealth of Images?

In Giorgione's *Tempesta* (Academia, Venice) the man stands alone. Behind him is a broken column denoting Fortune. In the foreground a woman suckles a child. There is a storm in the background. If the images are shuffled around, the whole story is there. A history of falling. A broken column. A childhood world of satisfaction and a grown up world of lost content.

In reaction to lost contentment, aware that a wholeness (which we project in origins) is lost, we form fantasies of return, to the womb, to Eden, to Byzantium, to some first unity, like the undifferentiated feeling of life before birth. A morbid fascination would be a perverse form of this: the night after is the same as the night before. There is a longing for a regained state of de-differentiation.[10]

The desire to regain a lost state of the undifferentiated may be one reason why people speak of a lost tradition and characterise it by the unity of art and architecture subsumed in a common vision. The other reason may be that there exists a stratum of shared symbolic imagery and shared feeling which only the arts express.

The inner life is voiced in imaginative work. Its subjects follow the myths of changing societies because those myths are unchanging, merely finding new clothes. Hence Osiris, Orpheus and Christ may be seen as all aspects of a developing image based in the god of vegetation, who dies at harvest, is scattered, and is reborn in the spring.

The core of such myths is universal. Only the form and language change according to the circumstances of history. Perhaps these are our "great subjects".

If myth is the area of subject matter, there is within it another, deeper level, from which are generated the meta-images of the Mother of God, the great Goddess who is the night sky (called Nut in Egypt), the sea, the winds and the earth. A contemporary equivalent of the universal goddess is seen in Claire Smith's *Limehouse Reach* (*Fig 1*).

Ucello's picture in the National Gallery, London, of *Saint George and the Dragon* shows another (more individuated) level of symbolism. A transcription of it is a mural in Swindon. A sculpture was made of the subject by Michael Sandle (*Fig 2*).

The man rides a white horse. He kills the dragon, which bleeds a pool

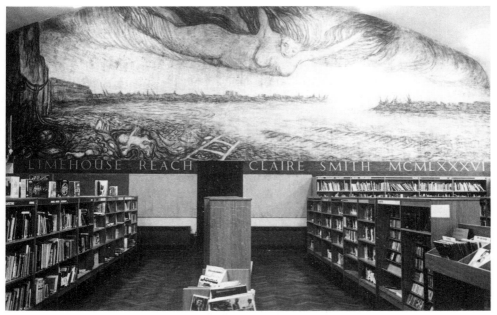

1. Clare Smith, *Limehouse Reach*, Limehouse Library, 1986 (C Smith)

of dark red blood. He marries the Princess. In some pictures she holds the dragon by a leash, as if it is part of her, in the sense of another aspect of her. She is meek and subservient, but the dragon is not. She is civilised, the dragon is not. The story may be interpreted in various ways.

Rational, civilised man triumphs over intuitive, primitive man. This is a historical level of reading. The dragon is his origin in the agricultural cycle, his rejected ancestry. He grows up, goes away, takes the Princess.

Order triumphs over chaos. This is a philosophical, or metaphorical reading. The Sun triumphs over the Moon. The man is proportionality and measure. The dragon is all-overness and fluidity.

Masculinity triumphs over femininity. This is a psychological reading. Or, rather, it is divide and rule: by splitting the feminine, part is allowed to remain whilst the rest is repressed. A stereotype of the white virgin is embodied in the Princess: passive and obedient. The dragon, bleeding like the moon, is active femininity with its dark wound, its mysterious power which threatens man.

George and the Dragon is our myth: it stands for our society, our metaphor, our psychic reality. A world divided by a relentless and unsatisfiable lust for power. Sandle's *St George* begins to stand for this reading of the story, though some of his other work has been more

218

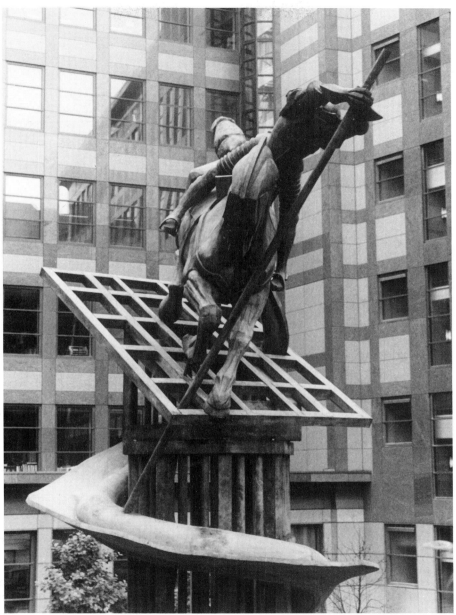

2. Michael Sandle, *George and Dragon*, London, 1987 (M Miles)

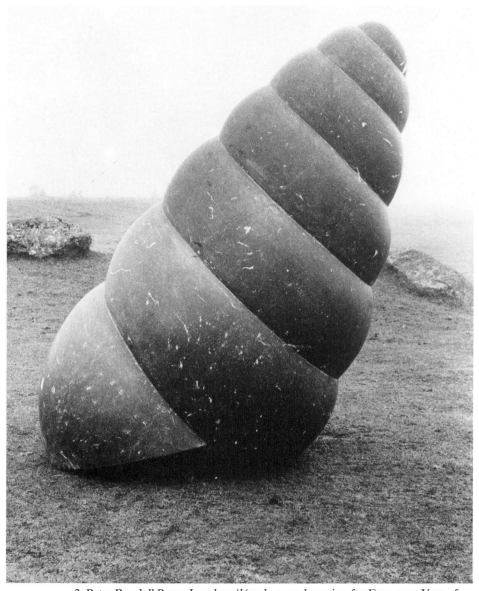

3. Peter Randall Page, *Land snail* (endangered species, for European Year of the Environment), 1987, photographed on Dartmoor (P R Page)

220

powerful.

So, can there be a return to great subjects? Perhaps these examples denote the kind of subjects which can be shared. And perhaps there is a third example in the carvings based on natural forms made by Peter Randall Page. The spiral shells in Dorset (for Common Ground) or the forms based on endangered species (*Fig 3*) can be interpreted at several levels, from the literal to the symbolic: the spiral itself is an archaic symbol of the interpenetration of life and death, unified in an image of cyclic time. These simple sculptures have the "presence" of "great subjects" and are accessible, vehicles for reverie.

Will we have a public art which explores great subjects? Is it possible to see beyond the writing on the wall in our urban wastes? Perhaps art can help us create places for people out of public spaces. Can it rediscover a Shared Common Wealth of Symbols?

FOOTNOTES

Chapter 1: The Arguments For Public Art

1. John Milton. Paradise Regained, book 1
2. Le Corbusier, "The Quarrel with Realism", in *Circle: International Survey of Constructive Art* Ed. J. L. Martin, B. Nicholson and N. Gabo (reprint), Faber 1971, pp 65 – 73.
3. D. Petherbridge, in *Art for Architecture*, HMSO 1987 (p 10) appears to wilfully misunderstand Le Corbusier through a selective quotation from his text.
4. Le Corbusier in *Circle*, op. cit.
5. R. Arad in Metropolis: catalogue to exhibition, Institute of Contemporary Arts, London 1988.
6. The *Attlee Memorial Statue* in the House of Commons, HMSO 1980 (includes speech made at the unveiling by Lord Shinwell).

Chapter 3: Community Murals in America

1. Lucy Lippard, "Gardens: some metaphors for a public art", *Art in America*, 69, Nov 1981. Cited in *Visual Dallas, the Programme for Public Art in Dallas*, 1987.
2. William Walker, Mark Rogovin, John Weber and others, cited in J. P. Weber, "Community Murals, an update", *New Art Examiner*, May 1978, p 4.
3. J. P. Weber, op. cit.
4. R. Smithson, quoted by K. Halbreich in "Sketching the Terrain", in *Going Public*, ed. P. Konza, 1988.
5. B. O'Doherty, "Public Art and the Government", *Art in America*, May 1974. The article is mainly concerned with "fine art" in public places, and represents the nearest thing to an official view of the programme he administered for the NEA.
6. Ibid.
7. Ibid.
8. "Faith Rinngold interviewed by Michele Wallace", *Feminist Art Journal*, 1, 1972.
9. Figures given in article "Art of the Matter" by P. MacMillan, *Los Angeles Times*, 16 Feb 1987.
10. Mark Favermann, "Community Murals Projects of 1975 and 1977", *Leonardo*, 11, 1978.
11. Lucy Lippard "The Death of a Mural Movement", *Art in America*, 62, 1974. The main text is an interview with Eva Cockroft recorded in 1973.
12. Ibid.

Chapter 4: Questions of Language

1. Marcus Aurelius, *Meditations*, VII, 27. Everyman edition, 1906.

2. Victor Hugo, cited by T. J. Clark, *The Absolute Bourgeois*, 1973, p 126.
3. See discussion of Heidegger's views of Van Gogh's paintings of *Old Boots*, in J. A. Walker, *Van Gogh*, 1981.
4. See M. Eliade, *The Myth of Eternal Return*.
5. See essays by S. Wilmoth and S. Wilson, in catalogue to Léger Exhibition at the Whitechapel Gallery, 1988.
6. R. Huyghé, cited in essay by S. Wilson, op. cit.
7. Fernand Léger, "The New Realism Goes On", *Art Front*, Feb 1937, cited by S. Wilmoth op. cit.
8. Fernand Léger, "Popular Dancing", *Bulletin de l'Effort Moderne*, Feb/Mar 1925, reprinted in catalogue to *Léger & Purist Paris*, Tate Gallery 1970.

Chapter 5: Public and Private

1. L. Jordanova, Paper to Association of Art Historians Conference, 1987.
2. *Campaign For A Popular Culture*, GLC, London, 1986.
3. P. Dunn, *Fires*, No 3, Spring 1987.
4. L. Lippard, *Studio International*, March/April 1977.
5. O. Kelly, *Community, Art & The State*, Comedia, London, 1984.
6. O. Mulgan and K. Worpole, *Saturday Night or Sunday Morning?* Comedia, London, 1986.
7. F. Bianchini, Unpublished paper loaned to the author, 1986.
8. F. Bianchini, loc. cit.
9. Special thanks for help with this article are owed to Andrew Brighton, Janis Jeffries, and Brian Sedgemore. In addition, thanks to those colleagues and students at Kent Institute of Art and Design with whom the debates continue.

Chapter 6: Community Murals in Britain

1. Leaflet produced by Neighbourhood Open Workshops, 1985.
2. For further information see J. Watson, "Brightening the Place Up", *Circa*, Jan 1983. This whole issue is about murals, and a major source of information. The University of Ulster has a good collection of slides of student and sectarian murals.
3. Joe Coyle, quoted by Watson, op. cit.
4. Des Wilson, "The Painted Message", *Circa*, Jan 1983.
5. Jackie Redpath, "No Murals Here", *Circa*, Jan 1983.
 These negative remarks should be set beside those of David Speir: "The object of the scheme is to encourage local people to participate in the provision of a brighter environment . . . to stimulate latent creativity . . ." He accepted "There have . . . been problems, both technical and personal. One can hardly expect otherwise when art students are suddenly involved in . . . a mural" (information sheet dated 1.11.78).
6. See Belinda Loftus, "Loyalist Wall Painting", *Circa*, Jan 1983.
7. J. Watson: letter to *Community Murals*, X, 1, 1985.
8. Ibid.
9. See N. McGuigan, op. cit. This article includes several statements by Con, one of the painters, who took art A level whilst imprisoned for membership of the IRA.

10. Quoted by John Kraska in "Public and Community Visual Arts Projects in Glasgow", in the *Visual Arts in Glasgow*, 1985.
11. G. Massey, Lecture at Glasgow School of Art.
12. For further information and another critique see the article and interview by A. Harkness, *Cencrastus*, Autumn 1987.
13. See the author's article on public art in Swindon, *Artists Newsletter*, Sept 1987.
14. C. Kenna, introduction to *Murals in London*, an invaluable list published by Grenwich Mural Workshop in 1986 and about to be revised.
15. C. Howden, "London Wall", *Everywoman*, June 1987.

Chapter 7: Galleries in the Streets

1. William Blake, *Gates of Paradise*.
2. *Brochure*, Lake County Convention and Visitors Bureau *(not dated)*.
3. C. Bailey, introduction to *Sculpture at Stoke*, 1987.
4. Isobel Vasseur, "Preface" to *Art in The Garden*, 1988.
5. George Mulvagh interviewed by Richard Cork in *Art in the Garden*, 1988.
6. Richard Cork, catalogue essay, *TSWA 3D*, ICA, 1987.
7. James Lingwood in *TSWA 3D*, ICA, 1987.
8. Antony Gormley in reply to a question from Rory Coonan at the Acanthus conference, Edinburgh, 1988.
9. Antony Gormley quoted in "Man of Iron", *Stroll*, 4/5, 1987.
10. B. McAvera, "The Emperor's New Clothes", *Art Monthly*, April 1988.
11. Conference on *Art Beyond the Galleries*, ICA Feb 1988.

Chapter 11: The Islington Schools Environment Project

1. Much has been written on this subject; see for example "Collaboration in Schools", *Studio International*, 2, 1977, and Sue Braden, *Artists and People*, London, 19??.

Chapter 12: Environmental Art

1. Patrick Creagh *The Lament of the Borderguard*.
2. Department of the Environment publications include: *Transforming Our Wasteland: the Way Forward*, 1986.
 Evaluation of Environmental Projects funded under the Urban Programme, 1987.
 Greening City Sites, 1987.
 Improving Urban Areas, 1988.
 Art for Architecture (by D. Petherbridge), 1987; all distributed through HMSO.
3. *Improving Urban Areas*, DoE, London, 1988.
4. Publicity leaflet published by Sandwell Metropolitan Borough Council, 1987.
5. *Action Blackness: broadsheet*, Scottish Development Agency, 1981.
6. *Action Blackness*, pamphlet, City of Dundee, 1985.
7. *Feasibility study for Dundee Public Art Programme*, Bob McGilvray, 1986.
8. Article by Ken Simon, *Glasgow Evening Times*, 25 August 1988.
9. Ibid.

Chapter 13: Public Art in the Countryside

1. Gerard Manley Hopkins, verse used as inscription to accompany the sculpture *Still Life* by Peter Randall Page. The client rejected the text, which is not displayed.
2. Joanna Morland, "The New Milestones Project", in *New Milestones, Sculpture, Community and the Land*, 1988.
3. Conversation between Peter Randall Page and the author, August 1988.
4. Ibid.
5. Ibid.

Chapter 14: Art in the Locality

1. William Blake, from the *Preface to Milton* (18??).
2. See N. Waterlow, "How they brought the Visual Arts to Milton Keynes", *Art Monthly*, May 1977.
3. See D. Petherbridge, *Art for Architecture*, 1987, which includes a summary of planning aspects of public art. Section 52 of the Town & Country Planning Act is the most widely quoted element of the law, but there are others. The Arts Council Steering Group on the Percent for Art is studying this matter, with legal advice.
4. Report by Public Arts on the Landmark scheme for Swindon, by Graham Roberts and Roland Miller, 1987.
5. John Buck, artist's statement, 1986.
6. Graham Roberts, Director of Public Arts, quoted by D. Hammond in the *Huddersfield Examiner*, 13 March 1987.
7. John White quoted in *Spen and Calder Weekly News*, 27 August 1987.
8. *The Connisborough Scene*, April 1988.
9. Lesley Greene, in a paper to a conference on Public Art at the Kent Institute of Art & Design (Canterbury), 16 March 1988.
10. Vivien Lovell, press statement from the Public Art Commissions Agency, 1988.
11. Antony Gormley, leaflet published by Kent County Council, 1988. See also remarks by D. Petherbridge in *Art Within Reach*, 1986.

Chapter 15: "Percent for Art" Schemes

1. T. S. Eliot, *The Wasteland*, 1922.
2. This and other information is taken from *Going Public, a field guide to developments in art in public places*, by J. L. Cruikshank and P. Korza (1988), an invaluable guide to both documentation and critical writing.
3. Theo Crosby, quoted by Amanda Baillieu, *Building Design*, 29, Jan 1988.
4. Richard Luce (Minister for the Arts) in written reply to Tony Banks MP, 15 Feb 1988.
5. Sheffield Universiade 1991, *Cultural Programme Appraisal*, by Simon Evans, 1988. See also Draft policy statement on *Art in Public Places* for Sheffield City Council, by David Alston, March 1988.

6. The members of the Arts Council Steering Group are: Richard Burton (chair), Conrad Atkinson, Robert Breen, Ernest Hall, Denys Hodson, Tess Jaray, Christopher Martin, Jane Priestman, Anne Sutton, Rory Coonan (Arts Officer ACGB), and Hilary Lester (assistant).
7. *Planning Policy Guidance Note 1*, para. 27.
8. See Leslie Greene's essay on Seattle in *Art for Architecture*, ed. D. Petherbridge, 1987.
9. *Downtown Art in Public Places Policy*, Los Angeles, adopted 1985.
10. Ibid.
11. J. Allen, "How Art becomes Public", *King County Arts Commission*, 1985.
12. J. Allen, letter to the author 13 August 1988, and *Visual Dallas: a public art plan for the city*, under the direction of J. Allen, 1987.
13. *Visual Dallas*, op. cit.
14. Andrea Blum, in *Projects and Proposals, New York City's Percent for Art Programme*, 1988.
15. Valerie Jaudon in *Projects and Proposals*, New York, op. cit.
16. I should like to thank Peter Hill for his help with the section on Los Angeles.

Chapter 18: The Lost or Broken Tradition?

1. T. S. Eliot, *The Wasteland*, 1922.
2. Antony Gormley expressed this at a conference at West Surrey College of Art and Design, November 1987, and at other later events, including the Acanthus Conference, Edinburgh, February 1988.
3. Tess Jaray, quoted by Richard Cork in catalogue essay "From the Studio to The City", for her exhibition at the Serpentine Gallery, 1988.
4. Peter Randall Page in conversation with the author, 1988.
5. Robert Graves, quoting the Welsh poet Alun Lewis, in the *White Goddess*, 1961.
6. Matthew Arnold, cited by F. R. Leavis in *New Bearing on English Poetry*, 1932.
7. *Art Journal*, 1873 (p 240), cited by R. Ormrod, in *Leighton's Frescoes*, 1975.
8. Morris & Co., quoted by H. W. Singer in *D. G. Rossetti*, 1906.
9. See M. Eliade, *The Myth of Eternal Return*, 1954.
10. See Anton Ehrenzweig, *The Hidden Order of Art*, 1967.

BIBLIOGRAPHY

1. BOOKS

Mark Angus, *Modern Stained Glass in British Churches*, Mowbray (Oxford), 1984.

John Beardsley, *Probing the Earth: Contemporary Land Projects*, Smithsonian Institute Press, Washington, 1977.

John Beardsley (Ed A. L. Harvey) *Art in Public Places: A survey of community sponsored projects supported by the National Endowment for the Arts*, Partners for Livable Places and National Endowment for the Arts (USA), 1981.

John Beardsley, *Earthworks and Beyond*, Abbeville Press (USA), 1984.

David Butler (Ed), *Making Ways*, Artic Producers, 1987.

Christopher Carrell and Joyce Laing, *The Special Unit, Barlinney Prison: its evolution through its art*, Third Eye Centre (Glasgow), 1982.

Gidean Chagy, *The New Patrons of the Arts*, Abrams (USA), 1973.

Jean Charlot, *The Mexican Mural Renaissance*, University of Texas Press (USA), 1962.

Brian Clarke, *Architectural Stained Glass*, Murray, London, 1979.

T. J. Clark, *The Absolute Bourgeois: artists and politics in France 1848–51*, Thames & Hudson, 1973.

T. J. Clark, *Image of the People: Gustave Courbet and the 1848 Revolution*, Thames & Hudson, 1973.

Graham Cooper and Douglas Sargent, *Painting the Town*, Phaidon, Oxford, 1979.

Richard Cork, *Art Beyond the Gallery in Early 20th Century England*, Yale University Press (USA), 1985.

Theo Crosby, *How to Play the Environment Game*, Penguin, London, 1973.

Jeffrey L. Cruikshank and Pam Korza (Ed P. Korza) *Going Public: a field guide to developments in art in public places*, Arts Extension Service and National Endowment for the Arts (USA), 1988.

Paul Damaz, *Art in European Architecture*, Reinhold (USA), 1968.

Peter Davies and Tony Knipe (Ed), *A Sense of Place*, Ceolfrith, 1984.

Barbarlee Diamonsytein (Ed), *Collaboration: artists and architects*, Whitney Library of Design (USA), 1981.

Nancy E. Douglas, *Public Plazas. Public Art, Public Reaction*, Vance Bibliographies (USA), 1983.

Ronald Lee Fleming and Renata von Tscharner, *Place Makers: Public Art that Tells You Where You Are*, Hastings House (USA), 1981.

Patricia Fuller, *Five Artists at NOAA: a casebook on art in public places*, Real Comet Press (USA), 1985.

John Greene, *Brightening the Long Days: hospital tile murals*, Tiles and Architectural Ceramics Society, 1987.

McKinley Helm, *Modern Mexican Painters*, Dover (USA), 1974.

David Humphries and Rodney Monk, *The Mural Manual*, Arts Council of New South Wales (Australia), 1982.

Rob Kier, *Urban Space*, Academy Editions, 1984.

Jean Lipman, *Calder's Universe*, Thames & Hudson, 1977.

Lucy Lippard, *Changing: Essays in art criticism*, Dutton (USA), 1971.

Kevin Lynch, *The Image of the City*, Harvard University Press (USA), 1960.

Kevin Lynch, *What Time is This Place?* MIT Press (USA), 1972.

Richard McKinzie, *The New Deal for Artists*, Princeton University Press (USA), 1973.

Michael Midleton, *Man Made the Town*, Bodley Head, London, 1987.

Joanna Morland, *New Milestones: Sculpture, community and the land*, Common Ground, 1988.

Francis O'Connor, *Federal Support for the Visual Arts: The new deal and now*, New York Graphic Society (USA), 1969.

Francis O'Connor (Ed), *Art for the Millions: essays from the 1930s by artists and administrators of the WPA Federal Art Project*, New York Graphic Society (USA), 1973.

Jean Parkin and William J. S. Bayle (Ed), *Art in Architecture: art for the built environment*, Visual Arts, Ontario (Canada), 1982.

Deanna Petherbridge, *Art for Architecture*, Dept of the Environment, HMSO, 1987.

Nancy Raine, *Arts on the Line: a public art handbook*, Cambridge Arts Council (USA), 1987.

Louise G. Redstone and R. Ruth, *Public Art: new directions*, McGraw Hill (USA), 1981.

Alma Reed, *The Mexican Muralists*, Crown (USA), 1960.

Margaret Robinette, *Outdoor Sculpture*, Whitney Library of Design (USA), 1976.

Desmond Rochfort, *The Murals of Diego Rivera*, Journeyman Press, 1988.

Antonio Rodriguez, *A History of Mexican Mural Painting*, Thames & Hudson, 1969.

Joyce P. Schwartz, *Artists and Architects: challenges in collaboration*, Cleveland Centre for Contemporary Art (USA), 1985.

Myra E. Schwartz, *Annotated Bibliography on Art in Public Places*, Vance Bibliographies (USA), 1984.

Jan C. Scruggs and Joel L. Swerdlow, *To Heal a Nation: the Vietnam veterans memorial*, Harper and Row (USA), 1985.

Robert Sommer, *Street Art*, Links Books (USA), 1985.

Werner Spies, *The Running Fence Project: Christo*, Abrams (USA), 1980.

W. J. Strachan, *Open Air Sculpture*, Zwemmer/Tate Gallery, 1984.

Lynn Thompson (Ed), *Artwork/Network: A planning study for Seattle — art in the civic context*, Storefront Press (USA), 1984.

Colin Tomkins, *Roy Lichtenstein: Mural with Blue Stroke*, Abrams (USA), 1988.

Peter Townsend (Ed), *Art Within Reach*, Arts Council & Art Monthly, 1984.

Donald Thalacker, *The Place of Art in World Architecture*, Chelsea House (USA), 1980.

Coosje Van Bruggen (Ed), *Claes Oldenburg Large Scale Projects, 1977 – 80*. Rizzoli Books (USA), 1980.

B. Volker, *Street Murals*, Penguin, 1982.
Nick Wates and Charles Knevitt, *Community Architecture: How people are creating their own environment*, Penguin, 1987.
Marian Wenzel, *House Decoration in Nubia*, Duckworth, 1972.
Stephen Willats, *Intervention and Audience*, Coracle Press, 1986.
Gavin Younge, *Art for the South African Townships*, Thames & Hudson, 1988.
Paul Zucker, *Town and Square*, Columbia University Press (USA), 1970.

2. CATALOGUES AND REPORTS

Aesthetics in Transportation. More-Heder Architects, Cambridge, MA, U.S. Dept of Transportation, 1980.
Allocation for Art for Public Facilities: A Model Act, National Assembly of State Arts Agencies, Washington DC (USA), 1984.
Art and Architecture, Institute of Contemporary Arts, London, 1982: conference report (ed) D. Petherbridge.
Art for Whom, Serpentine Gallery, London, 1978.
Art in Architecture Programme, J. Solomon, U.S. General Services Administration, Washington DC, 1977 and 1979.
Art in the Garden (Glasgow Garden Festival), Graeme Muray Gallery, Edinburgh and Glasgow Garden Festival, 1988.
Art in the National Health Service, Peter Coles, Dept of Health and Social Security (Cleveland), 1983.
Art in Public Places, Malcolm Miles, South East Arts Association, 1987.
Art in Public Places, Institute of Contemporary Art, Los Angeles, 1978.
Art in Public Places, Freedman Gallery, Albright College, Reading PA (USA), 1985.
Art into Landscape, Serpentine Gallery, London, 1974, 1977 and 1980.
Art on the Line. 8 year report. Massachusetts Bay Transportation Authority, Boston (USA), 1986.
Artists and Buildings, David Harding, Scottish Arts Council, 1977.
Kevin Atherton, Serpentine Gallery, London, 1988.
British Sculpture in the Twentieth Century, Whitechapel Gallery, London, 1982.
Campaign for Popular Culture, Greater London Council, 1986.
City Art Project, City of Portsmouth Art Gallery, 1974.
City Centres, City Cultures, Franco Bianchini, Mark Fisher, John Montgomery and Ken Worpole, Centre for Local Economic Strategies, Manchester, 1988.
Collected Artlaw Articles, H. Lydiate, J. Boswell (Ed), Artlaw Services, London, 1981.
Commissioning a Work of Public Art: an annotated model agreement, Volunteer Lawyers for the Arts, New York/American Council for Arts (USA), 1985.
Common Ground: 5 artists in the Florida Landscape, Ringling Museum of Art, Sarasota (USA), 1982.
Cultural Facilities in Mixed-Use Development, H. Snedcof, Urban Land Institute, Washington DC (USA), 1985.
Design, Art and Architecture in Transportation, U.S. Govt Printing Office, Washington DC (USA), 1977–80.
Design Competition Manual, National Endowment for the Arts, Washington DC (USA), 1980.

Documentation for Public Art Collections, Lynda K. Rockwood, Washington State Arts Commission (USA), 1982.
Downtown Art in Public Places, City of Los Angeles Policy Document, 1985.
Earthworks: land reclamation as sculpture, Seattle Art Museum (USA), 1979.
Economics of Amenity, R. H. McNulty, L. Penne, D. R. Jacobson, Partners for Livable Places, Washington DC (USA), 1985.
Education for Public Art, Malcolm Miles (Ed), Kent Institute of Art and Design (Canterbury), 1988.
Evaluation of Environmental Projects funded under the Urban Programme, Dept of the Environment, HMSO, 1986.
Facts About the Arts (2), John Myerscough, Policy Studies Institute, 1986.
Financial Incentives for Better Design, C. Hager and S. J. Pratter, National League of Cities, Washington DC (USA), 1981.
Fine Arts in New Federal Buildings, Museums of Art, Orleans (USA), 1976.
Andy Goldsworthy: rain, sun, snow, hail, wind, calm, Leeds City Art Gallery, 1985.
Greening City Sites, Dept of the Environment, HMSO, 1987.
Grizedale Forest Sculpture, A. Christian and P. Davies, Grizedale, 1981.
How Art Becomes Public, Jerry Allen, King County Arts Commission (USA), 1985.
Improving Urban Areas, Dept of the Environment, HMSO, London, 1988.
Industry: caring for the environment, Royal Society of Arts, 1987.
Insights/On sites: perspectives on Art in Public Places, Partners for Livable Places, Washington DC (USA), 1984.
Tess Jaray, Serpentine Gallery, London, 1988.
Land Use and Transportation Plan for Downtown Seattle, City of Seattle (USA), 1985.
Leeds Art Calendar, # 74. (Leeds Town Hall Decoration, pp 16–22), 1974.
Let's Build a Monument, Theo Crosby, Pentagram Design, London, 1987.
Local Government and the Arts, Luisa Kreisbergs, American Council for the Arts (NY, USA), 1979.
Loop Sculpture Guide, Chicago Office of Fine Arts and Chicago Tourism Council (USA), 1986.
Manchester Hospitals Art Project. Peter Coles, Gulbenkian, 1981.
Meanwhile Gardens, J. McCullogh, Gulbenkian, 1978.
Metropolis: new British architecture and the city, Institute of Contemporary Arts, London, 1988.
Mural Manual, Greenwich Mural Workshop and Artic Producers, 1985.
Murals, Malcolm Miles, Thamesdown Community Arts Group, 1986.
New York City: Percent for Art: Implementation Procedures, NY Dept Cultural Affairs (USA), 1985.
New York City's Percent for Art Program: projects and proposals, NY Dept Cultural Affairs (USA), 1988.
The Pioneers. Annual Report, Cardiff, 1986.
Overhead Sculpture for Underground Railway, Richard Cork. Whitechapel Gallery, London (in *British Sculpture in Twentieth Century*), 1982.
Places as Art, Mike Lipse, Publishing Centre for Cultural Resources, New York (USA), 1985.

Practical Conservation, Royal Society of Arts (conference report), 1985.
Private Vision, Public Art, Eduardo Paoloozi, Architectural Association, London, 1984.
Private Vision/Public Spaces, D. Berger, Bellevue Art Museum (USA), 1987.
Public Sculpture in the 1950s, R. Calvocoresi, Whitechapel Gallery, London (in *British Sculpture in the Twentieth Century*), 1982.
Public Sculpture, Urban Environment, Oakland Museum (USA), 1974.
Sculpture in the City, Arts Council, 1968.
Public Sector Designs, Page, Clint and Penelope Cuff, Partners for Livable Spaces, Washington DC (USA), 1984.
Diego Rivera, Hayward Gallery, London, 1988.
Michael Sandle, Whitechapel Gallery, London, 1988.
Sculptural Monuments in an Outdoor Environment, Pennsylvania Academy of the Fine Arts (USA), 1985.
Sculpture off the Pedestal, Barbara Rose, Grand Rapids Art Museum (USA), 1973.
The Sculpture Show, Arts Council, 1983.
Sitings, La Jola Museum of Contemporary Art, La Jolla (CA) (USA), 1986.
Social Life of Small Urban Spaces, W. H. Whyte, Conservation Foundation, Washington DC (USA), 1980.
Study of Airports: Design, Art and Architecture, Federal Aviation Administration (USA), 1981.
Ten Years of Public Art, Nancy Rosen, Public Art Fund, New York (USA), 1982.
Town Artists Report, David Thorpe, Scottish Arts Council, 1980.
Town and Country: Home and Work, Royal Society of Arts (conference report), 1982.
Transforming Our Wasteland, University of Liverpool Environmental Advisory Unit, HMSO, 1986.
TSWA 3D (incl. essay by Richard Cork), Institute of Contemporary Arts, London, 1987.
Urban Encounters: art, architecture and audience, Institute of Contemporary Art, Pennsylvania (USA), 1981.
Urban Wasteland, Royal Society of Arts, 1980.
Visual Dallas: A public art plan for the City, City of Dallas Division of Cultural Affairs (USA), 1987.
Ray Walker, Royal Festival Hall/Coracle Press, 1985.
1932 Outdoor Relief Strike Mural, Ivor Davies, Neighbourhood Open Workshops, Belfast, 1985.
6 Artists in Industry, Bradford Art Galleries, 1981.

3. ARTICLES

Alice Bain, "Glasgow Garden Festival", *Artists Newsletter*, Oct 1988, pp 25–27.

J. H. Balfe and M. J. Wyszomirski, "Public Art and Public Policy", *Journal of Arts Management and Law* (USA), 15, #4 Winter 1986.

Johnn Beardsley, "Personal Sensibilities in Public Places", *Art Forum* (USA), 19, #10 Summer 1981, pp 43–45.

G. Berman, "The Walls of Harlem", *Arts Magazine* (USA), 52, #2, Oct 1977, pp 122–126

G. Berman, "Murals Under Wraps", *Arts Magazine* (USA), 54, #1, Sept 1979, pp 168–171

J. Bloom, "Changing Walls", *Architectural Forum* (USA), 138 #4, May 1973, pp 20–27.

J. W. Burnham, "St Quentin Prison Mural Project", *New Art Examiner* (USA), 4 #3, May 1977, pp 4–5.

E. K. Carpenter, "Urban Art. Design & Environment" (USA), 5, #2, Summer 1974, pp 17–37.

D. Cashman, "Outside the System", *Studio 193*, #986, Mar–Apr 1977, pp 105–115.

G. L. Cignac, "Thoughts of Peace and Joy", *Journal of Canadian Art History* (CAN), 6, #2, 1982, pp 137–179.

Grady Clay, "Vietnam's Aftermath: sniping at the memorial", *Landscape Architecture* (USA), 72, Mar 1982, pp 54–56.

S. Cockcroft, "Women in the Community Mural Movement", *Heresies*, 1, Jan 1977, pp 14–22.

Richard Cork, "Royal Oak Murals", *Art Monthly*, 15, 1978, pp 10–11.

Ken Currie, "Fernand Léger", *Alba*, 8, 1988, pp 22–26.

Lyell Davies, "Dublin Here Today", *Circa*, Nov 1987, pp 24–25.

Peter Davies, "Commissions: after Gateshead", *Art Monthly*, 69, Sept 1983.

I. Davies, "Putting the Democracy Back Into Culture", *Artists Newsletter*, Oct 1986, p 25.

D. Dwerden, "Painting the Town", *Arts Review*, 34, #3, 29, Jan 1982, p 42.

J. Eagle, "Portrait of a Village", *Country Life*, 162, #4196, 8 Dec 1977.

Milton Esterow, "How Public Art Becomes a Political Hot Potato", *Art News* (USA), Jan 1986.

M. Favermann, "Community Mural Projects", *Leonardo*, 11, #4, Autumn 1978, pp 298–300.

William Feaver, "Woodwork", *Observer*, 19, Nov 1978.

B. Forgey, "It Takes More Than an Outdoor Site to Make Sculpture Public", *Art News* (USA) 79, #7, Sept 1980, pp 84–89.

Mildred Friedman (Ed), "Site: the Meaning of Place in Art and Architecture", *Design Quarterly* (USA), 122, 1983.

S. M. Goldman, "Resistance and Identity", *Artes Visuales* (MEX), 16, Spring 1978, pp 22–25.

Amy Goldin, "The Esthetic Ghetto: thoughts about public art", *Art in America* (USA), May–Jun, 1974, pp 30–35.

Mel Gooding, "Seeing the Sites", *Art Monthly*, 108, July 1987, pp 12–15.

Don Hawthorne, "Does the Public Want Public Sculpture?" *Art News*, May 1982, pp 56–63.

H. Haydon, "Whither Walls?" *New Art Examiner* (USA), 3, #5, Feb 1976, p 21.

Peter Hill, "Public Art in Los Angeles", *Artists Newsletter*, Mar 1987, p 24.

Les Hooper, "Aspects of Commissioning", *Artists Newsletter*, Jul 1983, pp 9 – 12.

C. M. Howet, "Landscape Architecture: making a place for art", *Places* (USA), 2, #4, 1985, pp 52 – 60.

Ian Hunter, "The Artangel Trust", *Artists Newsletter*, Mar 1987, p 23.

E. Kroll, "Murals in New Mexico", *Art Forum* (USA), 12, #1, Sept 1973, pp 55 – 57.

P. Kumar, "Folk Murals in Shekhawati", *Arts of Asia* (HK), 2, #1, Jan/Feb 1981, pp 96 – 104.

D. Kunzle, "Art in Chile's Revolutionary Process", *New World Review* (USA), 41, #3, pp 42 – 53.

K. Larson, "The Expulsion from the Garden: sculpture at the Winter olympics", *Art Forum* (USA), Apr, 1980, pp 36 – 45.

Bill Laws, "Country Seats, Common Ground", *Artists Newsletter*, Jul 1988, pp 26 – 27.

Jane Lee, "Glasgow Garden Festival", *Art Monthly*, 119, Sept 1988, pp 13 – 16.

Sol Lewitt, "Sol Lewitt's Wall Drawings", *Arts Magazine* (USA), 46, #4, Feb 1972, pp 39 – 44.

Kate Linker, "Public Sculpture: the pursuit of the pleasurable and profitable paradise", *Art Forum*, 19, #7, Mar 1981, pp 64 – 73.

Kate Linker, "Public Sculpture: Provisions for the Paradise", *Art Forum* (USA), Summer 1981, pp 37 – 42.

Lucy Lippard, "Death of a Mural Movement", *Art in America* (USA), 62, #1, Jan/Feb 1974, pp 35 – 37.

Lucy Lippard, "Five", *Studio*, 187, #962, Jan 1974, p 48.

Lucy Lippard, "Art Outdoors", *Studio*, 193, #986, Mar/Apr 1977, pp 83 – 90.

Lucy Lippard, "Complexes: architectural sculpture in nature", *Art in America* (USA), Jan/Feb 1979, pp 86 – 97.

Lucy Lippard, "Gardens: some metaphors for a public art", *Art in America* (USA), Nov 1981, pp 135 – 150.

Barbara Loeb, "Ways of Looking", *Seattle Arts* (USA), May 1984.

B. Loftus, "Loyalist Wall Paintings", *Circa*, Jan 1983, pp 10 – 14.

Belinda Loftus, "In Search of a Useful Theory", *Circa*, Jun 1988, pp 17 – 23.

Euan MacArthur, "Ken Currie", *Art Monthly*, 119, Sept 1988, pp 17 – 20.

Brian McAvera, "Past Tense, Present Tense: Irish Sculpture Symposia", *Alba*, 10, 1988, pp 26 – 33.

Declan McGonagle, "Art as an Issue of Place", *Alba*, 7, 1988, pp 14 – 17.

N. McGuigan, "The Open Air Gallery of Political Art", *Circa*, Jan 1983, pp 15 – 18.

Penelope McMillan, "Art of The Matter: MacArthur Park", *Los Angeles Times* (USA), 16 Feb 1987.

T. Matthews, "Mural Painting in South Africa", *African Arts* (USA), 10, #2, Jun 1977, pp 28 – 34.

T. Matthews, "A Xhosa Mural", *African Arts* (USA), 12, #3, May 1979, pp 48 – 57.

Malcolm Miles, "A New Common Wealth?" *Art Monthly*, 105, Apr 1987.

Malcolm Miles, "Beyond the Walls: public art education", *Alba*, 5, 1987.

Malcolm Miles, "Art and Architecture", *Alba*, 8, 1988, p 30.

Roland Miller, *The Percent for Art: enter Mickey Mouse, Artists Newsletter*, Nov 1986, pp 20 – 21.

H. Moller, "Street Colours", *Projekt* (POL), 90, 1972, pp 58 – 61.

Lisbet Nilsen, "Christo's Blossoms in the Bay", *Art News* (USA), Jan 1984, pp 54 – 62.

B. O'Doherty, "Public Art", *Art in America* (USA), 62, #3, May/Jun 1974, pp 44 – 49.

Octavio Paz, "Social Realism in Mexico: the murals of Rivera, Orozco and Siqueiros", *ArtsCanada* (CAN), 36, Dec 1979/Jan 1980, pp 55 – 65.

Deanna Petherbridge, "Making Space: art projects beyond the gallery", *Art Monthly*, 115, Apr 1988, pp 27 – 29.

J. Redpath, "No Murals Here", *Circa*, Jan 1983, pp 20 – 21.

J. Romotsky, "Places and Murals", *Arts in Society* (USA), 2, #2, Summer 1974, pp 288 – 299.

M. A. Scherer, "What Happened to our Art?" *Capital Times* (Madison, WI, USA), 6 May 1985.

B. Schwartz, "Art for Society's Sake", *Journal of Current Social Issues* (USA), 2, #5, 1974, pp 14 – 17.

E. Simpson, "Chicano Street Murals", *Journal of Popular Culture* (USA), 13, #3, Spring 1980, pp 516 – 525.

R. Sommer, "A New Mural Movement", *AIA Journal* (USA), 63, #4, Oct 75, pp 82 – 83.

Brandon Taylor, "Conrad Atkinson", *Art Monthly*, 115, Apr 1988, p 16.

Calvin Tomkins, "The Art World: Like Water in a Glass", *New Yorker* (USA), 21 Mar 1983.

Gerry Walker and Mo Bates, "Art in the Open", *Circa*, Aug 1988, pp 16 – 20.

M. Wallace, "For The Women's House", *Feminist Art Journal* (USA), 1, #1, Apr 1972, pp 14 – 15 and 27.

B. Waters, "Painter and Patron: Palace Green Murals", *Apollo*, 102, #165, Nov 1975, pp 338 – 341.

J. Watson, "Brightening the Place Up", *Circa*, Jan 1983, pp 4 – 9.

J. P. Weber, "Community Murals", *New Art Examiner* (USA), 5, #10, July 1987, pp 6 – 7.

A. Wheeler and R. Padwick, "The Growth of Art Agencies"; "Art Agencies: the public sector". *Artists Newsletter*, Oct 1986, pp 20 – 21; Nov 1986, pp 22 – 24.

J. White, "AE's Merrion Square Murals", *Arts In Ireland* (IR), 1, #3, 1973, pp 4 – 10.

D. Wilson, "The Painted Message", *Circa*, Jan 1983, pp 19 – 20.

NOTES ON CONTRIBUTORS

HUGH ADAMS *is Visual Arts Officer of the Southern Arts Region of the Arts Council.*

RICHARD BURTON *is an architect and his building designs have been concerned with the harmonious integration of art and craft and in this he includes landscape design.*
He is presently chairing the 'Percent for Art' Steering Committee for the Arts Council.

RICHARD CORK, *the Art Critic of* The Listener, *has been appointed the Slade Professor of Fine Art at Cambridge for 1989-90. His books include* Vorticism *(Llewelyn Rhys Memorial Prize, 1976);* The Social Note of Art; Art Beyond the Gallery *(Sir Banister Fletcher Award, 1986); and* David Bamberg.

AMAL GHOSH *is a muralist, and teaches at the Froebel Institute. He has made public art in Britain and India.*

JULIET STEYN *has written extensively on the theories of art, and is Senior Lecturer in Cultural Studies at the Kent Institute of Art and Design.*

DAVID STONE *is an artist, and Director of Islington Schools Environment Project.*

LOUISE VINES *is a muralist who works with London Wall mural group, and teaches at the Froebel Institute.*

MALCOLM MILES *is an artist and writer, and Deputy Head of Fine Art at the Kent Institute of Art and Design. He is an adviser to the Arts Council Steering Group on the Percent for Art, and Course Adviser to the MA in Public Art at Duncan of Jordanstone College of Art.*

235

INDEX

INDEX